THE
HIDDEN LIFE
OF TREES

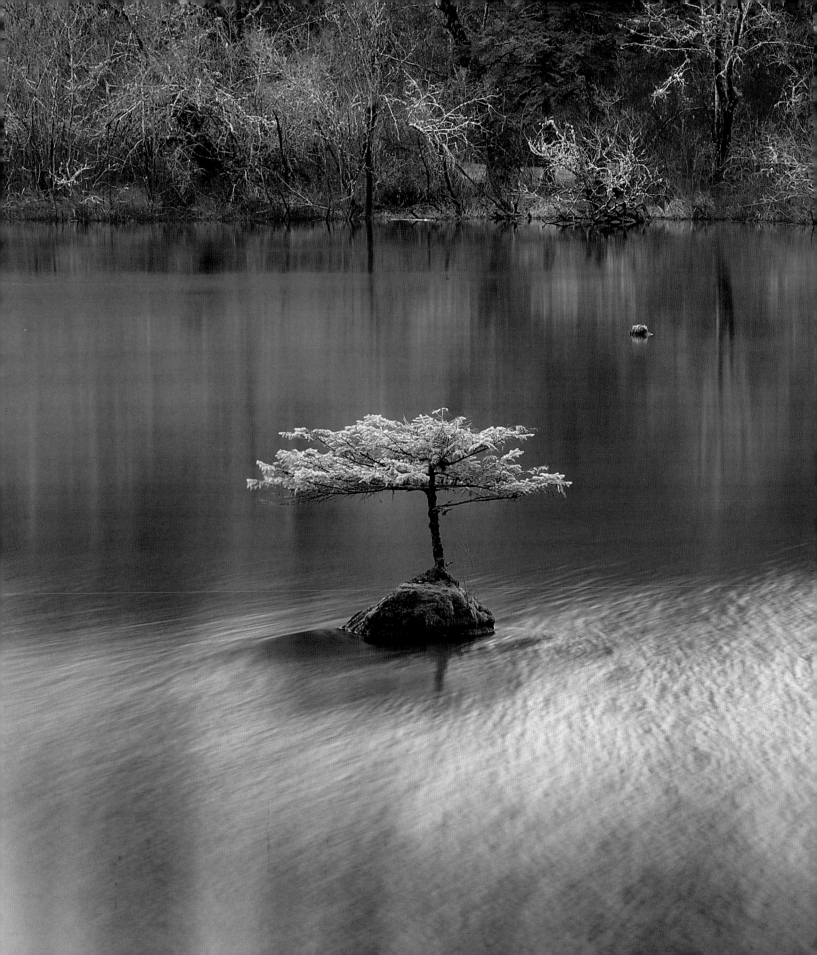

THE HIDDEN LIFE OF TREES

The Illustrated Edition

PETER WOHLLEBEN

Translation by Jane Billinghurst

DAVID SUZUKI INSTITUTE

GREYSTONE BOOKS

Vancouver/Berkeley

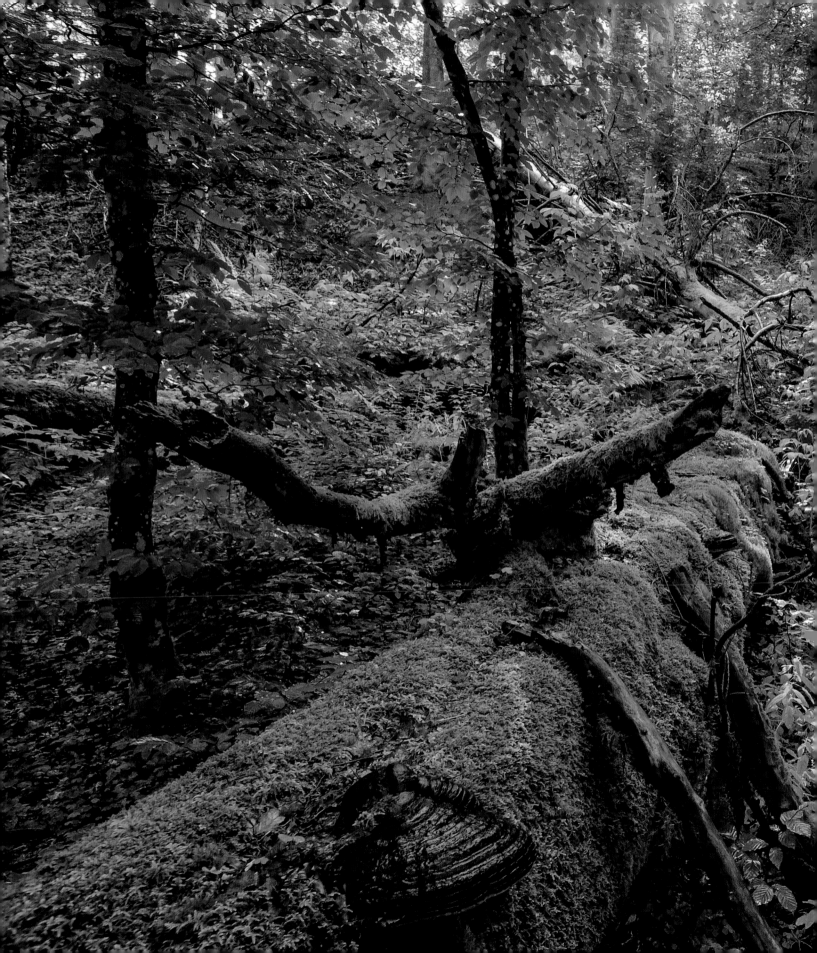

Unabridged text originally published in Germany as *Das geheime Leben der Bäume* by Peter Wohlleben copyright © 2015 by Ludwig Verlag, Munich, part of the Random House GmbH publishing group
English translation copyright © 2016 by Jane Billinghurst
Abridged text copyright © 2018 by Jane Billinghurst
Photographs copyright as credited on pages 164–166

18 19 20 21 22 5 4 3 2 1

Greystone Books Ltd.
greystonebooks.com

David Suzuki Institute
davidsuzukiinstitute.org

Cataloguing data available from Library and Archives Canada
ISBN 978-1-77164-348-1 (cloth)
ISBN 978-1-77164-349-8 (epdf)

Copyediting by Shirarose Wilensky
Jacket and interior design by Nayeli Jimenez
Jacket photograph by Bob van den Berg/Getty Images
Printed and bound in China on ancient-forest-friendly paper by 1010 Printing International Ltd.

We gratefully acknowledge the financial support of the Canada Council for the Arts, the British Columbia Arts Council, the Province of British Columbia through the Book Publishing Tax Credit, and the Government of Canada through the Canada Book Fund for our publishing activities.

Canadä

FIRST SPREAD
Fairy Lake, British Columbia

PREVIOUS SPREAD
Forest floor

FOLLOWING SPREAD
Beech tree in spruce forest

Contents

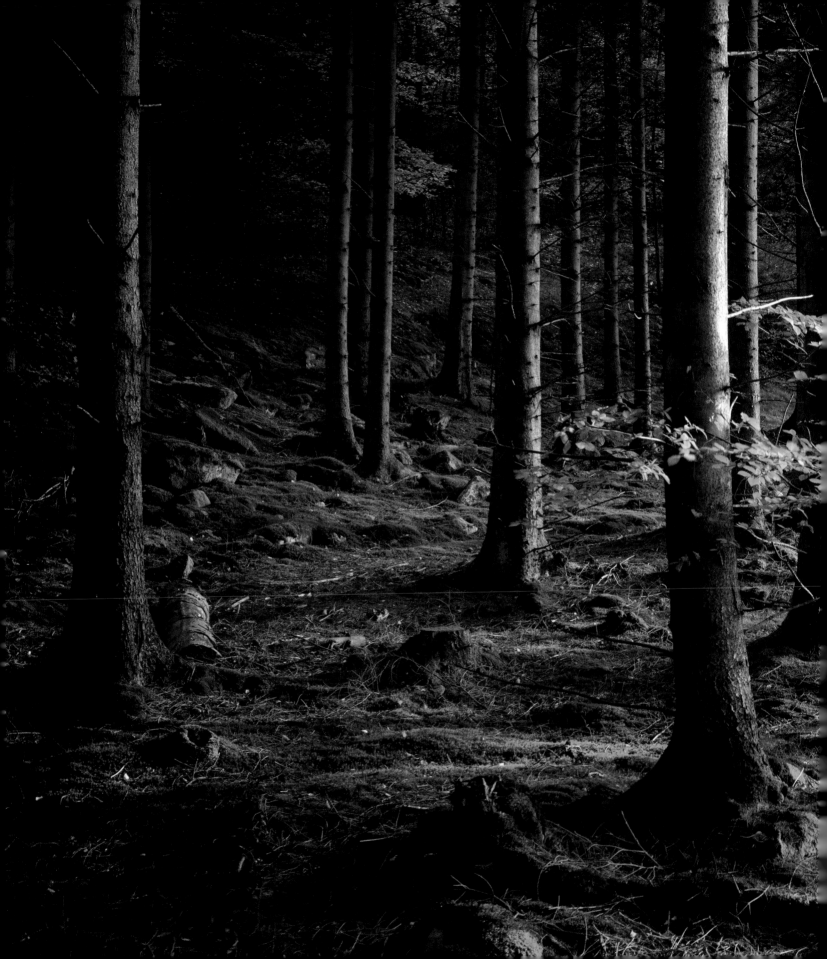

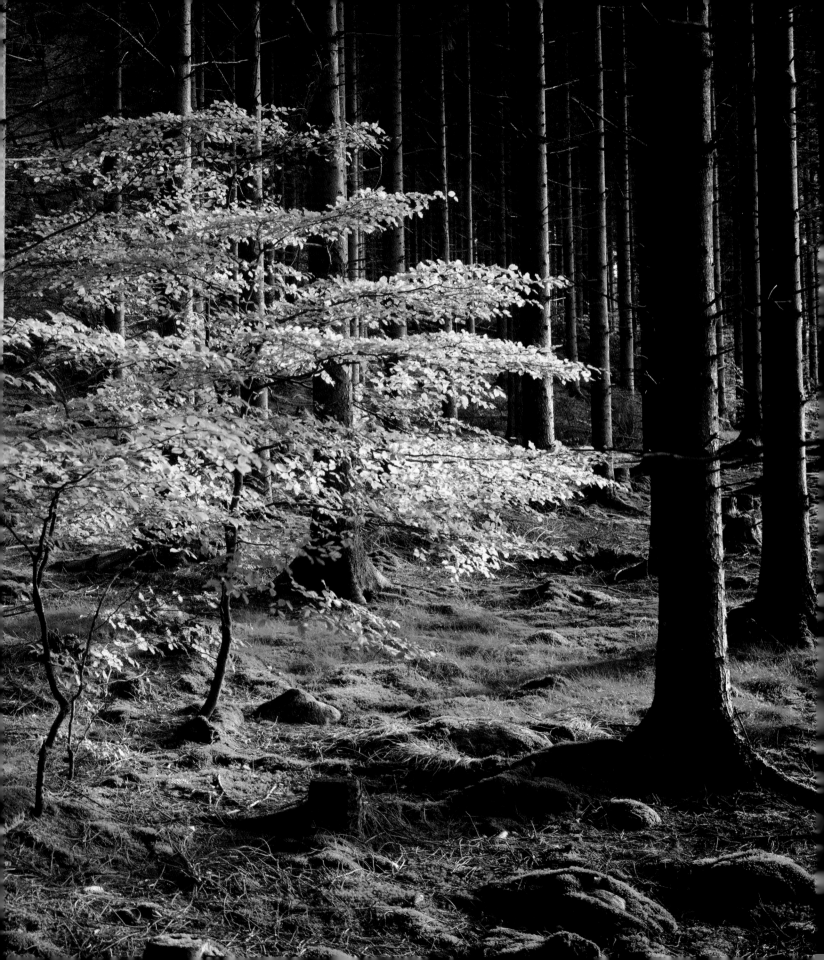

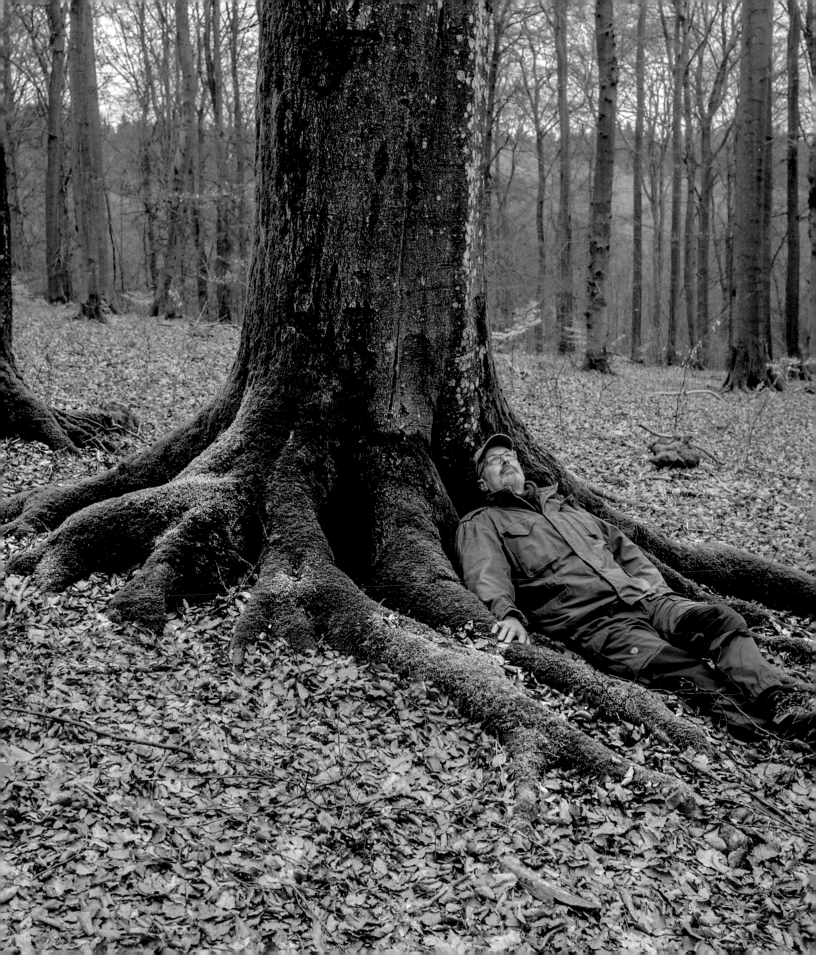

Introduction

Forests hide wonders we are only just beginning to explore.

WHEN I BEGAN my professional career as a forester, I knew about as much about the hidden life of trees as a butcher knows about the emotional life of animals. Because it was my job to look at hundreds of trees every day—spruce, beeches, oaks, and pines—to assess their suitability for the lumber mill and their market value, my appreciation of trees was restricted to this narrow point of view. About twenty years ago, I began to organize survival training in the woods and log-cabin tours for tourists. Then I added a place in the forest where people can be buried as an alternative to traditional graveyards, and an ancient forest preserve. In conversations with the many visitors

who came, my view of the forest changed. Visitors were enchanted by crooked, gnarled trees I would previously have dismissed because of their low commercial value. Walking with my visitors, I learned to pay attention to more than just the quality of the trees' trunks. I began to notice bizarre root shapes, peculiar growth patterns, and mossy cushions on bark. Suddenly, I was aware of countless wonders I could hardly explain even to myself. Life as a forester became exciting once again, and every day in the forest became a day of discovery.

I invite you to share with me the joy trees can bring us.

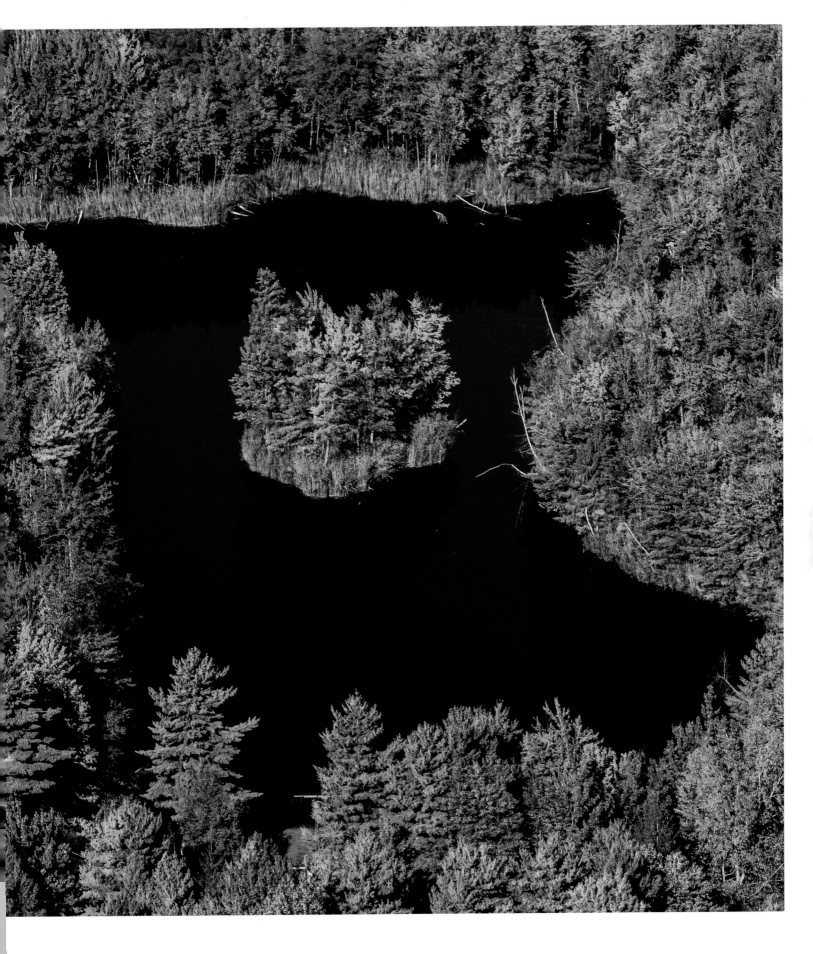

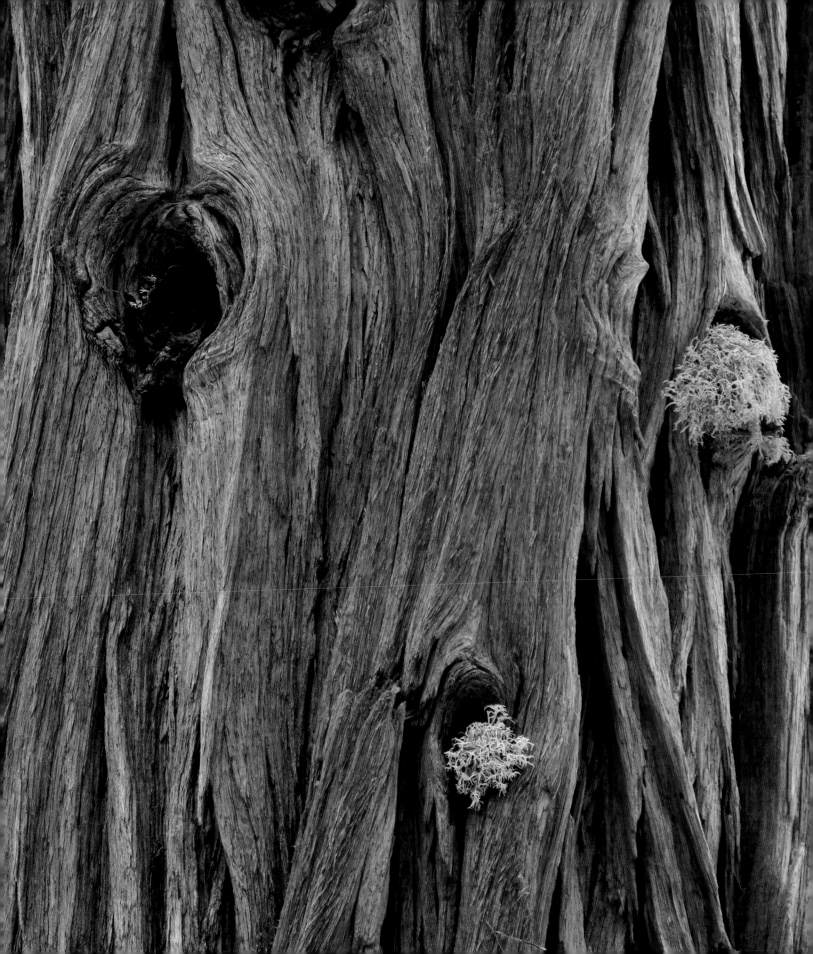

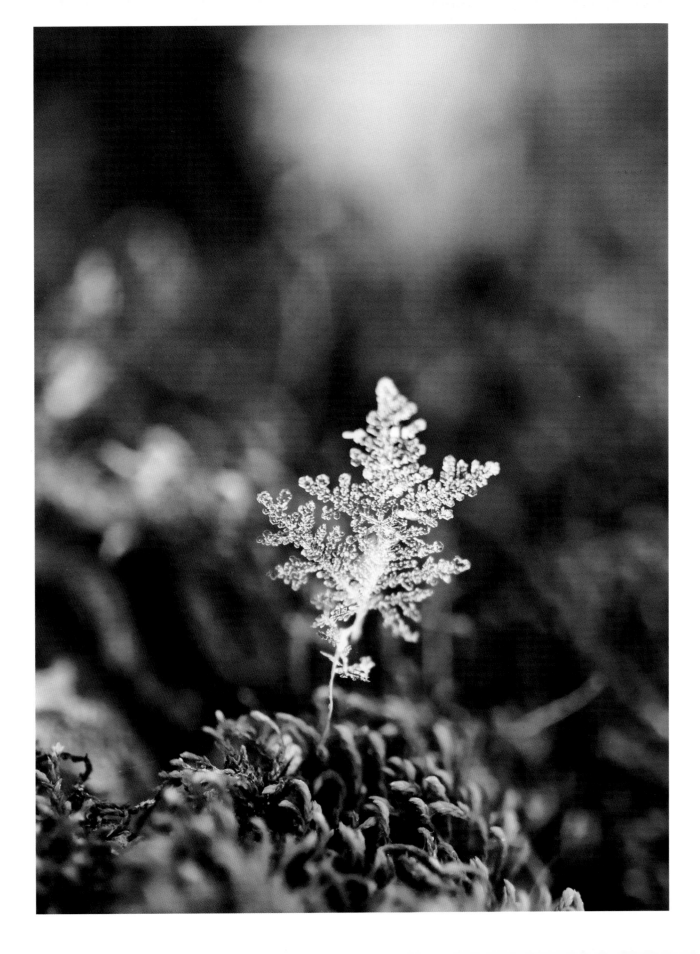

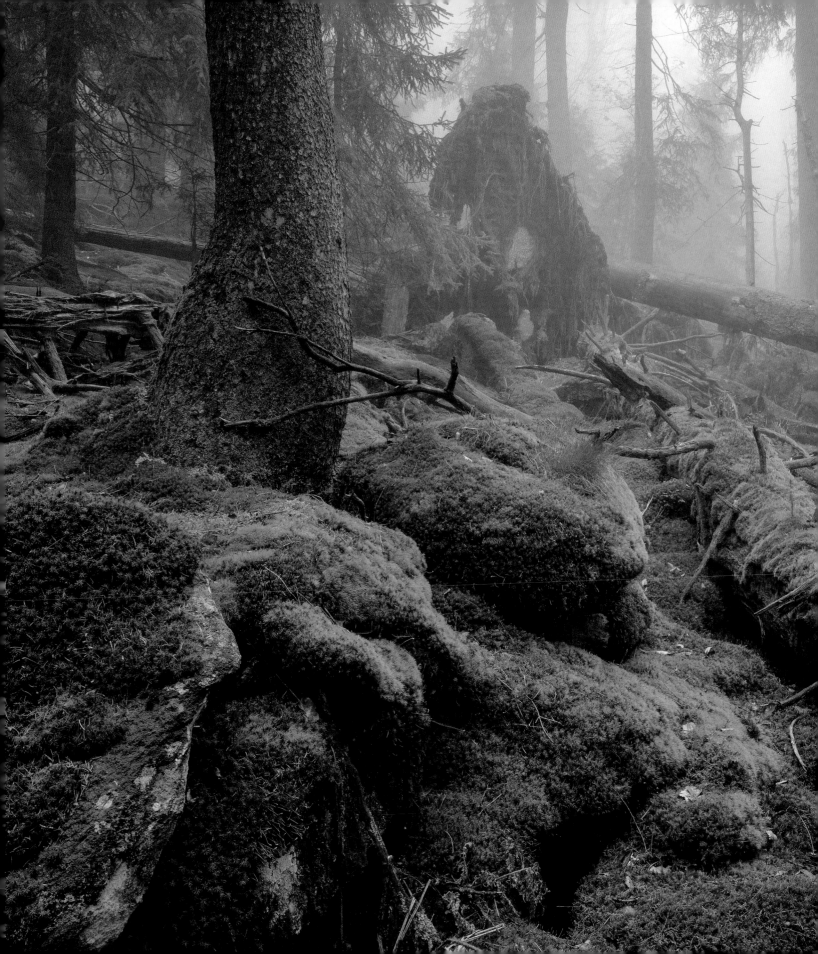

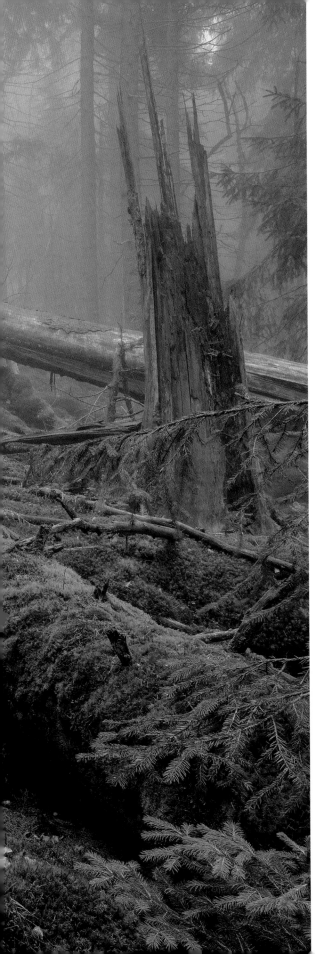

1

The Forest as Community

FRIENDSHIPS

ONE DAY, I stumbled across a patch of strange-looking mossy stones in a preserve of old beech trees. Casting my mind back, I realized I had passed by them many times before without paying them any heed. But that day, I stopped and bent down to take a good look. The stones were an unusual shape: they were gently curved with hollowed-out areas. Carefully, I lifted the moss on one of the stones. What I found underneath was tree bark. So these were not stones, after all, but old wood. I was surprised at how hard the "stone" was, because it usually takes only a few years for beechwood lying on damp ground to decompose. But what surprised me most was that I couldn't lift the wood. It was obviously attached to the ground in some way.

I took out my pocketknife and carefully scraped away some of the bark until I got down to a greenish layer. Green? This color is found only

in chlorophyll, which makes new leaves green; reserves of chlorophyll are also stored in the trunks of living trees. That could mean only one thing: this piece of wood was still alive!

I suddenly noticed that the remaining "stones" formed a distinct pattern: they were arranged in a circle with a diameter of about 5 feet. What I had stumbled upon were the gnarled remains of an enormous ancient tree stump. All that was left were vestiges of the outermost edge. The interior had completely rotted into humus long ago—a clear indication that the tree must have been felled at least four or five hundred years earlier. But how could the remains have clung on to life for so long? It was clear that something must have been going on. This stump was getting assistance from neighboring trees that were helping keep it alive.

If you look at roadside embankments, you might be able to see how trees connect with each other through their root systems. On these slopes, rain often washes away the soil, leaving the underground networks exposed. Scientists in the Harz mountains in Germany have discovered that this really is a case of interdependence, and most individual trees of the same species growing in the same stand are connected to each other through their root systems. It appears that exchanging nutrients and helping neighbors in times of need is the rule, and this leads to the conclusion that forests are superorganisms with interconnections much like ant colonies.

Of course, it makes sense to ask whether tree roots are simply wandering around aimlessly underground and connecting up when they happen to bump into roots of their own kind. Once connected, they have no choice but to exchange nutrients. They create what looks like a social network, but what they are experiencing is nothing more than a purely accidental give and take. In this scenario, chance encounters replace the more emotionally charged image of active support, though even chance encounters offer benefits for the forest ecosystem. But Nature is more complicated than that. According to Massimo Maffei from the University of Turin, plants—and that includes trees—are perfectly capable of distinguishing their own roots from the roots of other species and even from the roots of related individuals.

But why are trees such social beings? Why do they share food with others of their own species

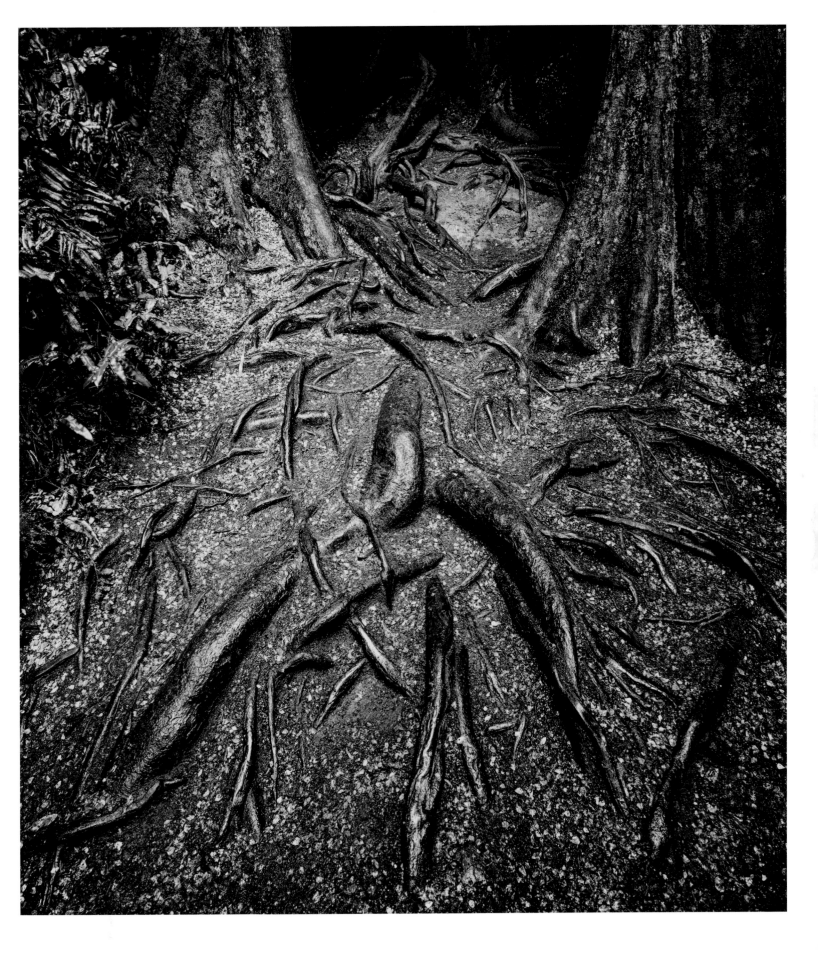

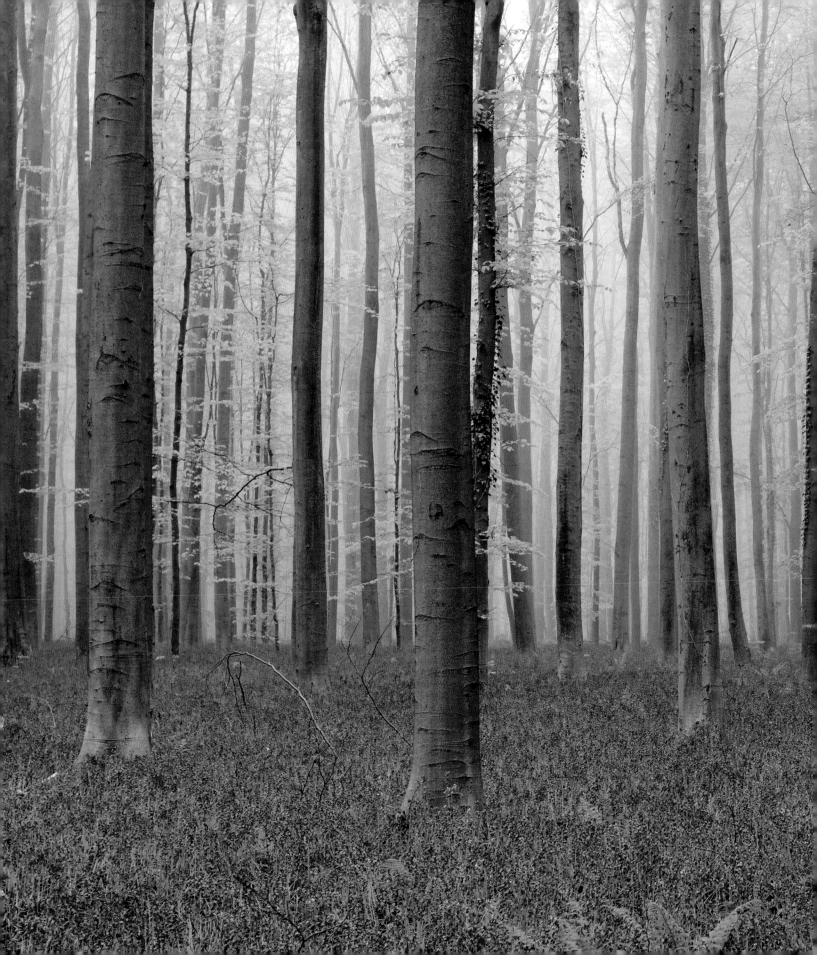

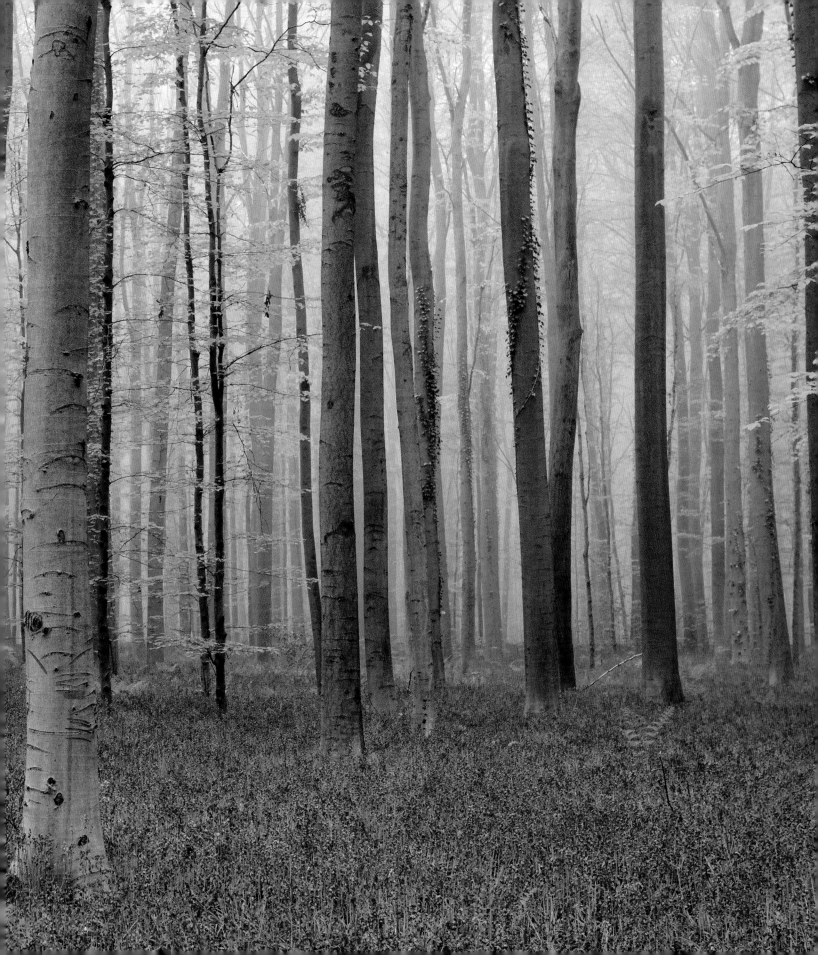

Thick silver-gray beeches remind me of a herd of elephants. Like the herd, they look after their own, they help their sick and weak back up onto their feet, and they are even reluctant to abandon their dead.

and sometimes even go so far as to nourish their competitors? The reasons are the same as for human communities: there are advantages to working together. A tree is not a forest. On its own, a tree cannot establish a consistent local climate. It is at the mercy of wind and weather. But together, many trees create an ecosystem that moderates extremes of heat and cold, stores a great deal of water, and generates a great deal of humidity. And in this protected environment, trees can live to be very old.

To get to this point, the community must remain intact no matter what. If every tree were looking out only for itself, then quite a few of them would never reach old age. Regular fatalities would result in many large gaps in the tree canopy, which would make it easier for storms to get inside the forest and uproot more trees. The heat of summer would reach the forest floor and dry it out. Every tree would suffer. Every tree, therefore, is valuable to the community and worth keeping around for as long as possible, but there are different levels of membership. For example, most stumps rot away into humus and disappear within a couple of hundred years (which is not very long for a tree). Only a few individuals are kept alive over the centuries,

like the mossy "stones" I've just described. What's the difference? Do tree societies have second-class citizens just like human societies? It seems they do, though the idea of "class" doesn't quite fit. It is rather the degree of connection—or maybe even affection—that decides how helpful a tree's colleagues will be.

You can check this out for yourself simply by looking up into the forest canopy. The average tree grows its branches out until it encounters the branch tips of a neighboring tree of the same height. It doesn't grow any wider, because the air and better light in this space is already taken. However, it heavily reinforces the branches it has extended, so you get the impression that there's quite a shoving match going on up there. But a pair of true friends is careful right from the outset not to grow overly thick branches in each other's direction. The trees don't want to take anything away from each other, and so they develop sturdy branches only at the outer edges of their crowns, that is to say, only in the direction of "non-friends." Such partners can be so tightly connected at the roots that they even die together.

As a rule, friendships that extend to looking after stumps can be established only in undisturbed forests.

TREE TALK

ACCORDING TO THE dictionary definition, language is what people use when we talk to each other. Looked at this way, we are the only beings who can use language, because the concept is limited to our species. But wouldn't it be interesting to know whether trees can also talk to each other? But how? They definitely don't produce sounds, so there's nothing we can hear. Trees, it turns out, have a completely different way of communicating: they use scent. Scent as a means of communication? The concept is not totally unfamiliar to us. Why else would we use deodorants and perfumes?

And even when we're not using these products, our own smell says something to other people, and scientists believe pheromones in sweat are a decisive factor when we choose our partners. So it seems fair to say that we possess a secret language of scent, and trees have demonstrated that they do as well.

Thanks to your sense of smell, you've probably picked up on many feel-good messages sent out by trees. I am referring to the pleasantly perfumed invitations broadcast by blossoms. Blossoms do not release scent at random or to please us. Fruit trees, willows, and chestnuts use their olfactory missives to draw attention to themselves and invite passing bees to drop by for a feast. Sweet nectar, a sugar-rich liquid, is the reward the insects get in exchange for the incidental dusting they receive while they visit. The form and color of blossoms are signals, as well. They act somewhat like a billboard that stands out against the general green of the tree canopy and points the way to a snack.

But there is much more to trees' scent communication than that. In the 1970s, scientists noticed something on the African savannah. The giraffes there were feeding on umbrella thorn acacias, and the trees didn't like this one bit. It took the acacias

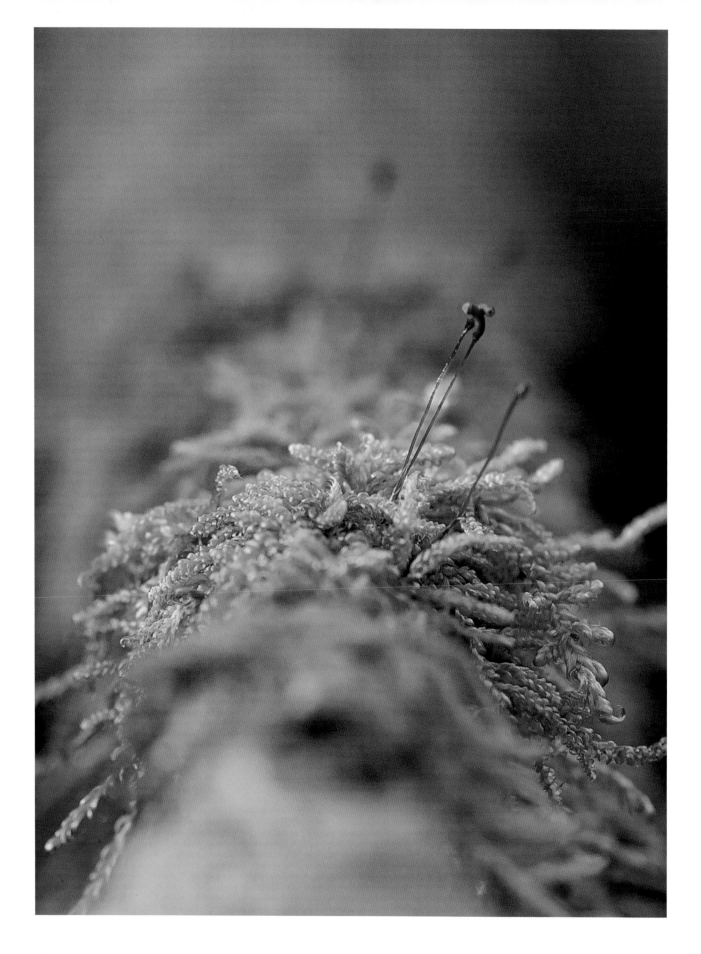

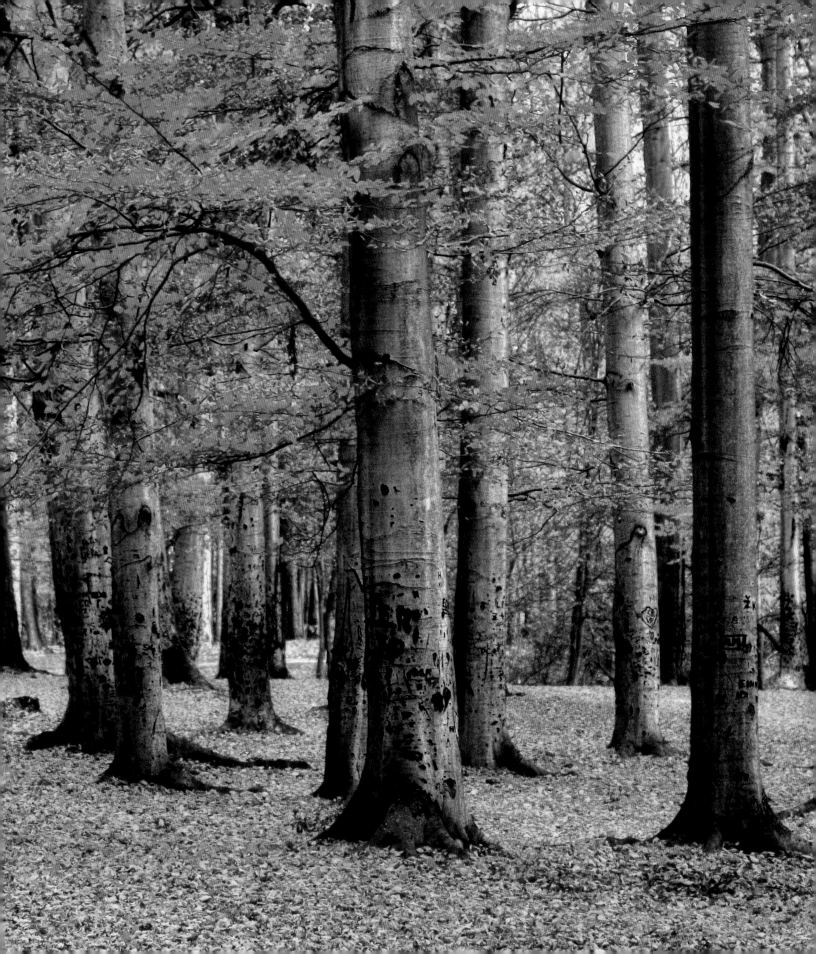

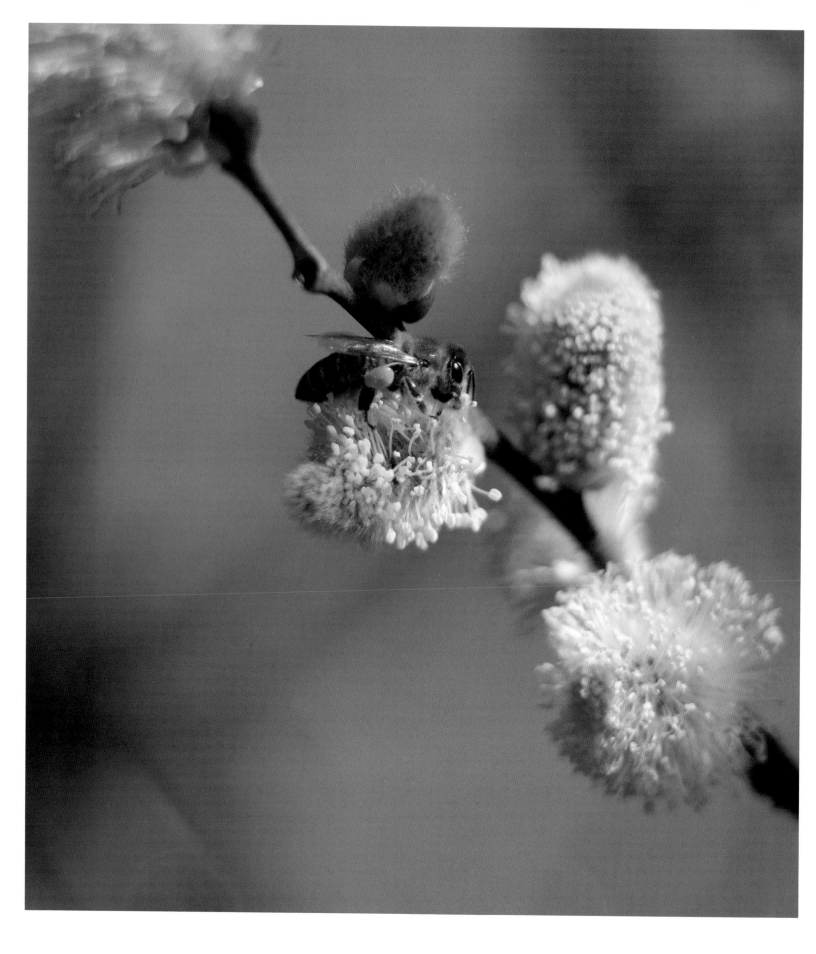

mere minutes to start pumping toxic substances into their leaves to rid themselves of the large herbivores. The giraffes got the message and moved on to other trees in the vicinity. But did they move on to trees close by? No, for the time being, they walked right by a few trees and resumed their meal only when they had moved about 100 yards away.

The reason for this behavior is astonishing. The acacia trees that were being eaten gave off a warning gas that signaled to neighboring trees of the same species that a crisis was at hand. Right away, all the forewarned trees also pumped toxins into their leaves to prepare themselves. The giraffes were wise to this game and therefore moved farther away to a part of the savannah where they could find trees that were oblivious to what was going on. Or else they moved upwind. For the scent messages were carried to nearby trees on the breeze, and if the animals walked upwind, they could find acacias close by that had no idea the giraffes were there.

Similar processes are at work in our forests. Beeches, spruce, and oaks all register pain as soon as some creature starts nibbling on them. When a caterpillar takes a hearty bite out of a leaf, the tissue around the site of the damage changes. Oaks,

for example, carry bitter, toxic tannins in their bark and leaves. These either kill chewing insects outright or at least affect the leaves' taste to such an extent that instead of being deliciously crunchy, they become biliously bitter. Willows produce the defensive compound salicylic acid, which works in much the same way. Leaf tissue also sends out electrical signals, just as human tissue does when it is hurt. However, the plant signal travels so slowly that if a tree wants to warn distant parts of its own structure that danger lurks, it can cover long distances much more quickly by releasing chemical compounds into the air.

And trees do not only mount their own defense; they can also use scent compounds to summon help. And not just any old scent compounds, but compounds that are specifically formulated for the task at hand. Because the saliva of each species of insect is different, a tree can match the saliva to the insect and accurately identify which of the bad guys it is up against. The match can be so precise that a tree can broadcast alarms that summon specific beneficial predators to devour the pests that are bothering it.

Trees don't rely exclusively on aerial defense systems, for if they did, some neighbors would not

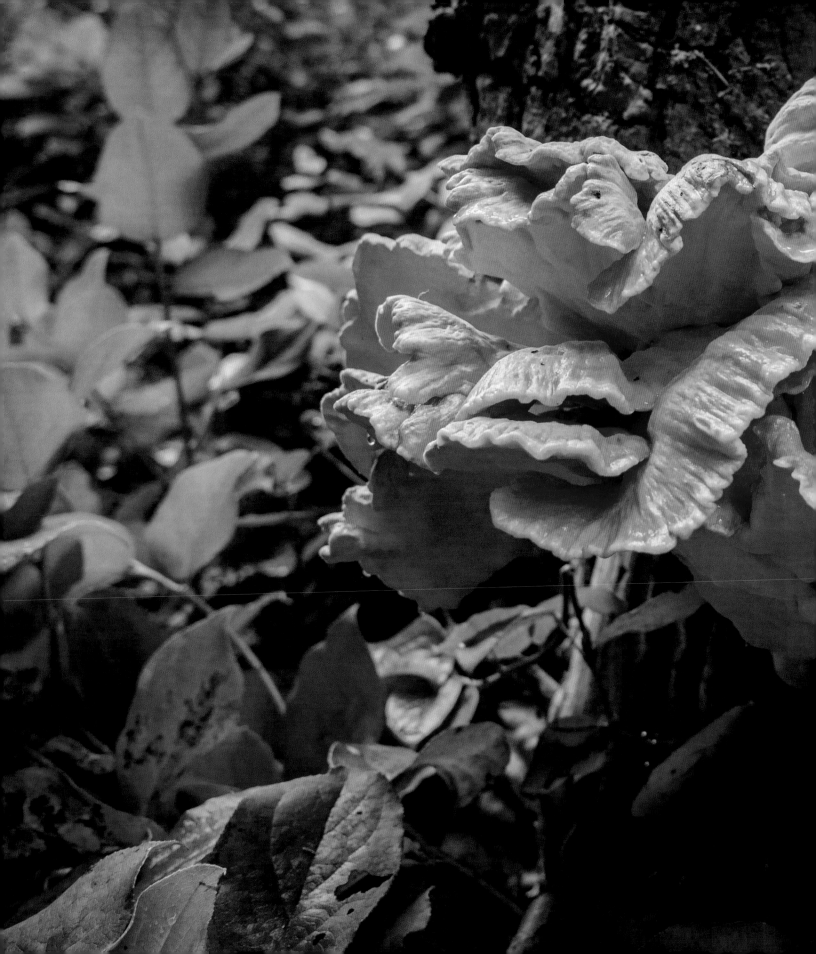

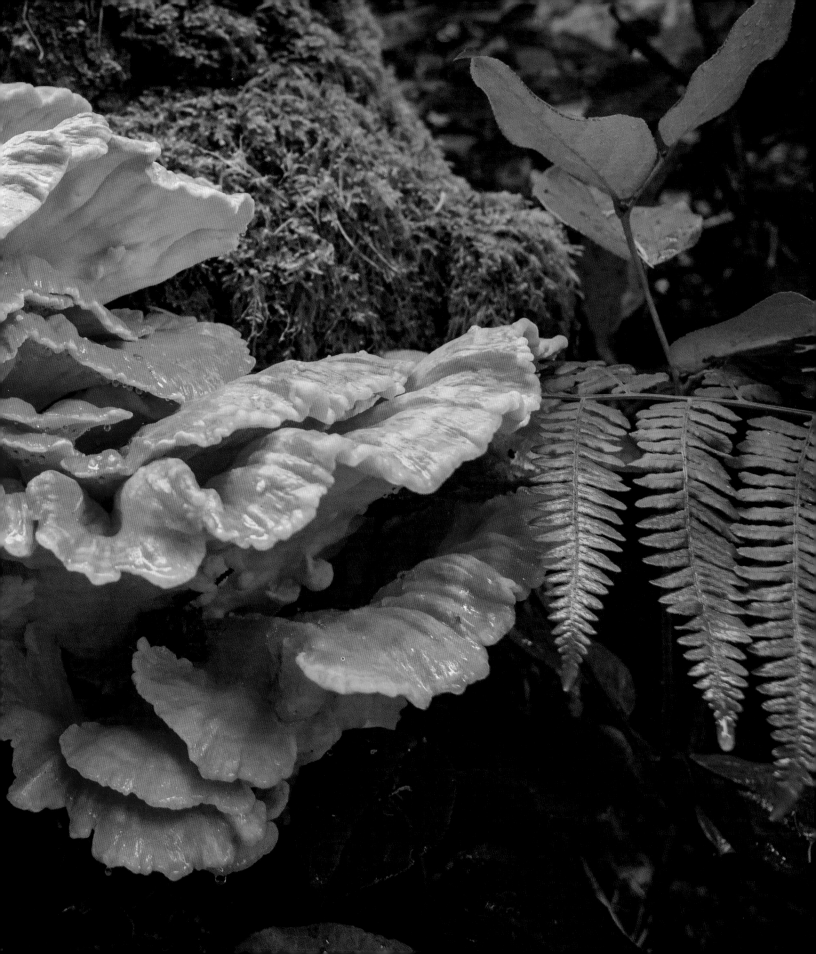

get wind of the danger. Dr. Suzanne Simard of the University of British Columbia in Vancouver has discovered that they also warn each other using chemical signals sent through the fungal networks around their root tips, which operate no matter what the weather. Surprisingly, news bulletins are sent via the roots by means of not only chemical compounds but also electrical impulses that travel from a form of nerve cell at the tips of the roots at the speed of a third of an inch per second. In comparison with our bodies, it is, admittedly, extremely slow. However, there are species in the animal kingdom, such as jellyfish and worms, whose nervous systems conduct impulses at a similar speed. Once the latest news has been broadcast, all the trees in the area promptly pump defensive compounds through their veins.

FABULOUS FUNGI

FUNGI OPERATE LIKE fiber-optic Internet cables. Their thin fungal filaments penetrate the ground, weaving through it in almost unbelievable density. Over centuries, a single fungus can cover many square miles and network an entire forest. The fungal connections transmit signals from one tree to the next, helping the trees exchange news about insects, drought, and other dangers. Science has adopted a term first coined by the journal *Nature* for Dr. Simard's discovery of the "wood wide web" pervading our forests.

Fungi are amazing. They don't really conform to the one-size-fits-all system we use to classify living organisms as either animals or plants. By definition, plants create their own food out of inanimate material, and therefore, they can survive completely independently. It's no wonder that green vegetation must sprout on barren, empty ground before animals can move in, for animals can only survive if they eat other living things. Fungi are in between animals and plants. Their cell walls are made of chitin—a substance never found in plants—which makes them more like insects. In addition, they cannot photosynthesize and so depend on organic connections with other living beings they can feed on.

Over decades, a fungus's underground cottony web, known as mycelium, expands. There is a fungus in Oregon that is estimated to be 2,400 years old, extends for 2,000 acres, and weighs 660 tons. That makes fungi the largest known living organisms in the world. This giant is not tree

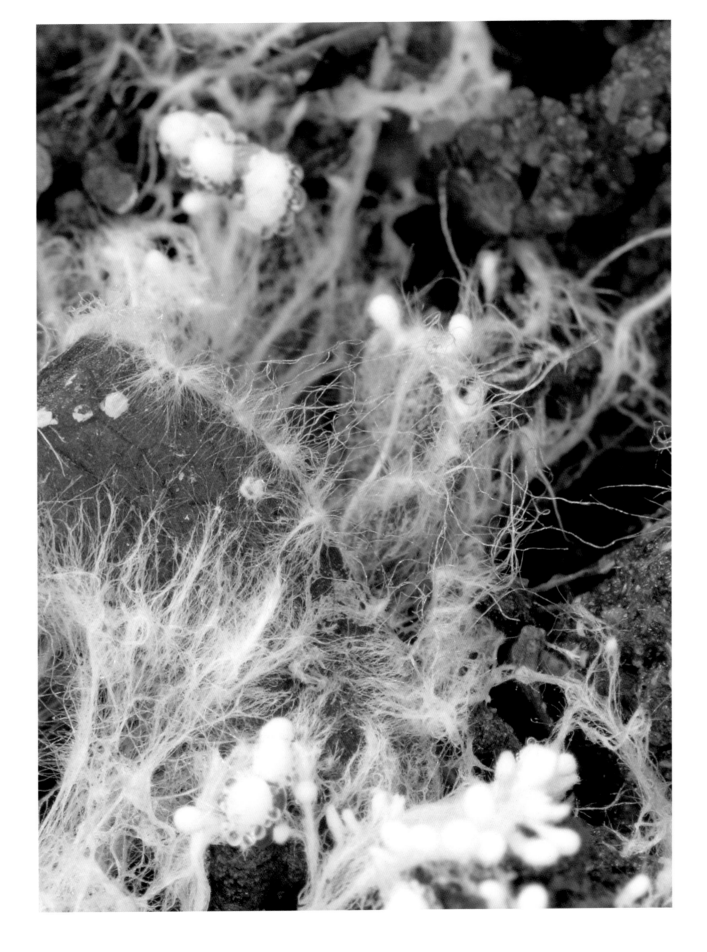

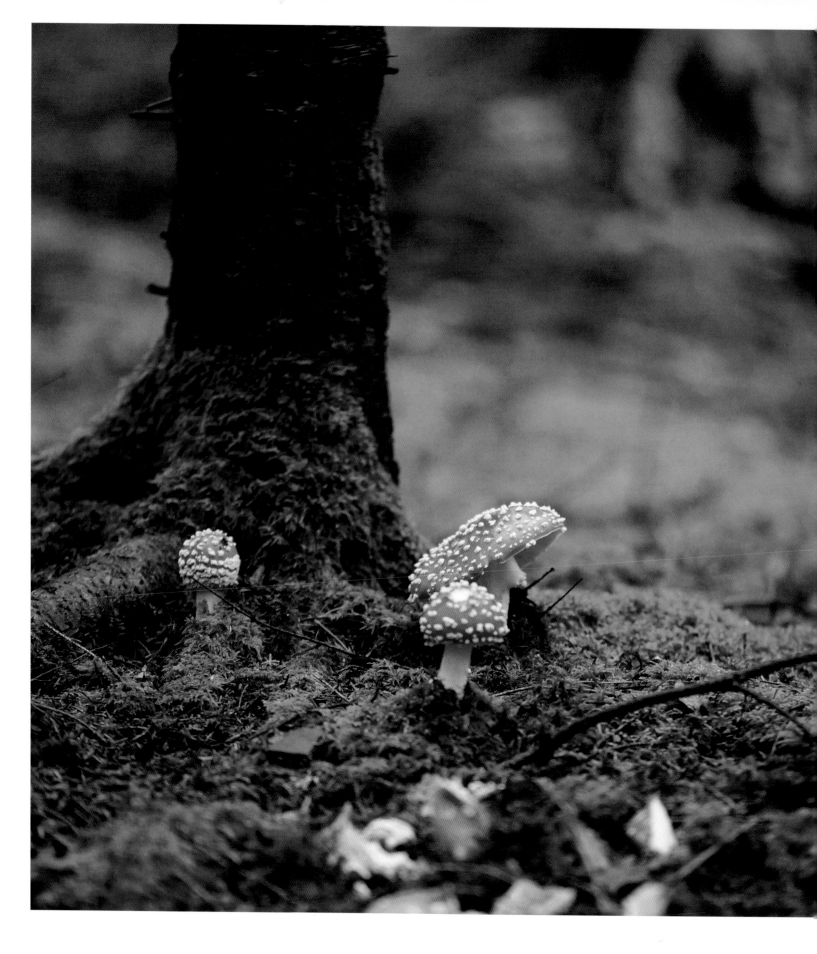

FACING
Fly amanita

friendly, however, since it kills them as it prowls the forest in search of edible tissue. So let's take a look instead at amicable teamwork between fungi and trees. Fungi not only help trees mount defenses against insect attacks, with the help of mycelium of an appropriate species for each tree— for instance, the oak milkcap for the oak—but also greatly increase a tree's functional root surface so that it can suck up considerably more water and nutrients.

You find twice the amount of life-giving nitrogen and phosphorus in plants that cooperate with fungal partners than in plants that tap the soil with their roots alone.

Mushrooms on a rotting stump

To enter into a partnership with one of the many thousands of kinds of fungi, a tree must be very open—literally—because the fungal threads grow into its soft root hairs. The fungus not only penetrates and envelops the tree's roots but also allows its web to roam through the surrounding forest floor. In so doing, it extends the reach of the tree's own roots as the web grows out toward other trees. There, it connects with other trees' fungal partners and roots. And so a network is created.

When trees grow together, nutrients and water can be optimally divided among them all so that each tree can grow into the best tree it can be. Students at the Institute for Environmental Research at Aachen University (RWTH Aachen) discovered something amazing about photosynthesis in undisturbed beech forests. Each beech tree grows in a unique location, and conditions can vary greatly in just a few yards. The soil can be stony or loose. It can retain a great deal of water or almost no water. It can be full of nutrients or extremely barren. Accordingly, each tree experiences different growing conditions; therefore, each tree grows more quickly or more slowly and produces more or less sugar or wood, and thus you would expect every tree to be photosynthesizing at a different rate. And that's what makes the research results so astounding. The rate of photosynthesis is the same for all the trees. The trees, it seems, are equalizing differences between the strong and the weak. This equalization is taking place underground through the roots. There's obviously a lively exchange going on down there. Whoever has an abundance of sugar hands some over; whoever is running short gets help. The fungal networks are acting as gigantic redistribution mechanisms. It's a bit like the way social security systems operate to ensure individual members of society don't fall too far behind.

A healthier—perhaps you could even say happier—forest is considerably more productive, and that means it is also more profitable.

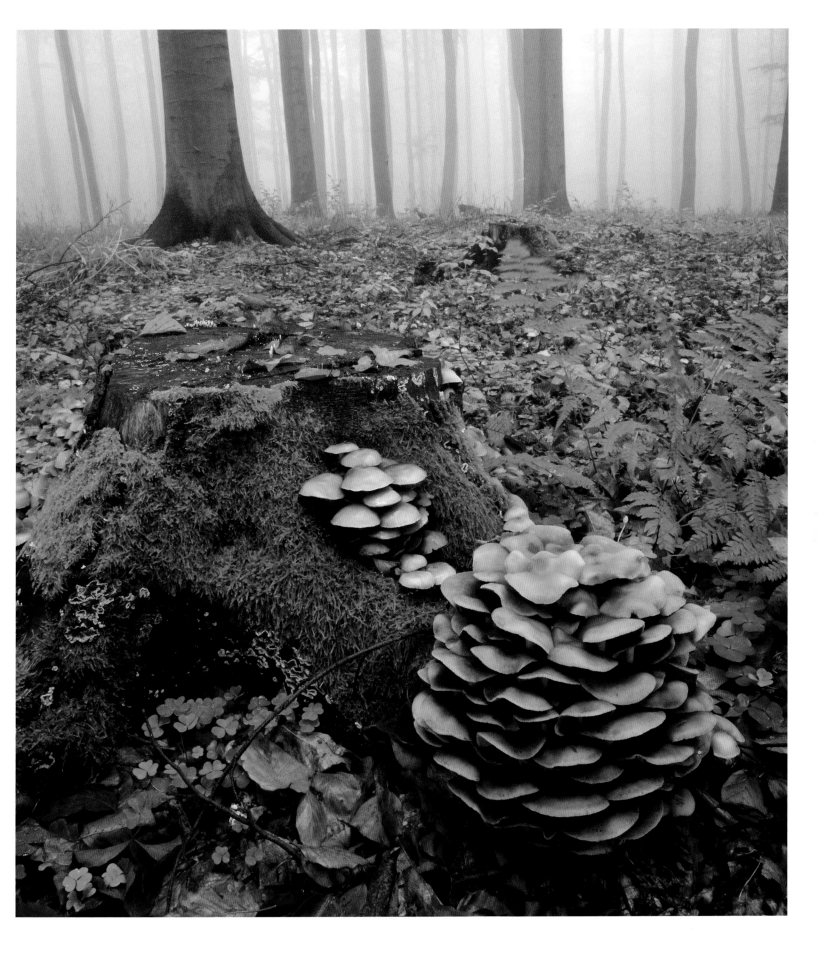

In such a cooperative system, it is not possible for the trees to grow too close to each other. Quite the opposite. Huddling together is desirable and the trunks are often spaced no more than 3 feet apart. Because of this, the crowns remain small and cramped, and many foresters believe this is not good for the trees. Therefore, plantation trees are spaced out through felling, meaning that supposedly excess trees are removed. However, colleagues from Lübeck in northern Germany have discovered that a beech forest is more productive when the trees are packed together.

If you "help" individual trees by getting rid of their supposed competition, the remaining trees are bereft. They send messages out to their neighbors in vain, because nothing remains but stumps. Every tree now muddles along on its own, giving rise to great differences in productivity. Some individuals photosynthesize like mad until sugar positively bubbles along their trunk. As a result, they grow better, but they aren't particularly long-lived. This is because a tree can only be as strong as the forest that surrounds it. And there are now a lot of losers in the forest. Weaker members, who would once have been supported by the stronger ones, suddenly fall behind. Whether the reason for their decline is their location and lack of nutrients, a passing malaise, or genetic makeup, they now fall prey to insects and fungi.

But isn't that how evolution works? you ask. The survival of the fittest? Trees would just shake their heads—or rather their crowns. Their well-being depends on their community, and when the supposedly feeble trees disappear, the others lose as well. When that happens, the forest is no longer a single closed unit. Hot sun and swirling winds can now penetrate to the forest floor and disrupt the moist, cool climate. Even strong trees get sick a lot over the course of their lives. When this happens, it's their turn to depend on their weaker neighbors for support. If they are no longer there, then all it takes is what would once have been a harmless insect attack to seal the fate even of giants.

Fungal connections, however, come with a price. Without a supply of food, fungi would, quite simply, starve. Therefore, they exact payment from their partner trees in the form of sugar and other carbohydrates. And fungi are not exactly dainty in their requirements. They demand up to a third of the tree's total food production in return for their services. It makes sense, in a situation where you are so dependent on another species, to leave

nothing to chance. And so the delicate fibers begin to manipulate the root tips they envelop. First, the fungi listen in on what the tree has to say. Depending on whether that information is useful for them, the fungi begin to produce plant hormones that direct the tree's cell growth to their advantage.

———

"A chain is only as strong as its weakest link." Because trees know this intuitively, they do not hesitate to help each other out.

———

In exchange for a rich sugary reward, the fungi provide a few complimentary benefits for the tree, such as filtering out heavy metals, which are less detrimental to the fungi than to the tree's roots. Medical services are also part of the package. The

delicate fungal fibers ward off intruders, including attacks by bacteria or destructive fellow fungi. Together with their trees, fungi can live to be many hundreds of years old, as long as they are healthy. But if conditions in their environment change, for instance, as a result of air pollution, then they breathe their last. Their tree partner, however, does not mourn for long. It wastes no time hooking up with the next species that settles in at its feet. Every tree has multiple options for fungi, and it is only when the last of these passes away that it is really in trouble.

TREE SENSES

IF TREES ARE weakened, it could be that they lose their conversational skills along with their ability to defend themselves. Otherwise, it's difficult to explain why insect pests specifically seek out trees whose health is already compromised. It's conceivable that to do this, insects listen to trees' urgent chemical warnings, and then test trees that don't pass the message on by taking a bite out of their leaves or bark. A tree's silence could be because of a serious illness or, perhaps, the loss of its fungal network, which would leave the tree cut off from

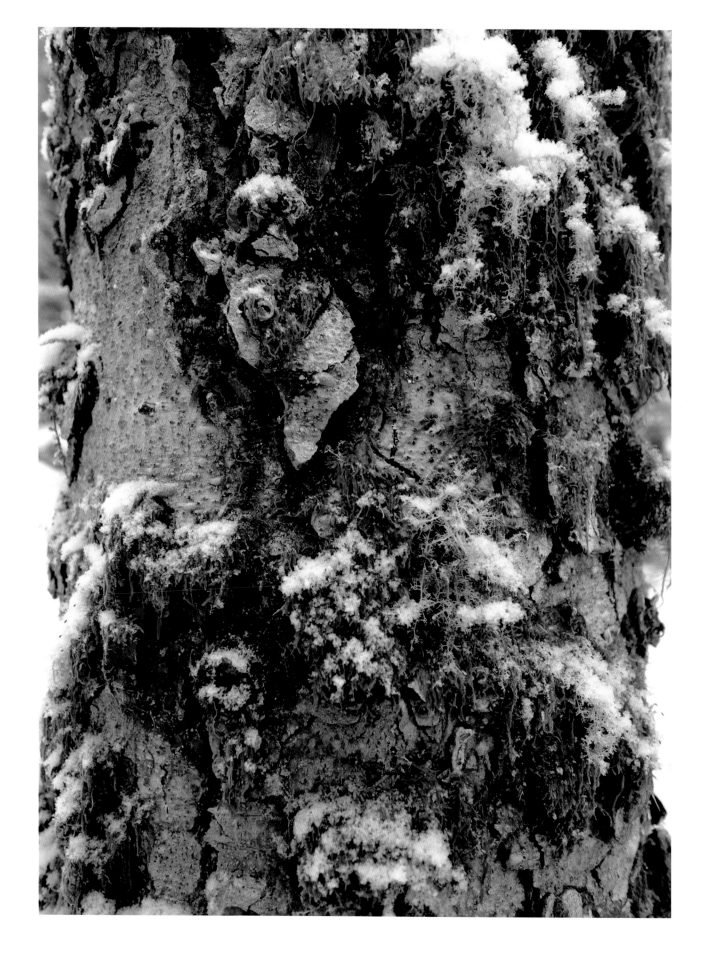

much of the latest news. The tree no longer registers approaching disaster, and the doors are open for the caterpillar and beetle buffet.

So trees communicate by means of olfactory, visual, and electrical signals. What about sounds? Let's get back to hearing and speech. Although I said earlier that trees definitely don't produce sounds, the latest scientific research casts doubt even on this statement. Along with colleagues from Bristol and Florence, Dr. Monica Gagliano from the University of Western Australia has, quite literally, had her ear to the ground. It's not practical to study trees in the laboratory; therefore, researchers substitute grain seedlings because they are easier to handle. They started listening, and it didn't take them long to discover that their measuring apparatus was registering roots crackling quietly at a frequency of 220 hertz. Crackling roots? That doesn't necessarily mean anything. After all, even dead wood crackles when it's burned in a stove. But the noises discovered in the laboratory caused the researchers to sit up and pay attention. For the roots of seedlings not directly involved in the experiment reacted. Whenever the seedlings' roots were exposed to a crackling at 220 hertz, they oriented their tips in that direction.

That means the grasses were registering this frequency, so it makes sense to say they "heard" it.

Plants communicating by means of sound waves? That makes me curious to know more, because people also communicate using sound waves. Might this be a key to getting to know trees better? To say nothing of what it would mean if we could hear whether all was well with beeches, oaks, and pines, or whether something was up. Unfortunately, we are not that far advanced, and research in this field is just beginning. But if you hear a light crackling the next time you take a walk in the forest, perhaps it won't be just the wind . . .

THE ESSENCE OF TREENESS

THE DICTIONARY DEFINES a tree as a woody plant with a trunk from which branches grow. So the main shoot must be dominant and grow steadily upward or the plant is classified as a shrub, which has many smaller trunks—or rather branches— that originate from a common rootstock. But what about size? Aren't trees supposed to be majestic beings under whose crowns we seem as insignificant as ants in the grass? Yet, on a journey to

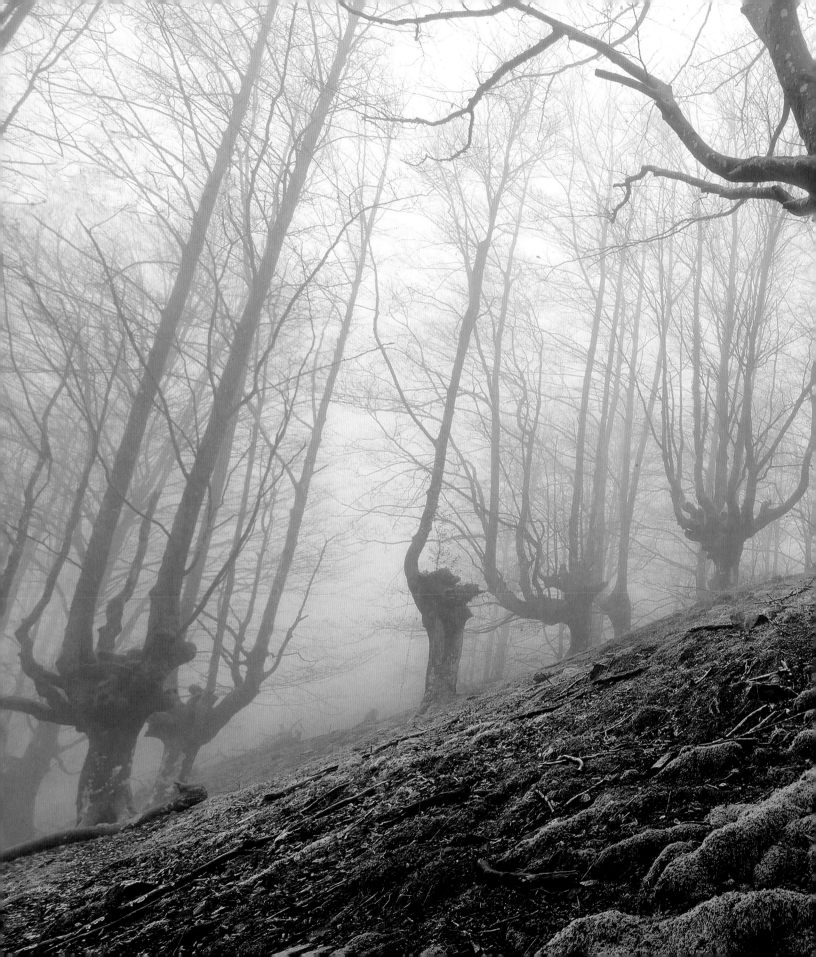

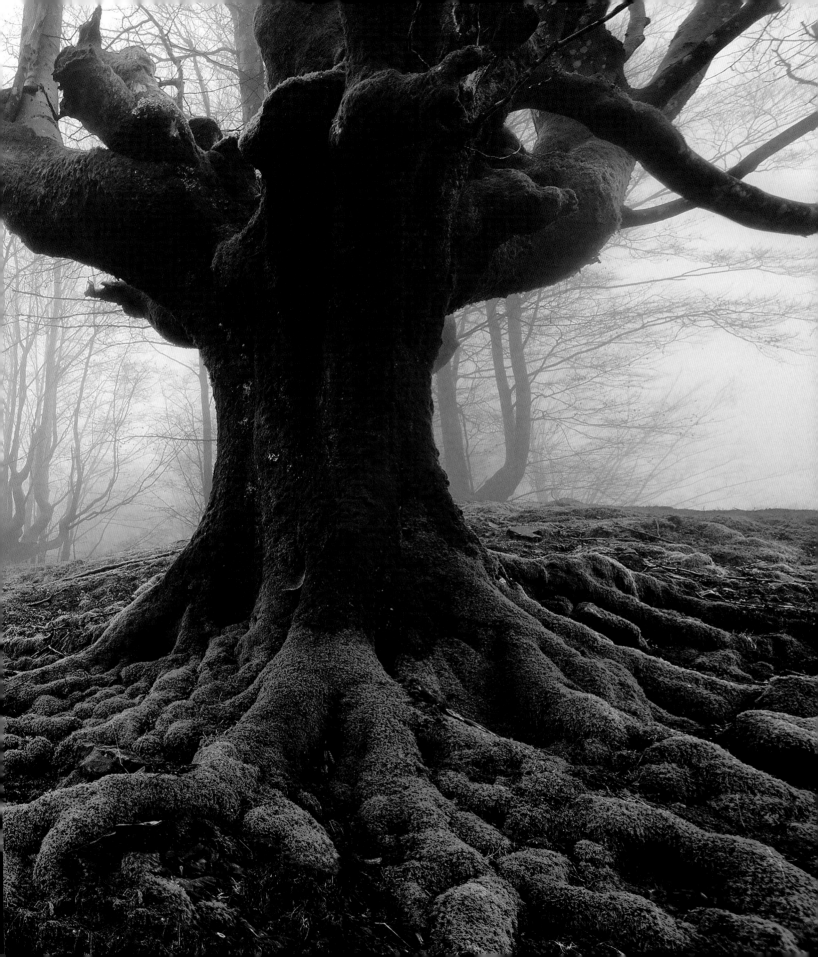

Lapland, I stumbled upon completely different ambassadors of the tree family that made me feel like Gulliver in Lilliput.

I'm talking about dwarf trees on the tundra, which are sometimes trampled to death by travelers who don't even know they are there. It can take these trees a hundred years to grow just 8 inches tall. I have to say that science doesn't recognize them as trees, because they mostly remain below eye level and, therefore, are clearly not taken seriously. But if you were to apply the same measure to other trees, then small beeches or mountain ash wouldn't count as trees either. These two are often browsed on so heavily by large mammals such as deer that they grow multiple shoots like bushes and hold out at a height of 20 inches for decades.

And what if you cut a tree down? Is it then dead? What about the centuries-old stump I introduced you to at the beginning of this book that is still alive today, thanks to its comrades? Is that a tree? And, if it isn't, then what is it? It gets even more complicated when a new trunk grows out of an old stump. In many woods, this happens all the time. For centuries in Europe, deciduous trees were cut right down to the base of their trunks by charcoal burners, who harvested them to make charcoal.

New trunks grew from the base. Oak and hornbeam forests, in particular, originate from this kind of harvesting, known as coppicing. The cycle of cutting back and allowing the trees to regrow was repeated every few decades, so the trees never grew tall or matured. You can spot these relics of bygone times when you take a walk in a European forest. Look for trees that have numerous bushy trunks or thick calluses at the base where periodic felling has encouraged a proliferation of growth. Are these trunks now young trees, or alternatively, are they really thousands of years old?

This is a question also asked by scientists, among them a group researching ancient spruce in Dalarna province in Sweden. The oldest spruce in Dalarna, Old Tjikko, has grown a carpet of flat shrubby growth around its single small trunk. All this growth belongs to one tree, and its roots were tested using carbon 14 dating. Research revealed the spruce to be an absolutely unbelievable 9,550 years old. The individual shoots were younger, but these new growths from the past few centuries were not considered to be stand-alone trees but part of a larger whole. And, I think, quite rightly so. The root is certainly a more decisive factor than what is growing above ground. After all, it is the

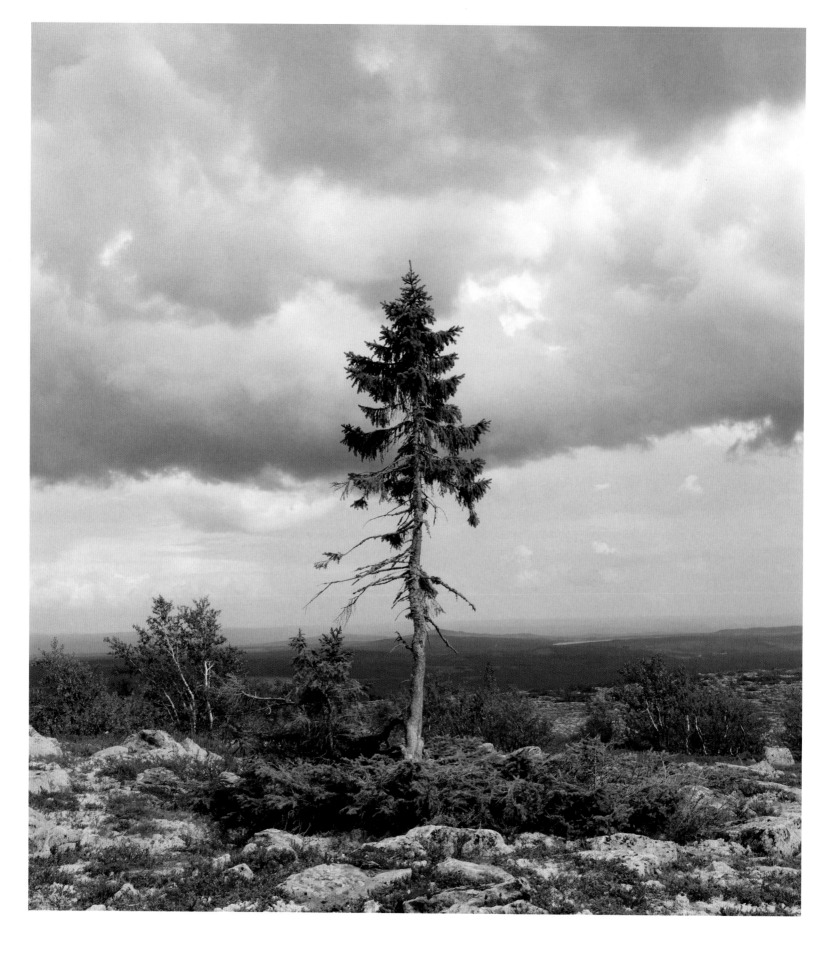

root that looks after the survival of an organism. It is the root that has withstood severe changes in climatic conditions. And it is the root that has regrown trunks time and time again. It is in the roots that centuries of experience are stored, and it is this experience that has allowed the tree's survival to the present day.

Conceivably, the roots are also where the tree equivalent of a brain is located. Brain? you ask. Isn't that a bit farfetched? Possibly, but we know that plants can learn, and we have evidence from the laboratory as well as from the forest. Australian scientist Dr. Monica Gagliano also studies mimosas, or "sensitive plants." Mimosas are tropical creeping herbs. They make particularly good research subjects, because it is easy to get them a bit riled up and they are easier to study in the laboratory than trees are. When they are touched, they close their feathery little leaves to protect themselves. Gagliano designed an experiment where individual drops of water fell on the plants' foliage at regular intervals. At first, the anxious leaves closed immediately, but after a while, the little plants learned there was no danger of damage from the water droplets. After that, the leaves remained open despite the drops. Even

more surprising for Gagliano was the fact that the mimosas could remember and apply their lesson weeks later, even without any further tests. If plants—and that includes trees—can learn, that means they must store experiences somewhere, and therefore, there must be some kind of a storage mechanism inside the organism. Just where it is, no one knows, but the roots are the part of the tree best suited to the task. Where else would it store important information over a long period of time?

And there is more. It is now an accepted fact that the root network is in charge of all chemical activity in the tree. And there's nothing earth shattering about that. Many of our internal processes are also regulated by chemical messengers. Roots absorb substances and bring them into the tree. In the other direction, they deliver the products of photosynthesis to the tree's fungal partners and route warning signals to neighboring trees. But for there to be something we would recognize as a brain, neurological processes must be involved, and for these, in addition to chemical messages, you need electrical impulses. And these are precisely what we can measure in the tree, and we've been able to do so since as far back as the nineteenth century.

For some years now, a heated controversy has flared up among scientists. Can plants think? Are they intelligent? In conjunction with his colleagues, František Baluška from the Institute of Cellular and Molecular Botany at the University of Bonn is of the opinion that brain-like structures can be found at root tips. In addition to signaling pathways, there are also numerous systems and molecules similar to those found in animals. When a root feels its way forward in the ground, it is aware of stimuli. The researchers measured electrical signals that led to changes in behavior after they were processed in a "transition zone." If the root encounters toxic substances, impenetrable stones, or saturated soil, it analyzes the situation and transmits the necessary adjustments to the growing tip. The root tip changes direction as a result of this communication and steers the growing root around problem areas.

Right now, the majority of plant researchers are skeptical about whether such behavior points to a repository for intelligence, the faculty of memory, and emotions. Among other things, they get worked up about carrying over findings in similar situations with animals and, at the end of the day, about how this threatens to blur the boundary between plants and animals. And so what? What would be so awful about that? The distinction between plant and animal is, after all, arbitrary and depends on the way an organism feeds itself: the former photosynthesizes and the latter eats other living beings. Finally, the only other big difference is in the amount of time it takes to process information and translate it into action. Does that mean that beings that live life in the slow lane are automatically worth less than ones on the fast track?

I suspect we would pay more attention to trees if we could establish beyond a doubt just how similar they are in many ways to animals.

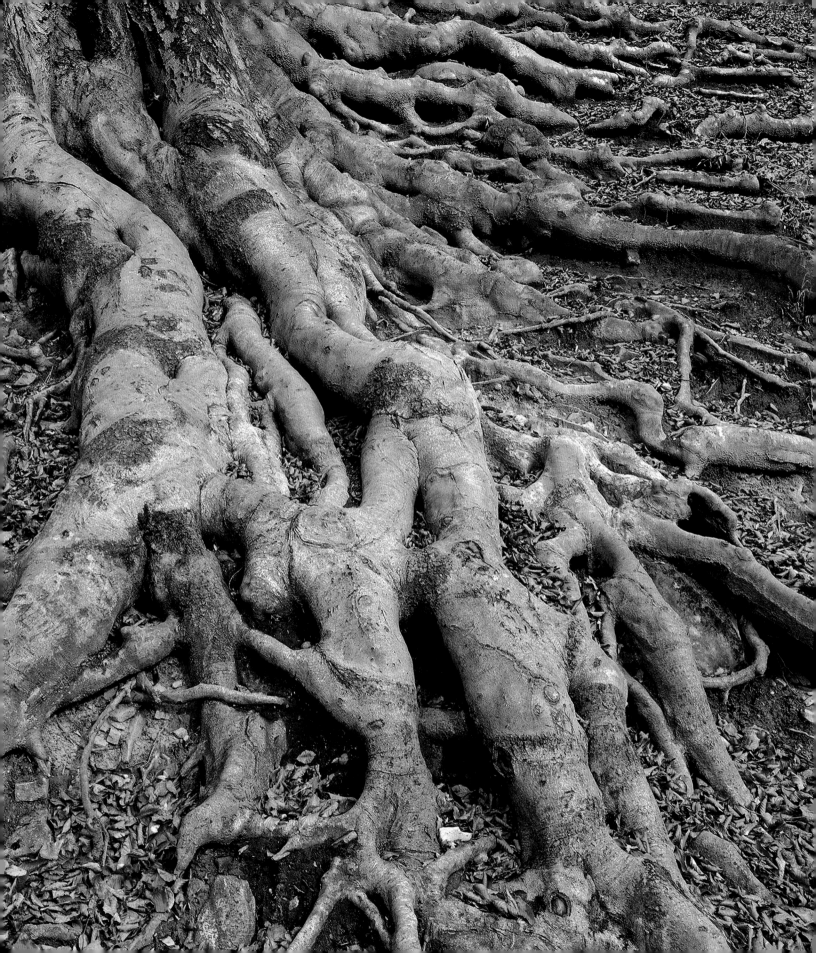

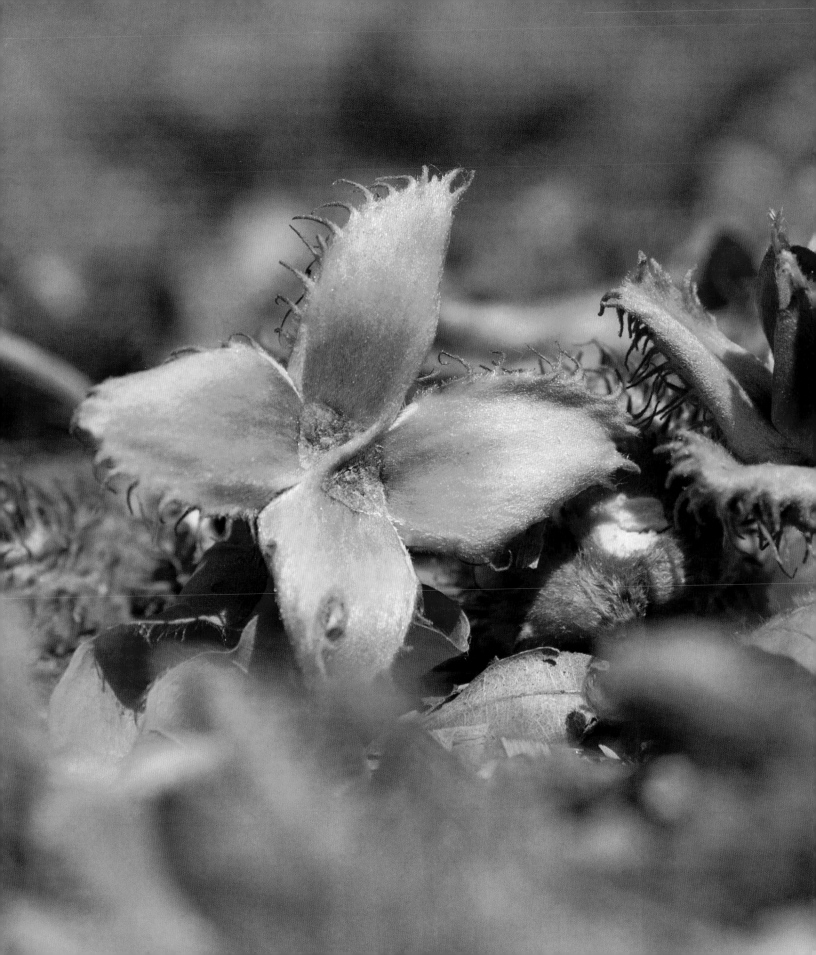

2

Life Lessons

SETTING SEED

THE LEISURELY PACE at which trees live their lives is also apparent when it comes to procreation. Reproduction is planned at least a year in advance. Whether tree love happens every spring depends on the species. Whereas conifers send their seeds out into the world at least once a year, deciduous trees have a completely different strategy. Before they bloom, they agree among themselves. Should they go for it next spring, or would it be better to wait a year or two? Trees in a forest prefer to bloom at the same time so that the genes of many individual trees can be well mixed. Conifers and deciduous trees agree on this, but deciduous trees have one other factor to consider: browsers.

Browsers such as wild boar and deer are extremely partial to beechnuts and acorns, both of which help them put on a protective layer of fat for winter. They seek out these nuts because they contain up to 50 percent oil and starch—more than any other food. Often whole areas of forest are

picked clean in the fall so that, come spring, hardly
any beech and oak seedlings sprout. And that's
why the trees agree in advance. If they don't bloom
every year, then the herbivores cannot count on
them. The next generation is kept in check because
over the winter the pregnant animals must endure
a long stretch with little food, and many of them
will not survive. When the beeches or oaks finally
all bloom at the same time and set fruit, then it is
not possible for the few herbivores left to demolish
everything, so there are always enough undiscov-
ered seeds left over to sprout.

"Mast" (from the German *mästen*, "to fatten")
is an old term used to describe years when beeches
and oaks set seed. In these years of plenty, wild
boar can triple their birth rate because they find
enough to eat in the forests over the winter. In ear-
lier times, European peasants used the windfall
for the wild boar's tame relatives, domestic pigs,
which they herded into the woods. The idea was
that the herds of domestic pigs would gorge on the
wild nuts and fatten up nicely before they were
slaughtered. The year following a mast year, wild
boar numbers usually crash because the beeches
and oaks are taking a time-out and the forest floor
is bare once again.

*Mother trees are dominant
trees widely linked to other
trees in the forest through their
fungal–root connections.*

LISTEN TO MOTHER

ACORNS AND BEECHNUTS fall at the feet of large
"mother trees," who pass their legacy on to the
next generation and exert their influence in the
upbringing of their offspring. Young trees are so
keen on growing quickly that it would be no prob-
lem at all for them to grow about 18 inches taller
per season. Unfortunately for them, their moth-
ers do not approve of rapid growth. They shade
the youngsters with their enormous crowns, and
the crowns of all the mature trees close up to form
a thick canopy over the forest floor. This canopy
lets only 3 percent of available sunlight reach the

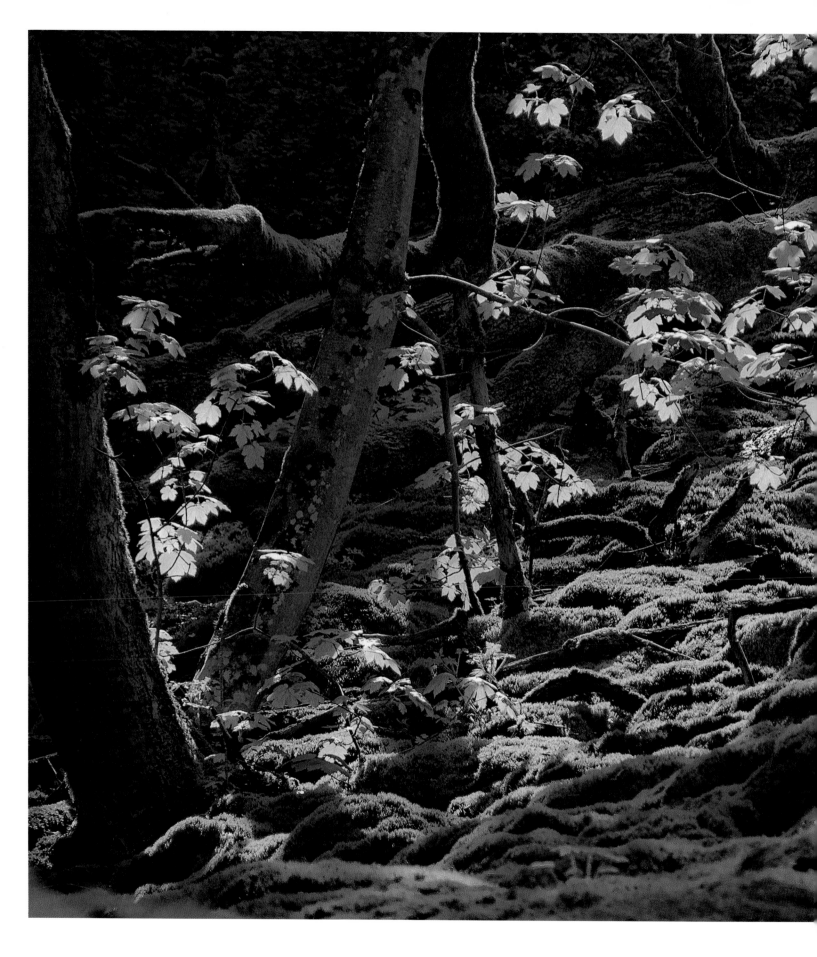

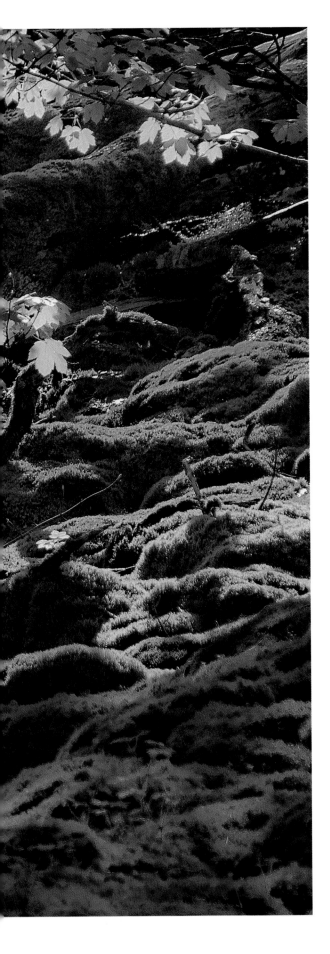

ground and, therefore, their children's leaves. Three percent—that's practically nothing. With that amount of sunlight, a tree can photosynthesize just enough to keep its own body from dying. There's nothing left to fuel a decent drive upward or even a thicker trunk. And rebellion against this strict upbringing is impossible, because there's no energy to sustain it. Upbringing? you ask. Yes, I am indeed talking about a pedagogical method that ensures the well-being of the little ones. And I didn't just come up with the term out of the blue— it's been used by generations of foresters to refer to this kind of behavior.

The method used in this upbringing is light deprivation. But what purpose does this restriction serve? Don't parents want their offspring to become independent as quickly as possible? Trees, at least, would answer this question with a resounding no, and recent science backs them up. Scientists have determined that slow growth when the tree is young is a prerequisite if a tree is to live to a ripe old age. As people, we easily lose sight of what is truly old for a tree, because modern forestry targets a maximum age of 80 to 120 years before trees are cut down and turned into cash. Under natural conditions, trees that age are no

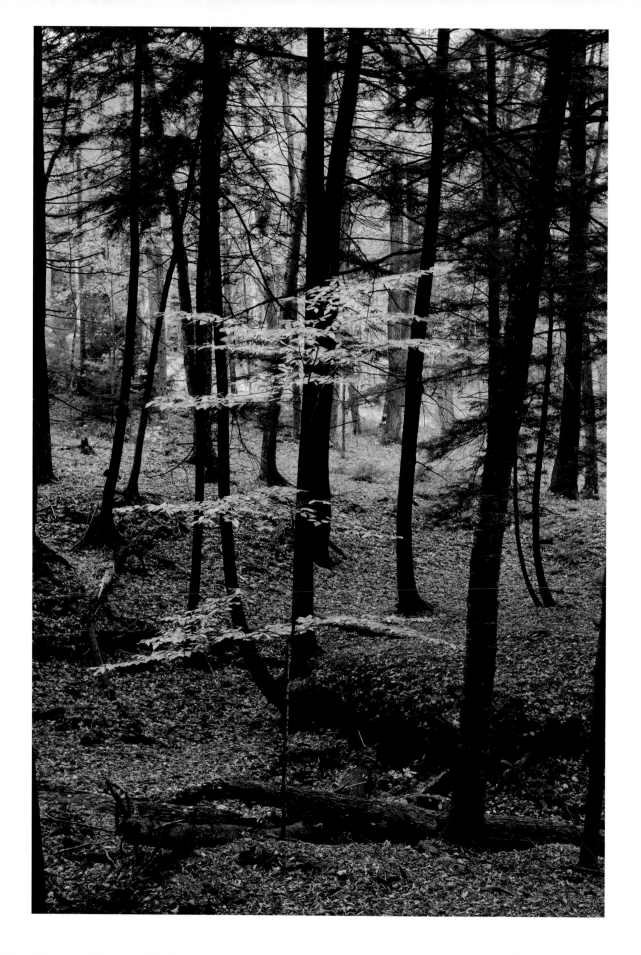

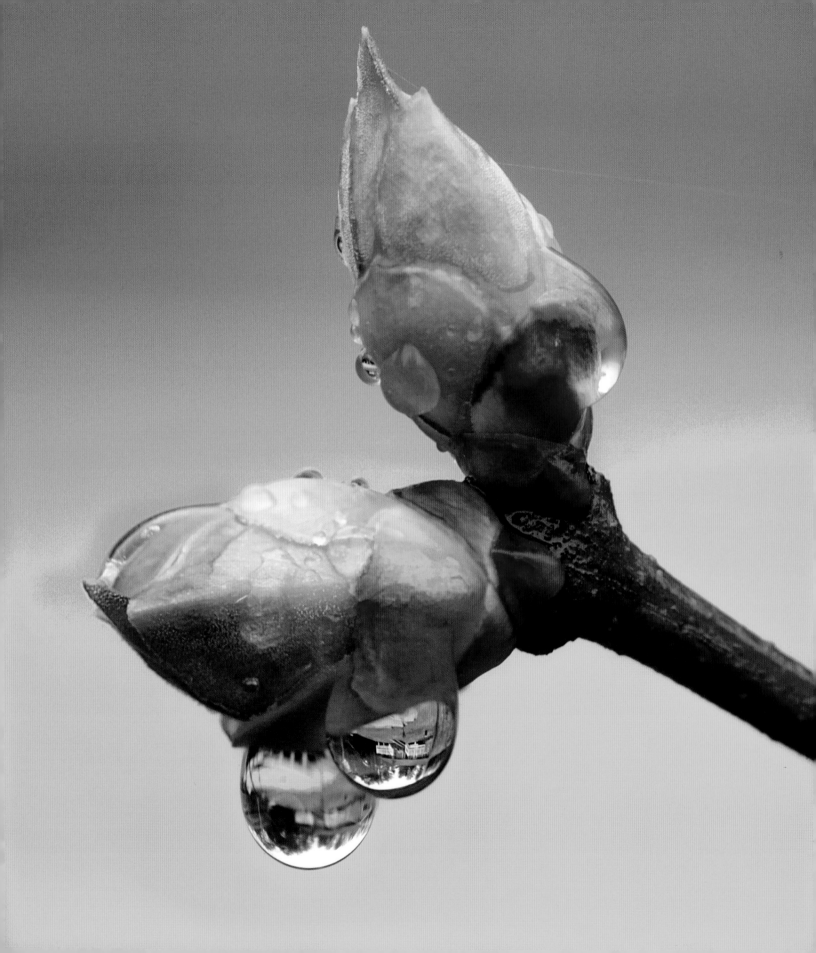

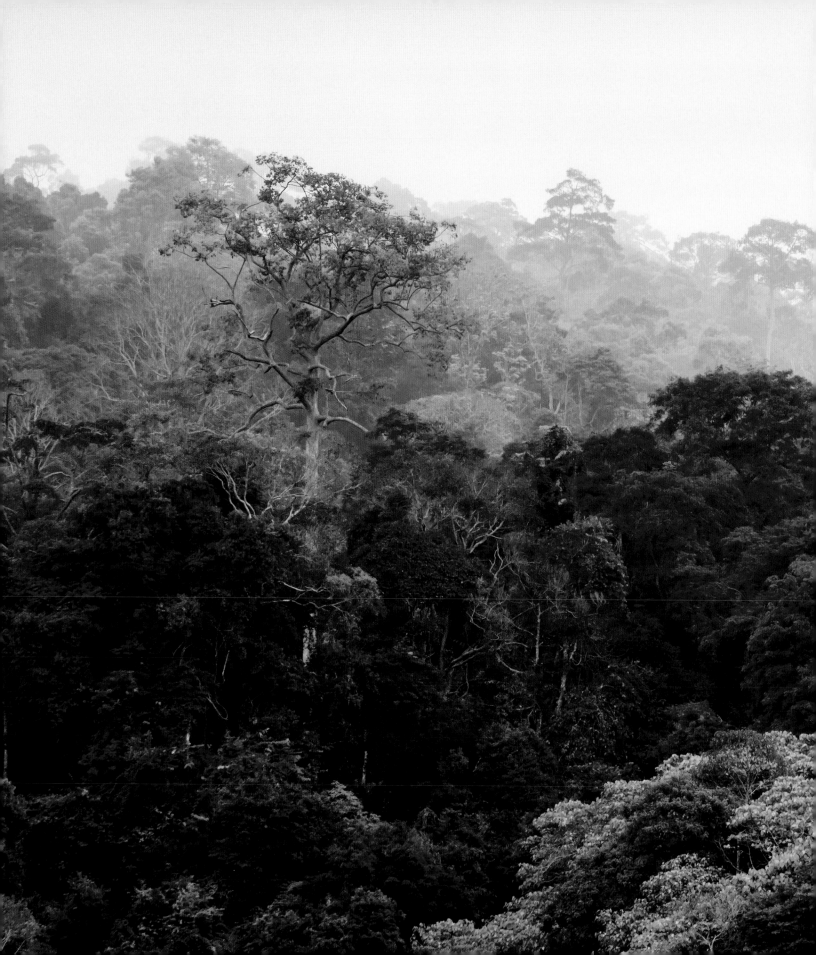

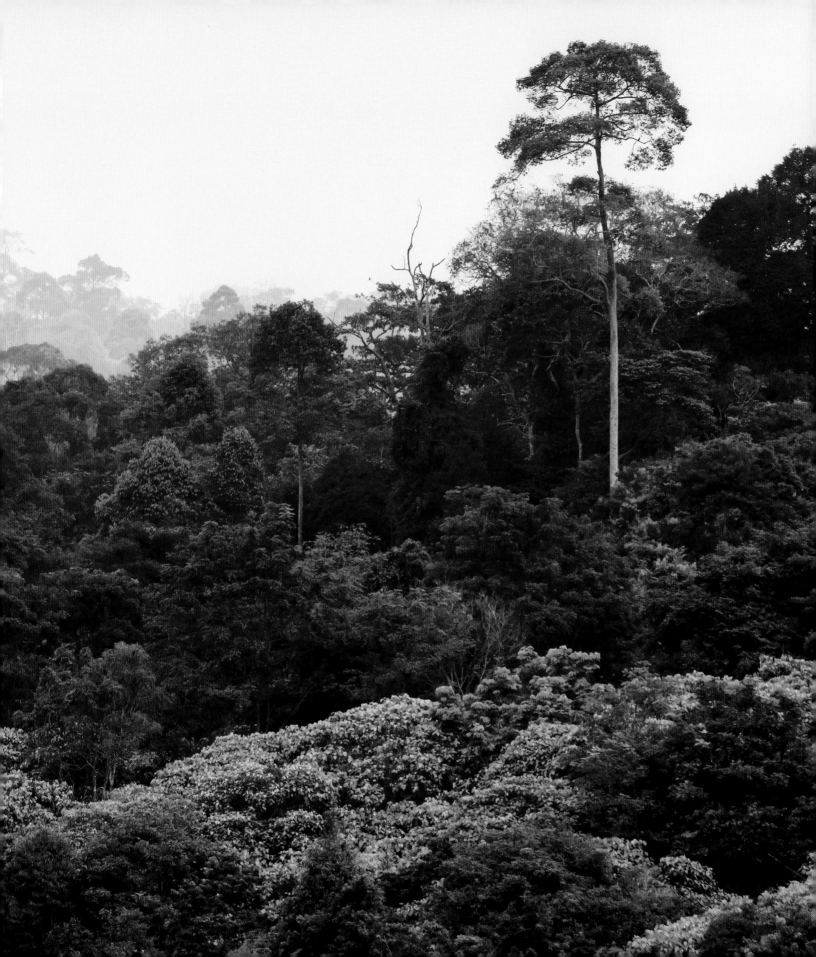

thicker than a pencil and no taller than a person. Thanks to slow growth, their inner woody cells are tiny and contain almost no air. That makes the trees flexible and resistant to breaking in storms. Even more important is their heightened resistance to fungi, which have difficulty spreading through the tough little trunks. Injuries are no big deal for them, either, because these dense little trees can easily close up the wounds by growing bark over them before any decay occurs.

Small beech trees in my forest, which have by now been waiting for at least eighty years, are standing under mother trees that are about two hundred years old—the equivalent of forty-year-olds in human terms. The stunted trees can probably expect another two hundred years of twiddling their thumbs before it is finally their turn. The wait time is, however, made bearable. Their mothers are in contact with them through their root systems, and they pass along sugar and other nutrients. You might even say they are nursing their babies.

One day, it's finally time. The mother tree reaches the end of her life or becomes ill. The showdown might take place during a summer storm. As torrents of rain pour down, the brittle trunk can no longer support the weight of several tons of crown, and it shatters. As the tree hits the ground, it snaps a couple of waiting seedlings. The gap that has opened up in the canopy gives the remaining members of the kindergarten the green light, and they can begin photosynthesizing to their hearts' content. Now their metabolism kicks into gear, and the trees grow sturdier leaves and needles that can withstand and metabolize bright light.

This stage lasts between one and three years. Once it is over, it's time to get a move on. The go-getters use up the greater part of what weak light remains; the stragglers give up the ghost and become humus once again. Further dangers are lurking on the way to the top. As soon as the bright sunlight increases the rate of photosynthesis and stimulates growth, the buds of those who have shot up receive more sugar. While they were waiting in the wings, their buds were tough, bitter pills, but now they are sweet, tasty treats—at least as far as the deer are concerned—but as the crowd of trees is enormous, there are still plenty that keep on growing.

The young trees that overcome all obstacles will have their patience tested yet again before another

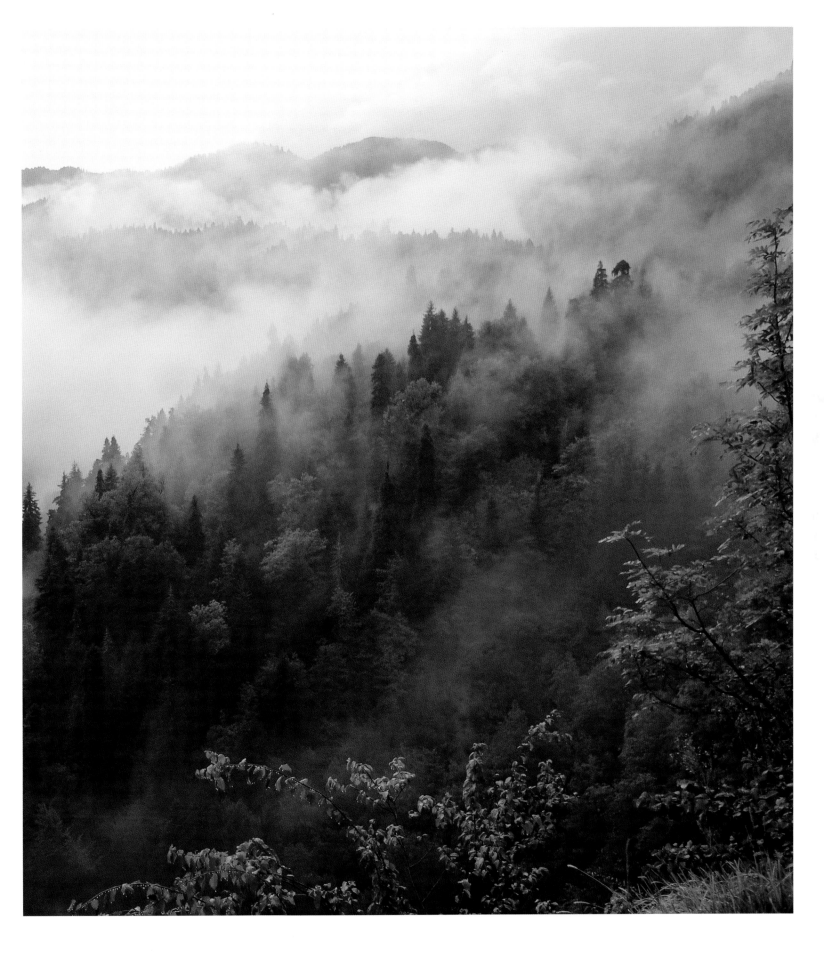

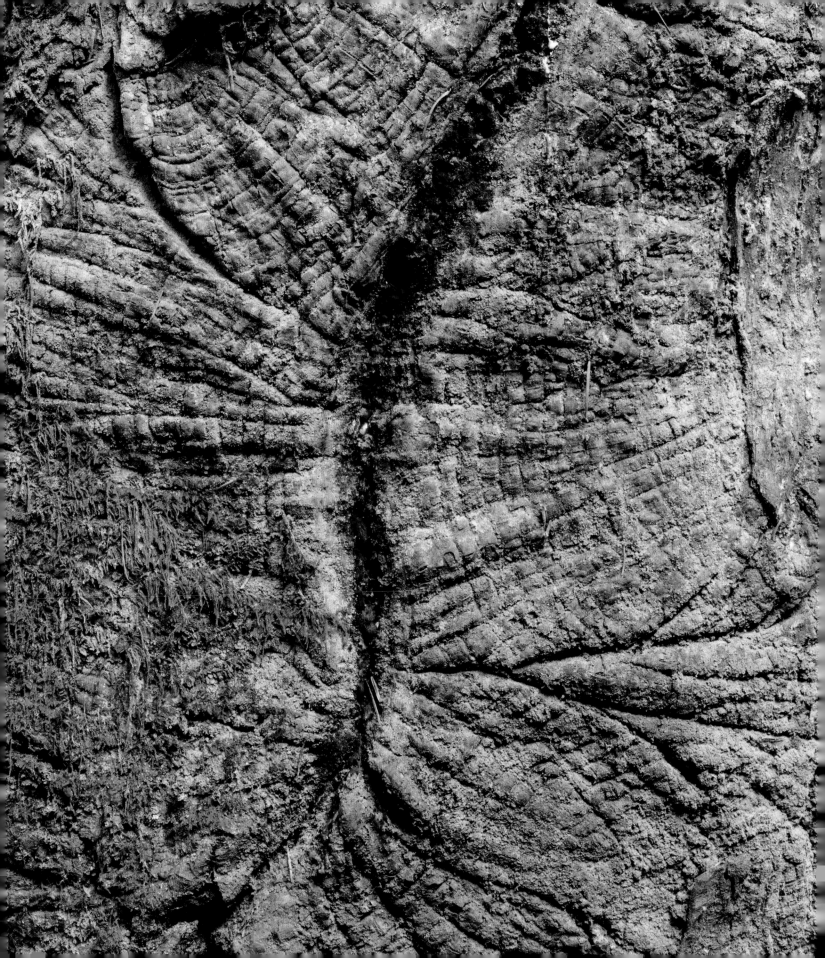

twenty years have passed. For this is how long it takes for the dead mother's neighbors to grow their branches out into the gap she left when she fell. They take advantage of the opportunity to build out their crowns and gain a little additional space for photosynthesis in their old age. Once the upper story grows over, it is dark once again down below. The young beeches, firs, and pines that have put the first half of their journey behind them must now wait until one of these large neighbors falls to make space for them. That can take many decades, but even though it takes time, in this particular arena, the die has already been cast. All the trees that have made it as far as the middle story are no longer threatened by competitors. They are now the crown princes and princesses who, at the next opportunity, will finally be allowed to grow up.

TREE SCHOOL

TREES NEED FOOD to grow. Like a baker who always has enough bread, a tree can satisfy a rumbling stomach right away using photosynthesis. But even the best baker cannot bake without water, and the same goes for a tree: without moisture, food production stops.

A mature beech can send more than 130 gallons of water a day coursing through its branches and leaves, and this is what it does as long as it can draw enough water up from below. However, the moisture in the soil would soon run out if the tree were to do that every day in summer. In the warmer seasons, it doesn't rain nearly enough to replenish water levels in the desiccated soil. Therefore, the tree stockpiles water in winter.

In winter, there's more than enough rain, and the tree is not consuming water, because almost all plants take a break from growing at that time of year. Together with belowground accumulation of spring showers, the stockpiled water usually lasts until the onset of summer. But in many years, water then gets scarce. After a couple of weeks of high temperatures and no rain, forests usually begin to suffer. The most severely affected trees are those that grow in soils where moisture is usually particularly abundant. These trees don't know the meaning of restraint and are lavish in their water use, and it is usually the largest and most vigorous trees that pay the price for this behavior.

In the forest I manage, the stricken trees are usually spruce, which burst not at every seam but certainly along their trunks. If the ground has

dried out and the needles high up in the crown are
still demanding water, at some point the tension
in the drying wood simply becomes too much for
the tree to bear. It crackles and pops, and a tear
about 3 feet long opens in its bark. This tear pen-
etrates deep into the tissue and severely injures
the tree. Fungal spores immediately take advan-
tage of the tear to invade the innermost parts of
the tree, where they begin their destructive work.
In the years to come, the spruce will try to repair
the wound, but the tear keeps reopening. From
some distance away, you can see a black chan-
nel streaked with pitch that bears witness to this
painful process.

And with that, we have arrived at the heart of
tree school. Unfortunately, this is a place where
learning is accompanied by a certain amount of
physical punishment, for Nature is a strict teacher.
If a tree does not pay attention and do what it's
told, it will suffer. Splits in its wood, in its bark, in
its extremely sensitive cambium (the life-giving
layer under the bark): it doesn't get any worse than
this for a tree. It has to react, and it does this not
only by attempting to seal the wound. From then
on, it will also do a better job of rationing water
instead of pumping whatever is available out of the

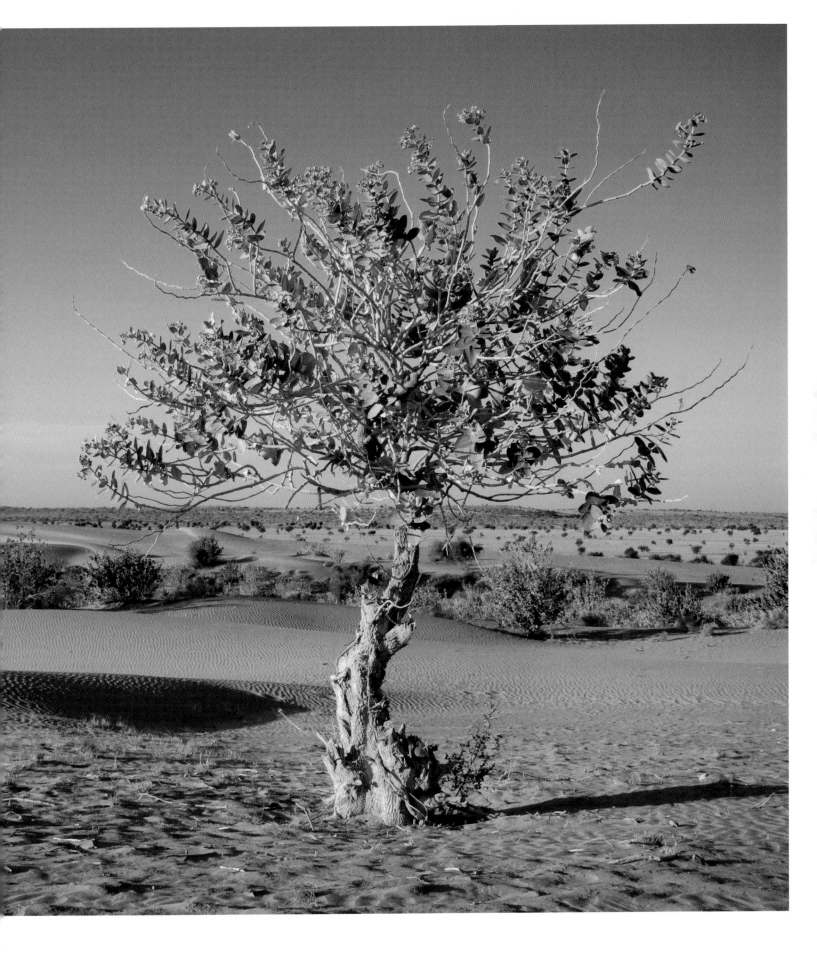

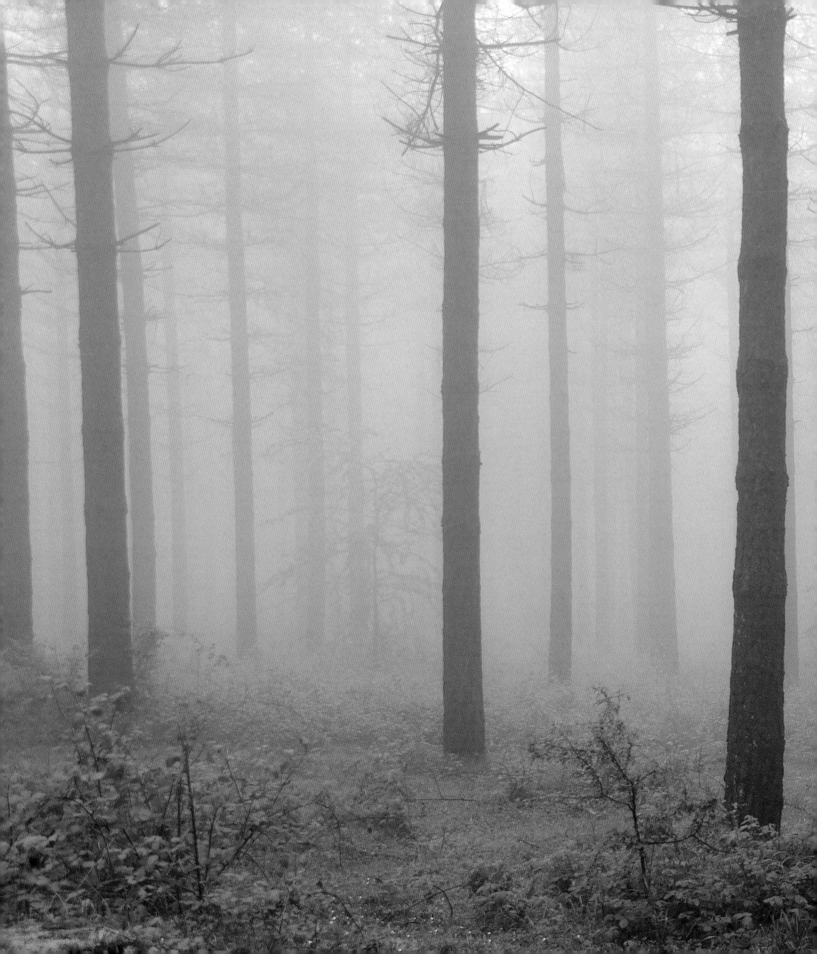

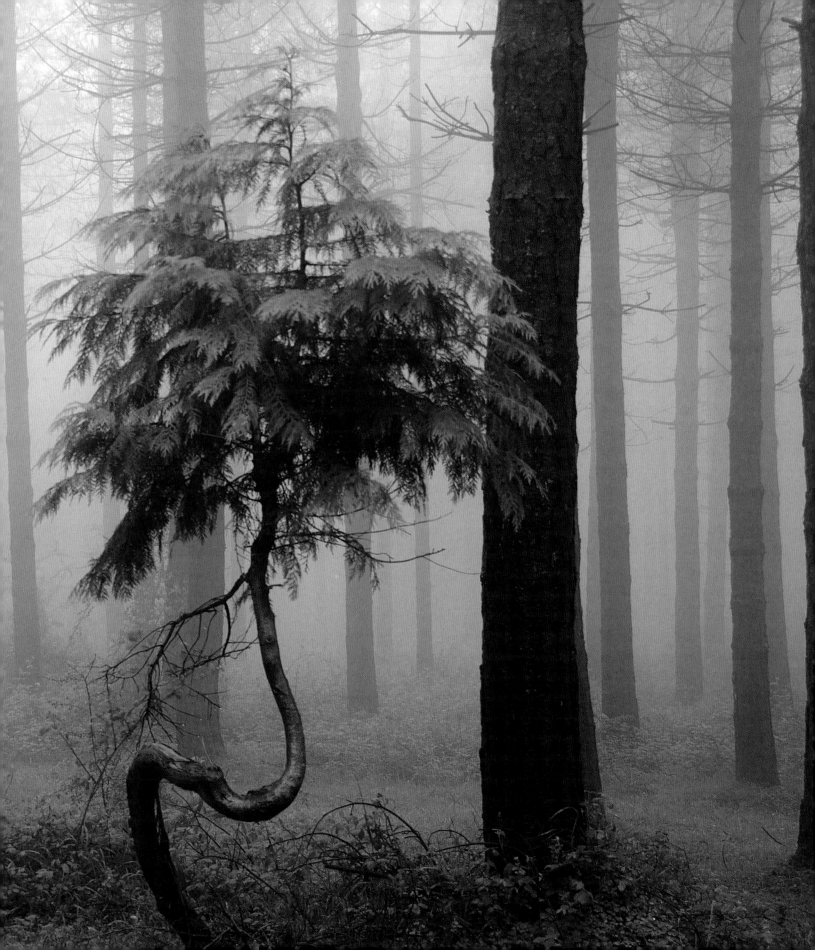

ground as soon as spring hits without giving a second thought to waste. The tree takes the lesson to heart, and from then on it will stick with this new, thrifty behavior, even when the ground has plenty of moisture—after all, you never know!

There is research in the field that reveals more than just behavioral changes in response to drought: when trees are really thirsty, they begin to scream. If you're out in the forest, you won't be able to hear them, because this all takes place at ultrasonic levels. Scientists at the Swiss Federal Institute for Forest, Snow, and Landscape Research recorded the sounds, and this is how they explain them: Vibrations occur in the trunk when the flow of water from the roots to the leaves is interrupted. This is a purely mechanical event and it probably doesn't mean anything. And yet?

We know how the sounds are produced, and if we were to look through a microscope to examine how humans produce sounds, what we would see wouldn't be that different: the passage of air down the windpipe causes our vocal cords to vibrate. When I think about the research results, it seems to me that these vibrations could indeed be much more than just vibrations—they could be cries of thirst. The trees might be screaming out a dire

warning to their colleagues that water levels are running low.

FOREST ETIQUETTE

Forest etiquette lays down guidelines for the proper appearance and acceptable forms of behavior for upright members of ancient forests.

THIS IS WHAT a mature, well-behaved deciduous tree looks like. It has a ramrod-straight trunk with a regular, orderly arrangement of wood fibers. The roots stretch out evenly in all directions and reach down into the earth under the tree. In its youth, the tree had narrow branches extending sideways from its trunk. They died back a long time ago, and

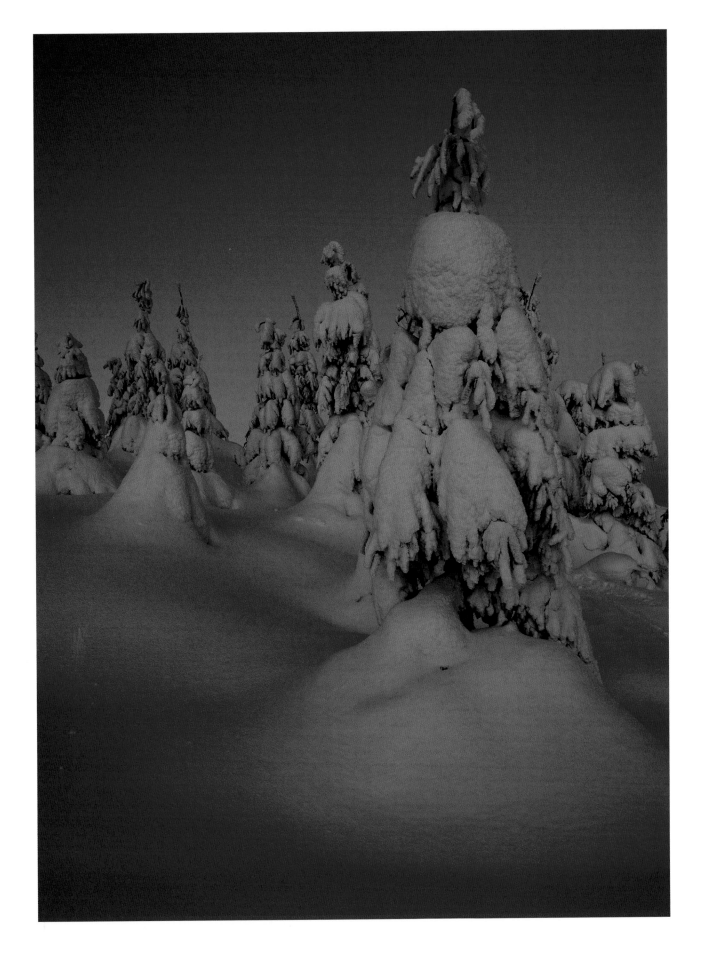

the tree sealed them off with fresh bark and new wood so that what you see now is a long, smooth column. Only when you get to the top do you see a symmetrical crown formed of strong branches angling upward like arms raised to heaven. An ideally formed tree such as this can grow to be very old. Similar rules hold for conifers, except that the topmost branches should be horizontal or bent slightly downward.

And what is the point of all this? Deep down inside, do trees secretly appreciate beauty? Unfortunately, I cannot say, but what I can tell you is that there is a good reason for this ideal appearance: stability. The large crowns of mature trees are exposed to turbulent winds, torrential rains, and heavy loads of snow. The tree must cushion the impact of these forces, which travel down the trunk to the roots. The roots must hold out under the onslaught so that the tree doesn't topple over. If there is a weak spot anywhere in the tree, it will crack. In the worst-case scenario, the trunk breaks off completely and the whole crown tumbles down. Evenly formed trees absorb the shock of buffeting forces, using their shape to direct and divide these forces throughout their structure.

The process of learning stability is triggered by painful micro-tears that occur when the trees bend way over in the wind, first in one direction and then in the other. Wherever it hurts, that's where the tree must strengthen its support structure. In a natural forest, this little game can be repeated many times over the lifetime of a tree as gaps open in the canopy. When they close again, then everyone can go back to leaning on everyone else.

Despite the dangers, some trees clearly don't want to follow tried-and-true branch patterns. In these trees, the branches start by pointing away from the trunk, only to then bend and grow upward and continue to hold this course. If a branch that grows in this J shape is bent down toward the ground—by heavy rain or snow—the branch breaks because downward pressure compresses the fibers on the underside (that would be the fibers on the outside of the J curve) and over-extends those on the inside.

Sometimes it is the trunk itself that is mal-formed in this way, often in whole sections of a forest. Are the rules of Nature being set aside here? Not at all. It is Nature herself that forces the trees to adopt such growth patterns. Take, for example, trees on high mountain slopes just below the

tree line. In winter, the snow frequently lies many feet deep, and it is often on the move. And not just in avalanches. Even when it is at rest, snow is sliding at a glacial pace down toward the valleys, even though we can't detect the movement with our eyes. And while the snow is doing that, it's bending trees—the young ones, at least. That's not the end of the world for the smallest among them. They just spring back up again without any ill effects after the snow has melted. However, the trunks of immature trees already 10 feet or so tall are damaged. In the most severe cases, the trunk breaks. If it doesn't break, it remains at an angle. From this position, the tree tries to get back to vertical. And because a tree grows only from its tip, the lower part remains crooked. The following winter, the tree is once more pressed out of alignment. Next year's growth points vertically once again. If this game continues for a number of years, gradually you get a tree that is bent into the shape of a saber, or curved sword. It is only with increasing age that the trunk thickens and becomes solid enough that a normal amount of snow can no longer wreak havoc. The lower "saber" keeps its shape, while the upper part of the trunk, left undisturbed, is nice and straight like a normal tree.

Trees that don't follow the etiquette manual may find themselves in trouble.

Something similar can happen to trees even in the absence of snow, though also on hillsides. In these cases, it is sometimes the ground itself that is sliding extremely slowly down to the valley over the course of many years, often at a rate of no more than an inch or two a year. When this happens, the trees slip slowly along with the ground and tilt over while they continue to grow vertically. You can see extreme cases of this in Alaska and Siberia, where climate change is causing the permafrost to thaw. Trees are losing their footing and being thrown completely off balance in the soggy subsoil. And because every individual tree is tipped in a different direction, the forest looks like a group of drunks staggering around. Accordingly, scientists call these "drunken forests."

59

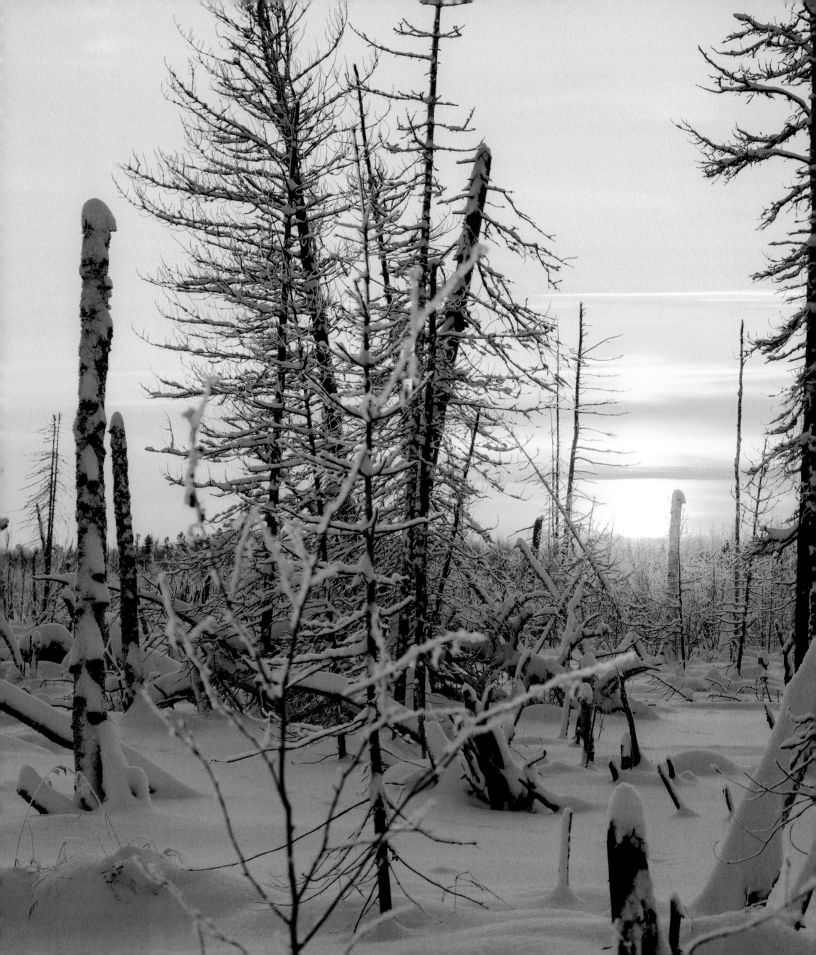

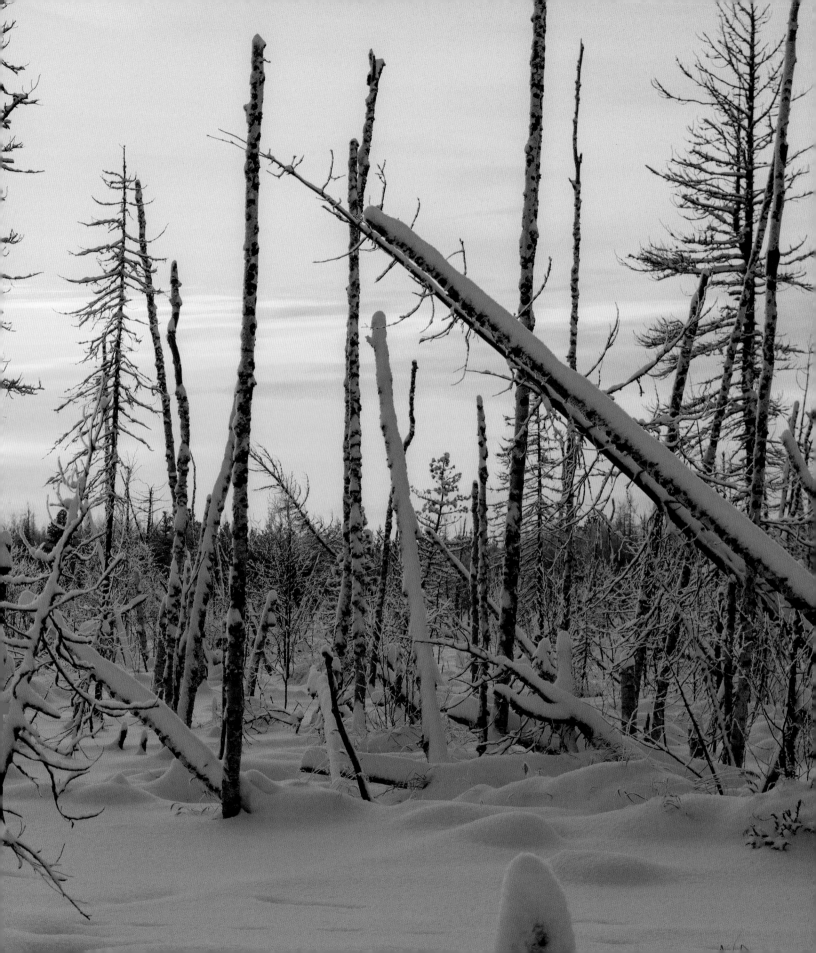

3

The Delights of Decay

AGING GRACEFULLY

AS TREES GROW, they age just like us, but before I talk about age, I would like to talk about skin. Trees and skin? Let's approach the subject from the human point of view. Our skin is a barrier that protects our innermost parts from the outer world. It holds in fluids. It stops our insides from falling out. And all the while it releases and absorbs gas and moisture. In addition, it blocks pathogens that would just love to spread through our circulatory system. Aside from that, it is sensitive to contact, which is either pleasant and gives rise to the desire for more, or painful and elicits a defensive response.

Annoyingly, this complicated structure doesn't stay the same forever but gradually sags as we age. Folds and wrinkles appear so that our contemporaries can playfully guess how old we are, give or take a few years. The necessary process of regeneration is not exactly pleasant, either, when

PREVIOUS SPREAD
White birch trees

FACING
Pine bark

looked at close up. Ten billion skin cells flake off us every day. That doesn't sound very attractive, but sloughing off dead skin is necessary to keep our outer organ in good condition. And without the ability to renew and expand the covering Nature gives us, sooner or later we would burst.

But how does this relate to trees? It's just the same with them. The biggest difference is simply the vocabulary we use. The skin of Beeches, Oaks, Spruce & Co. is called bark. It fulfills exactly the same function and protects trees' sensitive inner organs from an aggressive outer world. A tree contains almost as much liquid inside it as we do, and so it's unappealing to insect pests and destructive fungi because they would, quite simply, suffocate. Without bark, a tree would dry out. A break in its bark, then, is at least as uncomfortable for a tree as a wound in our skin is for us. And, therefore, the tree relies on mechanisms similar to the ones we use to stop this from happening. Every year, a tree in its prime adds from 0.5 to 1 inch to its girth. Surely this would make the bark split? It should. To make sure that doesn't happen, the giants constantly renew their skin while shedding enormous quantities of skin cells. In keeping with

trees' size in comparison to ours, these flakes are correspondingly larger and measure up to 8 inches across. If you take a look around on the ground under trunks in windy, rainy weather, you will see the remains lying there. The red bark of pines is particularly easy to spot.

But not every tree sheds in the same way. There are species that shed constantly (fastidious people would recommend an anti-dandruff shampoo for such cases). Then there are others that flake with restraint. You can see who's doing what when you look at the exterior of a tree. What you see is the outer layer of bark, which is dead and forms an impervious exterior shell. This outer layer of bark also happens to be a good way of telling different species apart. This works for older trees, anyway, for the distinguishing characteristics have to do with the shapes of the cracks or, you could say, with the folds and wrinkles in a tree's skin. In young trees of all species, the outer bark is as smooth as a baby's bottom. As trees age, wrinkles gradually appear (beginning from below), and they steadily deepen as the years progress.

For beeches, whose silver-gray bark remains smooth until they are two hundred years old, the

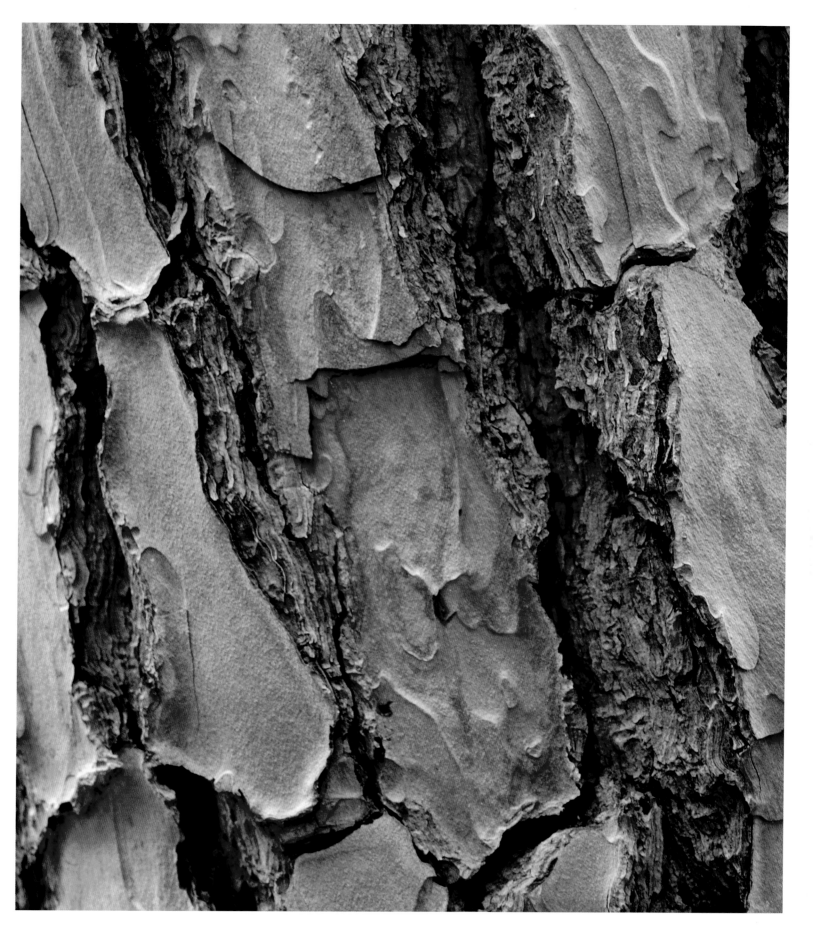

FACING
The yew, the epitome of frugality and patience, can live to be a thousand years old or more.

rate of bark renewal is very high. Because of this, their skin remains thin and fits their age—that is to say, their girth—exactly and, therefore, doesn't need to crack in order to expand. Pines and the like, however, drag their feet when it comes to external makeovers. For some reason, they don't like to be parted from their baggage, perhaps because of the additional security a thick skin provides. Whatever the reason, they shed so slowly that they build up really thick outer bark and their exterior layers can be decades old. This means the outer layers originated at a time when the trees were still young and slim, and as the trees age and increase in girth, the outer layers crack way down into the youngest layer of bark that—like the bark of the beeches—fits the girth of the tree as it is now.

The deeper the cracks, the more reluctant the tree is to shed its bark.

Apart from wrinkled skin, there are other physical changes that indicate a tree's age. Take, for example, the crown, which I can compare with something I have as well. Up top, my hair is thinning. It just doesn't grow like it did when I was young. And it's the same with the highest branches up in a tree's crown. After a specific time—one hundred to three hundred years, depending on the species—the annual new growth gets shorter and shorter. In deciduous trees, the successive growth of such short shoots leads to curved, claw-like branches that resemble fingers plagued by arthritis. In conifers, the ramrod-straight trunks end in topmost shoots or leaders that are gradually reduced to nothing.

Every tree gradually stops growing taller. Its roots and vascular system cannot pump water and nutrients any higher because this exertion would be too much for the tree. Instead, the tree just gets wider (another parallel to many people of advancing years . . .). The tree is also not capable of maintaining its mature height for long because its energy levels diminish slowly over the years. At first, it can no longer manage to feed its topmost twigs, and these die off. And so, just as an old person gradually loses body mass, an old tree

does too. The next storm sweeps the dead twigs out of the crown. The process is repeated each year, reducing the crown so gradually we barely notice. Once all the topmost twigs and small branches are lost, only the thicker lower branches remain. Eventually, they die too, though they are not so easily dislodged. Now the tree can no longer hide its advanced age or its infirmity. Then one day, it's all over. The trunk snaps and the tree's life is at an end. "Finally," you can almost hear the young trees-in-waiting sigh. In the years to come, they will quickly push their way up past the crumbling remains.

COMMUNITY HOUSING

THERE IS MORE than one way for a tree to die, and sometimes it can be a long-drawn-out process. The thick trunks of older trees attract a number of creatures looking for sturdy, well-insulated homes. In Europe, it's usually a great spotted woodpecker or a black woodpecker that gets things started. The bird hacks out a hole in the trunk that may be only an inch or two deep. Contrary to popular opinion, the birds don't restrict themselves to rotten trees, often starting construction in healthy trees.

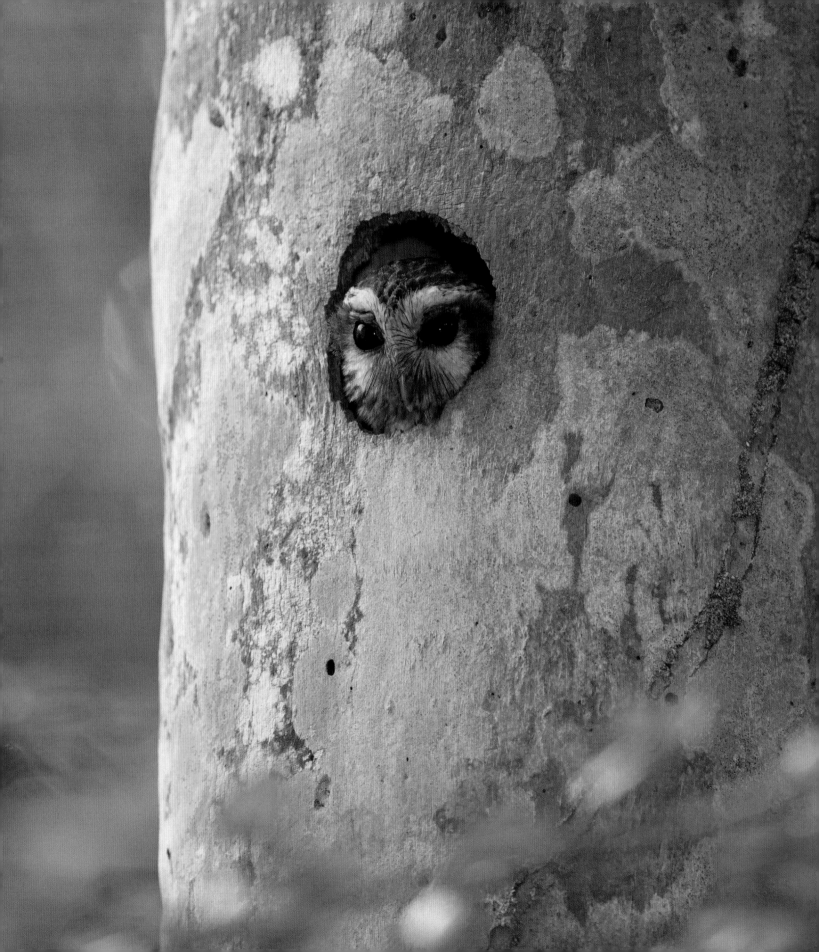

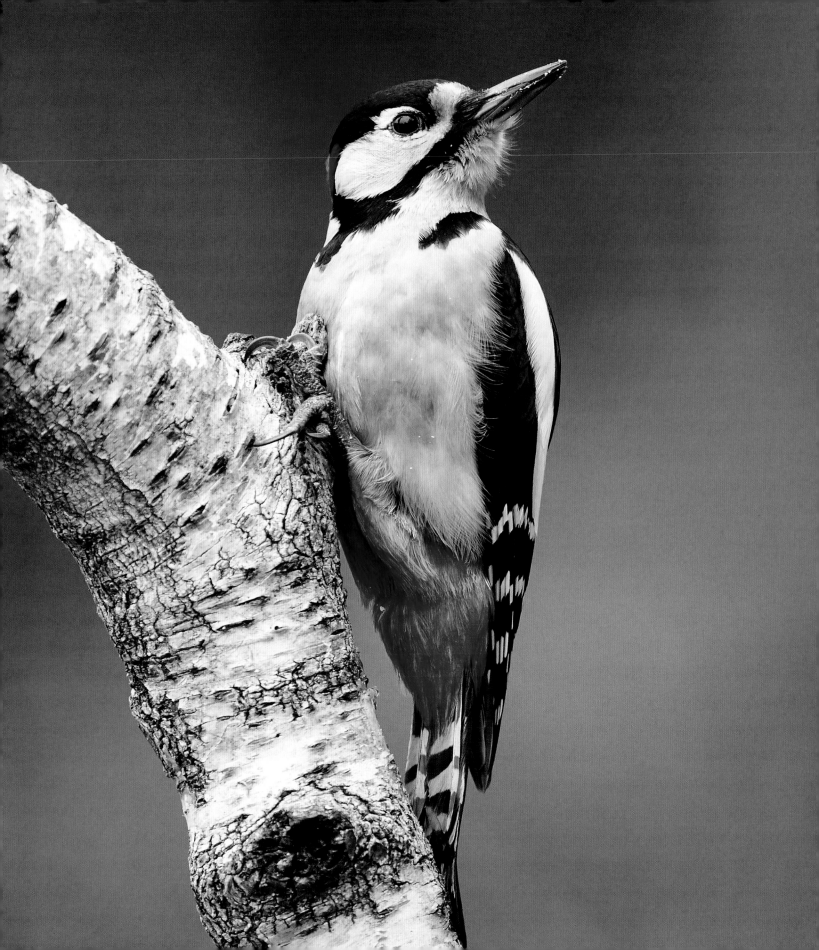

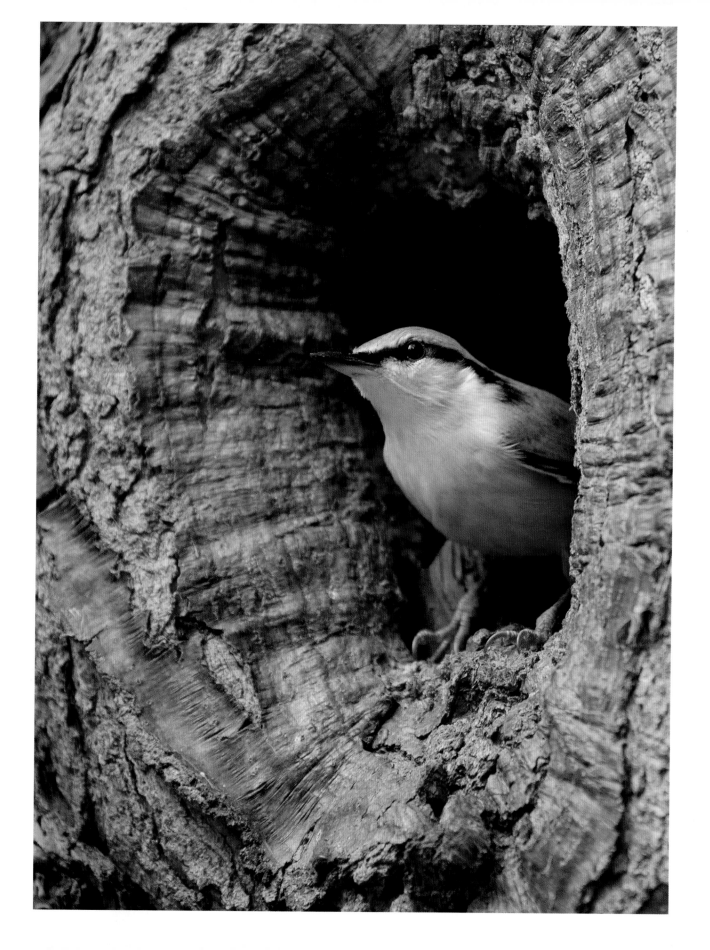

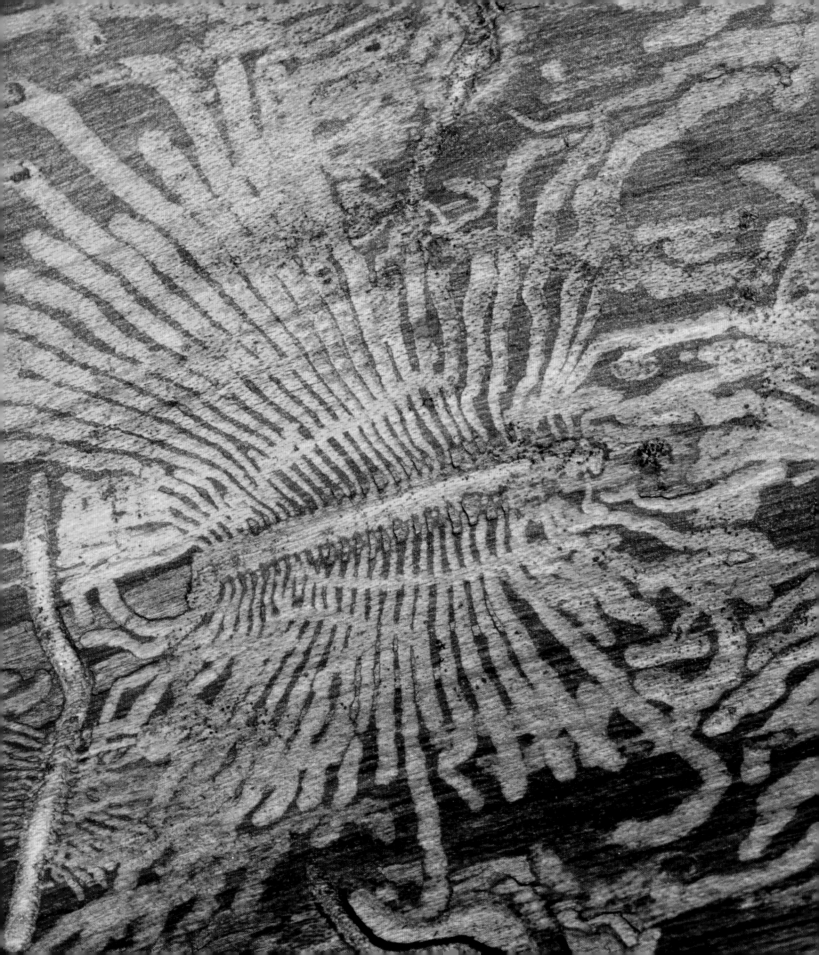

Would you move into a ramshackle home if you could build a new one next door? Just like us, woodpeckers want the place where they bring up their families to be solid and durable. Even though the birds are well equipped to hammer away at healthy wood, it would be too much for them to complete the job all at once. And that's why they take a months-long break after the first phase, hoping fungi will pitch in. As far as the fungi are concerned, this is the invitation they have been waiting for, because usually they can't get past the bark. In this case, they quickly move into the opening and begin to break down the wood. What the tree sees as a coordinated attack, the woodpecker sees as a division of labor. After a while, the wood fibers are so soft that it's much easier for the woodpecker to enlarge the hole.

Finally, the day comes when construction is complete and the cavity is ready to move into. But that's not enough for the crow-sized black woodpecker, and so he works on a number of cavities at the same time. He uses one for the kids, one for sleeping, and the others for a change of scene. Every year, the cavities are renovated, and wood chips at the base of the trees are evidence of this activity. Renovation is necessary because the fungi that have invaded the space are by now unstoppable. They keep eating deeper into the trunk, transforming the wood into damp mush, which isn't an ideal environment in which to raise a family. Every time the woodpecker cleans out the soggy mess, the nesting cavity gets a little larger. Sooner or later, the cavity becomes too large and, above all, too deep for the baby birds, which must climb up out of the opening to make their first flight. And now it's time for the subletters to move in.

The subletters are species that can't work with wood themselves. There's the nuthatch, which is somewhat like a woodpecker but much smaller. Like woodpeckers, it hops around on dead wood, pecking away to get at beetle larvae. It loves to build its nests in abandoned great spotted woodpecker nesting cavities. But there's a problem. The entrance is way larger than it needs and could let in predators intent on eating its brood. To prevent this, the bird makes the entrance smaller using mud, which it arranges artfully around the perimeter.

While we're on the subject of predators: trees also offer their subletters a special service on the side, thanks to a characteristic of their wood.

Wood fibers conduct sound particularly well, which is why they are used to make musical instruments such as violins and guitars. You can do a simple experiment to test for yourself how well these acoustics work. Put your ear up against the narrow end of a long trunk lying on the forest floor and ask another person at the thicker end to carefully make a small knocking or scratching sound with a pebble. On a still day, you can hear the sound through the trunk incredibly clearly, even if you lift your head. Birds use this property of wood as an alarm system for their nesting cavities. In their case, what they pick up is not benign knocking but scrabbling sounds made by the claws of martens or squirrels. The sounds can be heard high up in the tree, which gives the birds a chance to escape. If there are young in the nest, they can try to distract the attackers, though such attempts are usually doomed to failure. But at least the parents escape with their lives and can compensate for their loss by raising a second brood.

Owls don't fit very well into woodpecker cavities, and so they must be patient for a few more years. Over time, the tree continues to rot, and sometimes the trunk splits opens a bit more so that the entrance gets bigger. And sometimes a series of woodpecker cavities up the trunk, like woodpecker apartments stacked one on top of the other, speeds the owls' entrance. As the process of decay progresses, they slowly merge into each other, and when that happens, they are ripe for the arrival of the tawny owl and his friends.

As the rot continues, the trunk becomes home to a complex living community. Wood ants move in and chew the moldy wood to make their papery nests. Wood ants farm aphids for their honeydew, and this sugary excretion soaks the nest walls. Fungi bloom on this substrate, and their fibrous web stabilizes the nest. A multitude of beetles are drawn to the mushy, rotten interior of the cavity. Their larvae can take years to develop, and so they need stable, long-term accommodations. This is why they choose trees, which take decades to die and, therefore, remain intact for a long time. The presence of beetle larvae ensures that the cavity remains attractive to fungi and other insects, which keep a constant supply of excrement and sawdust raining down into the rot.

The excrement of bats, owls, and dormice also drops down into the dark depths. And so the

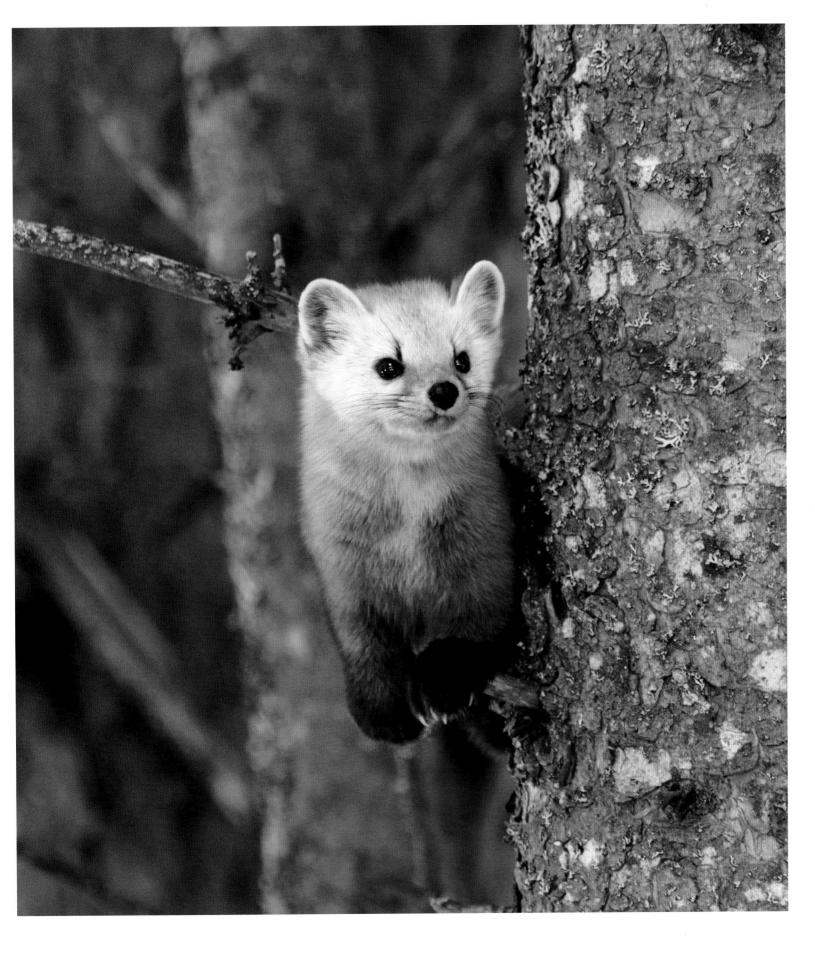

rotten wood is constantly supplied with nutrients, which feed species such as the blood-necked click beetle, or the larvae of the European hermit beetle, a big black beetle that can grow up to 1.5 inches long. Hermit beetles are very reluctant to move and prefer to spend their whole lives in a dark hole at the base of a rotting tree trunk. And because these beetles rarely fly or walk, whole generations of the same family can live for decades in the same tree. This explains why it is so important to keep old trees. If they are cleared away, these little black guys can't just wander over to the next tree; they simply don't have the energy to do that. Even if one day the tree gives up and breaks off in a storm, it has still served the community well.

REBIRTH

NOT EVERY TREE is targeted by woodpeckers as a nesting site and doomed to gradual rot. Many trees die quickly. A storm might snap a mighty trunk, or bark beetles might destroy a tree's bark in a few short weeks, causing its leaves to wither and die. Then the ecosystem around the tree changes suddenly. Animals and fungi that are dependent on the tree pumping a steady supply of moisture through its veins or sugar from its crown must now leave the corpse or starve. A small world has come to an end. Or has it just begun?

A dead trunk is as indispensable for the cycle of life in the forest as the live tree.

For centuries, the tree sucked nutrients from the ground and stored them in its wood and bark. And now it is a precious resource for its children. But they don't have direct access to the delicacies contained in their dead parents. To access them, the youngsters need the help of other organisms. As soon as the snapped trunk hits the ground, the tree and its root system become the site of a culinary relay race for thousands of species of fungi and insects. Each is specialized for a particular stage of the decomposition process and for a particular part of the tree. And this is why these

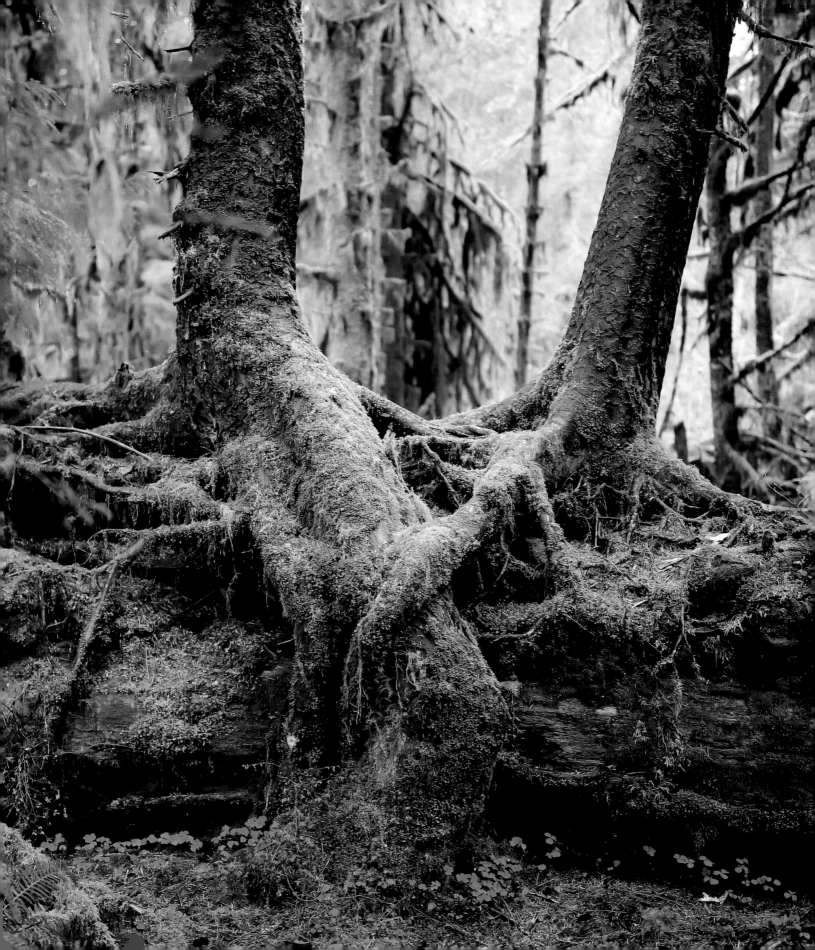

FACING
Bracket fungus gets its name because it sticks
out from the dead trunk like a shelf made
from half a broken plate. It feeds on the white
threads of cellulose in the wood, leaving
brown crumbs as evidence of its meal.

species can never pose a danger to a living tree—it would be much too fresh for them. Soft, woody fibers and moist, moldy cells—these are the things they find delicious.

Some fungi fight bitterly over feeding territory. You can see this clearly on dead wood that has been sawn into pieces. You'll find marbled structures of lighter and darker tissue clearly separated by black lines. The different shades indicate different species of fungi working their way through the wood. They wall off their territory from other species with dark, impenetrable polymers, which look to us as though they are drawing battle lines. In total, a fifth of the animal and plant species in Central European forests—that's about six thousand of the species we know about—depend on dead wood.

An armada of decomposers helps feed living trees.

Sometimes dead wood is directly beneficial to trees, for example, when a downed trunk serves as a cradle for its own young. Young spruce sprout particularly well in the dead bodies of their parents. This is known as "nurse-log reproduction" in English and, somewhat gruesomely, as *Kadaververjüngung*, or "cadaver rejuvenation," in German. The soft, rotten wood stores water particularly well, and some of the nutrients it contains have already been released by fungi and insects. There is just one teeny problem: the trunk isn't a permanent replacement for soil, as it is constantly being degraded, until one day it disintegrates completely into humus. So what happens to the young trees then? Their roots are exposed and lose their support, but because the process plays out over decades, the roots follow the disintegrating wood into the forest floor. The trunks of spruce that grow up this way end up being elevated on stilts. The height of the stilts corresponds to the diameter of the nurse log on which they once lay.

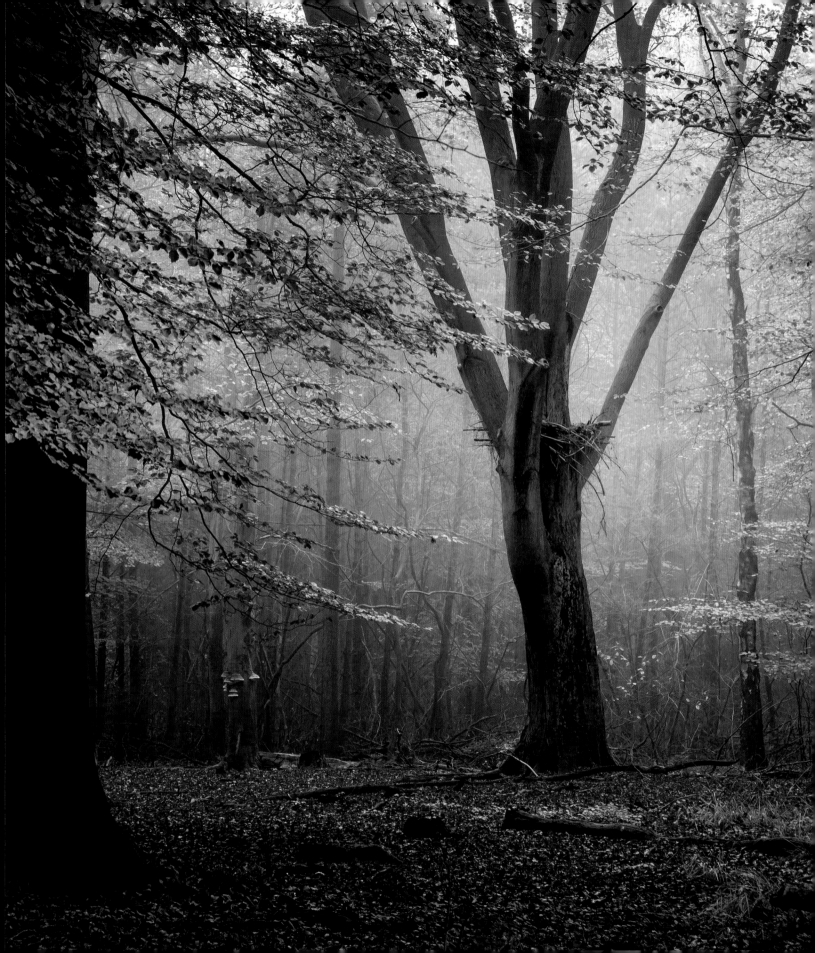

4

Strategies for Survival

WINTER BREAK

IT'S LATE SUMMER, and the forest is in a strange mood. The trees have exchanged the lush green in their crowns for a washed-out version verging on yellow. It seems as though they are getting increasingly tired. Exhaustion is setting in, and the trees are waiting for the stressful season to end. They feel just like we do after a busy day at work—ready for a well-earned rest.

Grizzly bears hibernate and so do dormice. But trees? The grizzly bear is a good candidate for comparison, because it follows a similar strategy to that of trees. In summer and early fall, it eats to lay down a thick layer of fat it can live off all winter. And this is exactly what our trees do as well. Of course, they don't feed on blueberries or salmon, but they fuel themselves with energy from the sun, which they use to make sugar and other compounds they can hold in reserve. And they store these under their skin just like a bear. Because they

can't get any fatter (only their bones—that is to say, their wood—can grow), the best they can do is fill their tissues with food. And whereas bears can go on eating everything they can find, at some point the trees get full.

You can see this very well, especially if you look at wild cherries, bird cherries, and wild service trees any time after August. Even though there are many beautiful sunny days they could make use of before October, they begin to turn red. And what that means is that they are shutting up shop for the year. The storage spaces under their bark and in their roots are full. If they made more sugar, there would be nowhere to stash it. While the bears happily go on eating, for these trees the sandman is already knocking on the door. Most other tree species seem to have larger storage areas, and they continue to photosynthesize hungrily and without taking a break right until the first hard frosts. Then they, too, must stop and shut down all activity. One reason for this is water. It must be liquid for the tree to work with it. But if wood is too wet when it freezes, it can burst like a frozen water pipe. This is the reason most species begin to gradually reduce the moisture content in their wood—and this means cutting back on activity—as early as July.

But trees can't switch to winter mode yet, for two main reasons. First, unless they are members of the cherry family, they use the last warm days of late summer to store energy. And second, most species still need to fetch energy reserves from the leaves and get them back into their trunk and roots. Above all, they need to break down their green coloring, chlorophyll, into its component parts so that the following spring they can send large quantities of it back out to the new leaves. As this pigment is pumped out of the leaves, the yellow and brown colors that were there all along predominate. These colors are made of carotene and probably serve as alarm signals. Around this time, aphids and other insects are seeking shelter in cracks in the bark, where they will be protected from low temperatures. Healthy trees advertise their readiness to defend themselves in the coming spring by displaying brightly colored fall leaves. Aphids & Co. recognize these trees as unfavorable places for their offspring because they will probably be particularly vigorous about producing toxins. Therefore, they search out weaker, less colorful trees.

But why bother with all this extravagance? Many conifers demonstrate that things can be

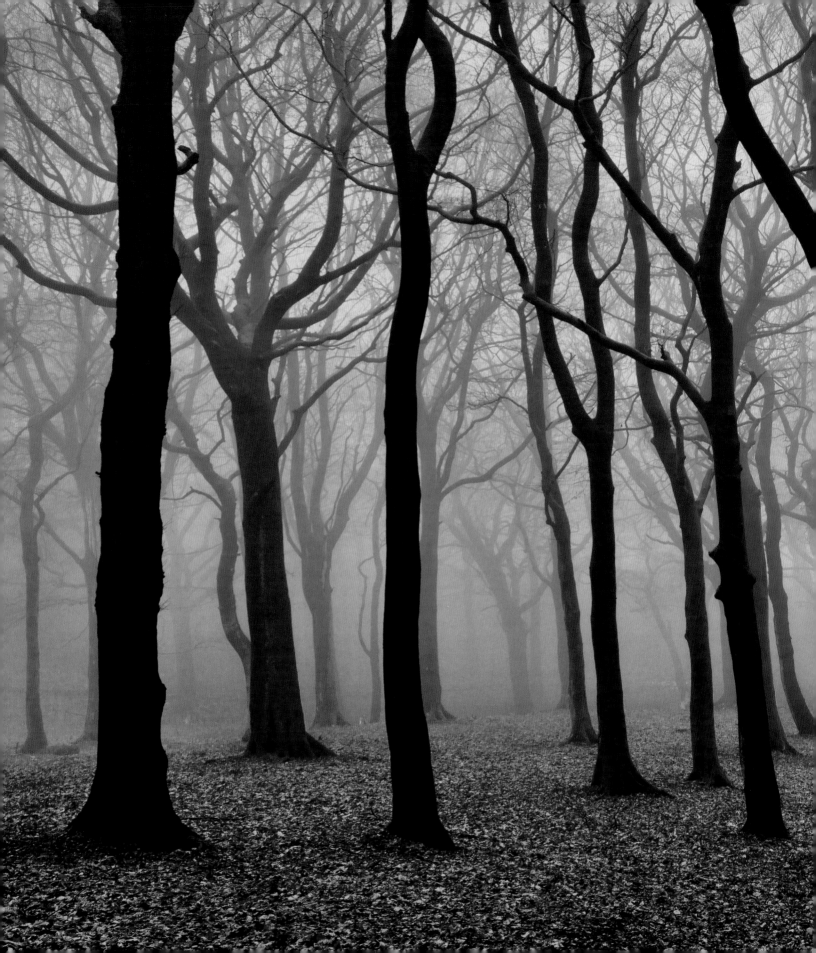

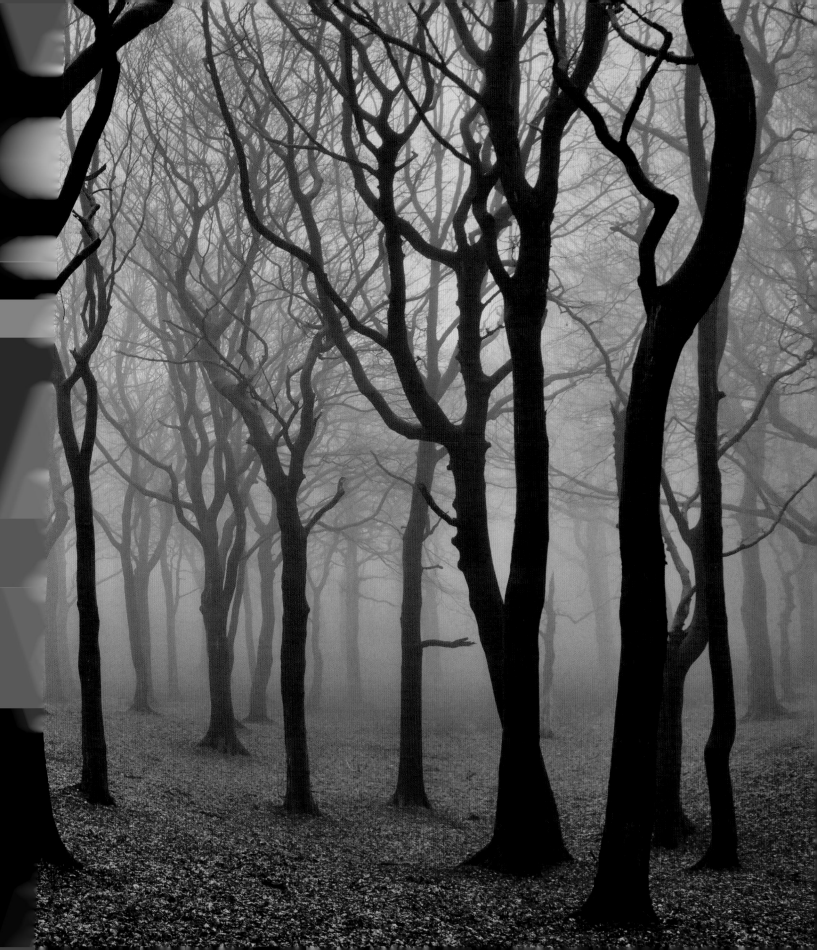

PREVIOUS SPREAD
Beech trees

FACING
Alpine larch

done differently. They simply keep all their green finery on their branches and thumb their noses at the idea of an annual makeover. To protect its needles from freezing, a conifer fills them with antifreeze. To ensure it doesn't lose water to transpiration over the winter, it covers the exterior of its needles with a thick layer of wax. As an extra precaution, the skin on its needles is tough and hard, and the small breathing holes on the underside are buried extra deep. All these precautions combine to prevent the tree from losing any significant amount of water. Such a loss would be tragic, because the tree wouldn't be able to replenish supplies from the frozen ground. It would dry out and could then die of thirst.

In contrast to needles, leaves are soft and delicate—in other words, they are almost defenseless. It's little wonder beeches and oaks drop them as quickly as they can at the first hint of frost. But why didn't these trees simply develop thicker skins and antifreeze over the course of their evolution? Does it really make sense to grow millions of new leaves per tree every year, use them for a few months, and then go to the trouble of discarding them again? Apparently, evolution says it

does, because when it developed deciduous trees about 100 million years ago, conifers had already been around on this planet for 170 million years. This means deciduous trees are a relatively modern invention. When you take a closer look, their behavior in fall actually makes a lot of sense. By discarding their leaves, they avoid a critical force—winter storms.

Winds blowing at more than 60 miles an hour can uproot large trees. Fall rains soften the forest floor, so it's difficult for tree roots to find purchase in the muddy soil. Any tree unprepared for the onslaught can't withstand the pressure and falls over. But deciduous trees are well prepared. To be more aerodynamic, they cast off their solar panels. And that's not all. The trunk and branches are shaped so that their combined wind resistance is somewhat less than that of a modern car. Moreover, the whole construction is so flexible that the forces of a strong gust of wind are absorbed and distributed throughout the tree.

These measures all work together to ensure that hardly anything happens to deciduous trees over the winter. If snow falls, it has no place to land but on the branches, which means that most of it falls

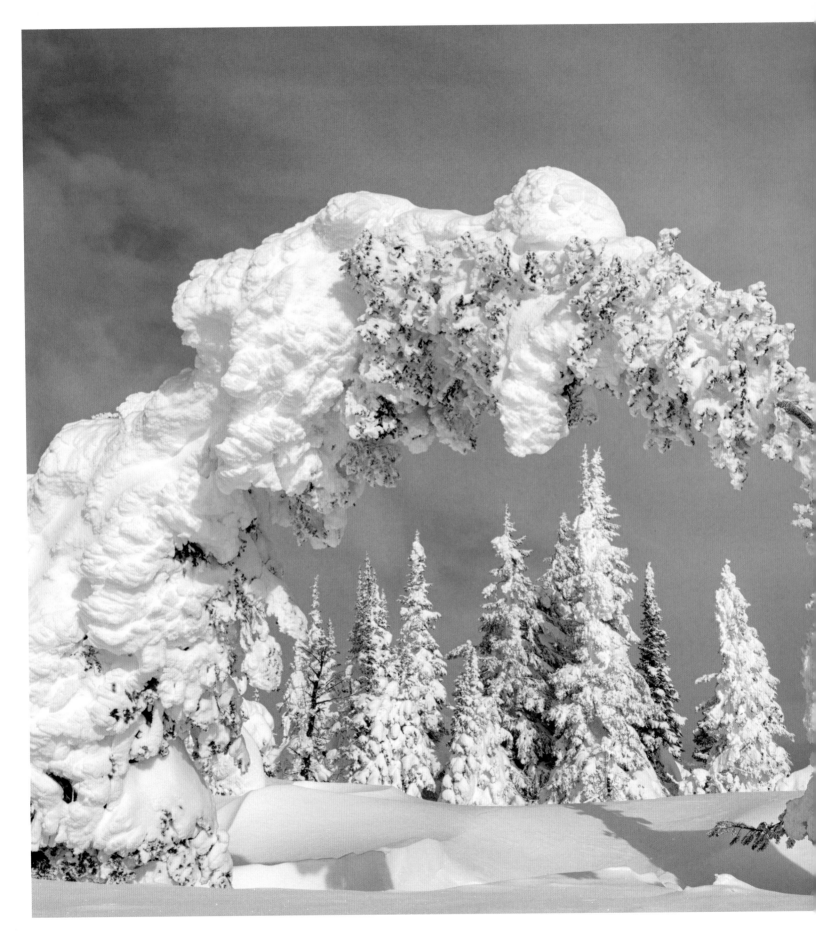

through to the ground. And if there's an unusually strong hurricane-force wind, the tree community stands together to help each individual tree. Every trunk is different. Each has its own pattern of woody fibers, a testament to its unique history. This means that, after the first gust—which bends all the trees in the same direction at the same time—each tree springs back at a different speed. And usually it is the subsequent gusts that do a tree in, because they catch the tree while it's still severely bowed and bend it over again, even farther this time. But in an intact forest, every tree gets help. As the crowns swing back up, they hit each other, because each of them is straightening up at its own pace. While some are still moving backwards, others are already swinging forward again. The result is a gentle impact, which slows both trees down. By the time the next gust of wind comes along, the trees have almost stopped moving altogether and the struggle begins all over again.

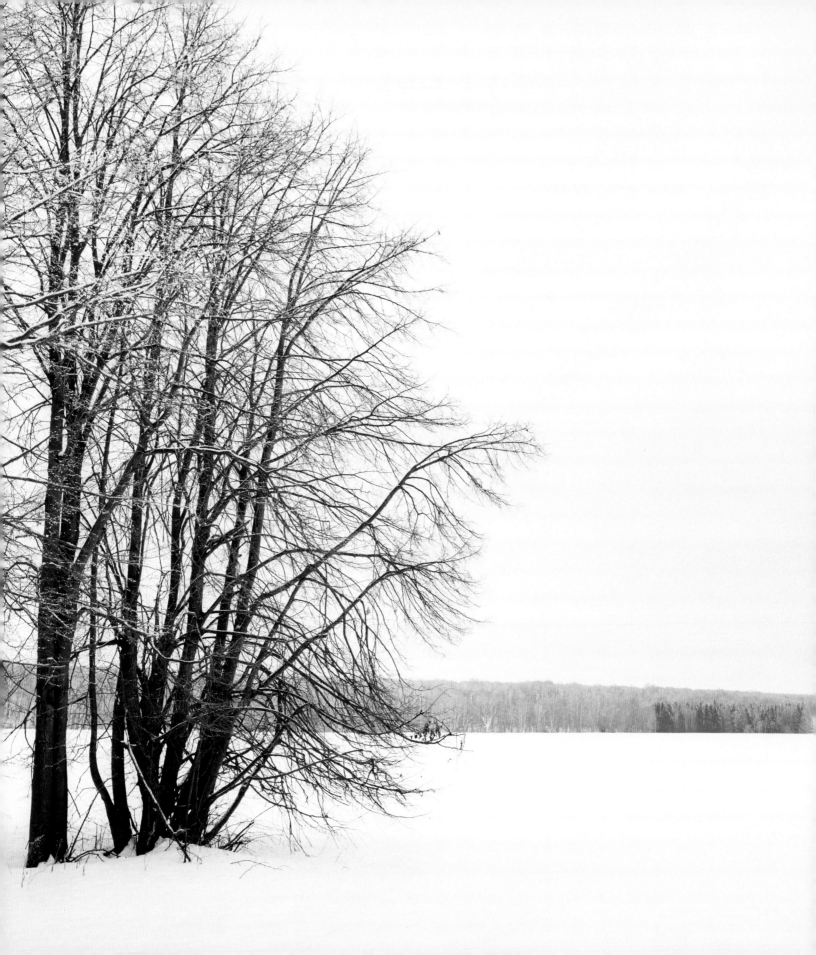

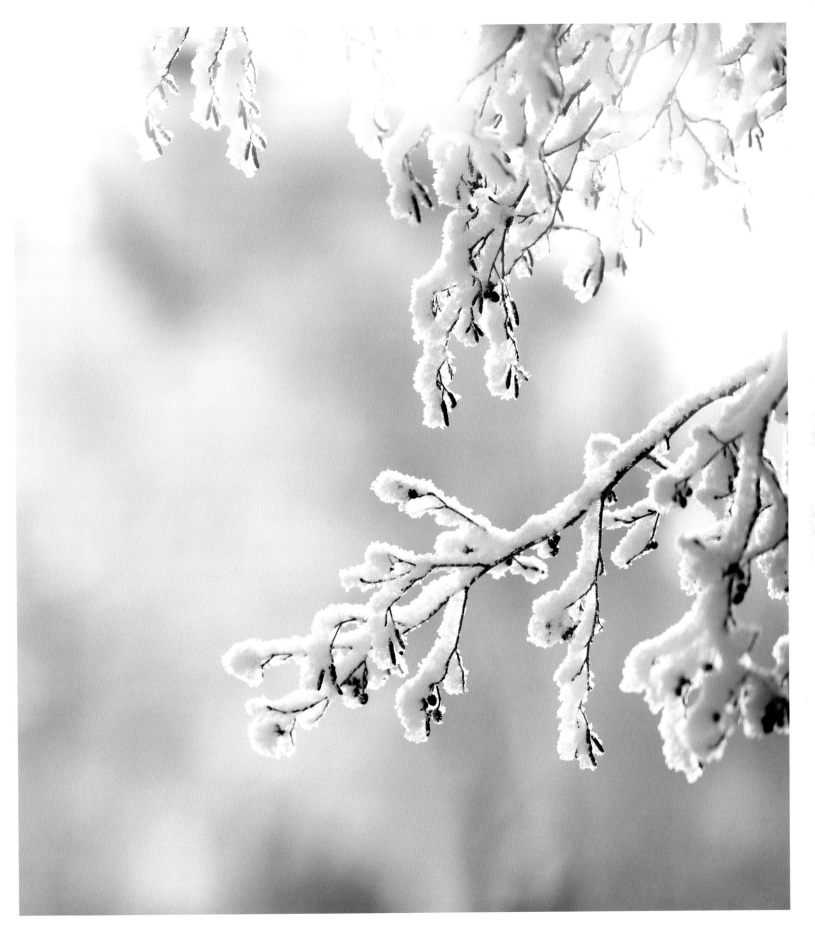

Beautiful but potentially deadly, a crystal casing of ice after freezing rain may be too much for a branch to bear.

When tree crowns sway in a storm, you can see both the movement of the whole community and the movements of individual trees.

An intact forest also helps in the rare event when below-freezing temperatures and foggy conditions combine to produce hoarfrost. Fine drops of moisture immediately freeze wherever they touch a branch or a needle, making them look as though they've been sprinkled with sugar. If the weather conditions persist for days, hundreds of pounds of frost crystals can accumulate in the treetops. When the sun finally breaks through a hole in the fog, all the trees sparkle as though they were in a fairy tale. But unfortunately for them, they are in the real world, and they are groaning under the weight of the ice and beginning to bend dangerously. Woe to the tree that has a weak spot in its wood. Then a dry crack echoes through the forest like a gunshot, and the whole crown comes tumbling down. The less integrated the tree is in a community of its own species, the greater the danger. Loners standing unprotected out in the cold fog succumb markedly more often than well-connected individuals in a dense forest who can lean on their neighbors for support. Moreover, the moist air tends to drift up and over dense forest canopies, so mostly it is just the highest branch tips that get heavily blanketed with frost.

Dropping leaves has another advantage for trees: it is an opportunity for them to finally excrete waste. Just as we take a trip to a quiet little room before we go to bed, trees also rid themselves of substances they do not need and would like to part with. These drift down to the ground in their discarded leaves. Shedding leaves is an active process, so the tree can't go to sleep yet. After the reserve supplies have been reabsorbed from the leaves back into the trunk, the tree grows a layer of cells that closes off the connection between the leaves and the branches. Now all it takes is a light breeze, and

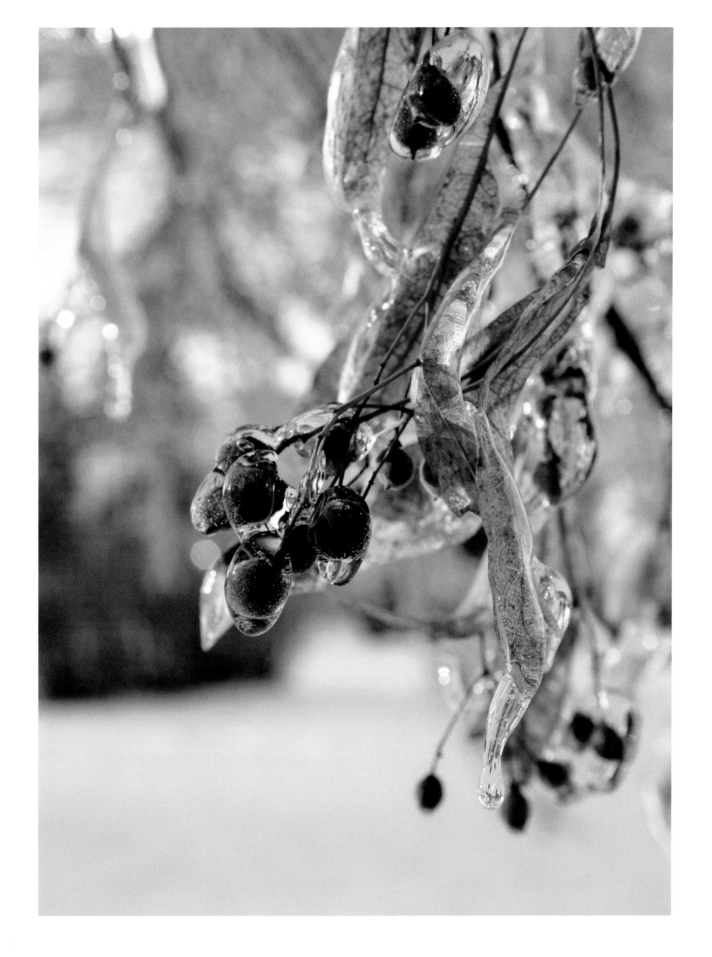

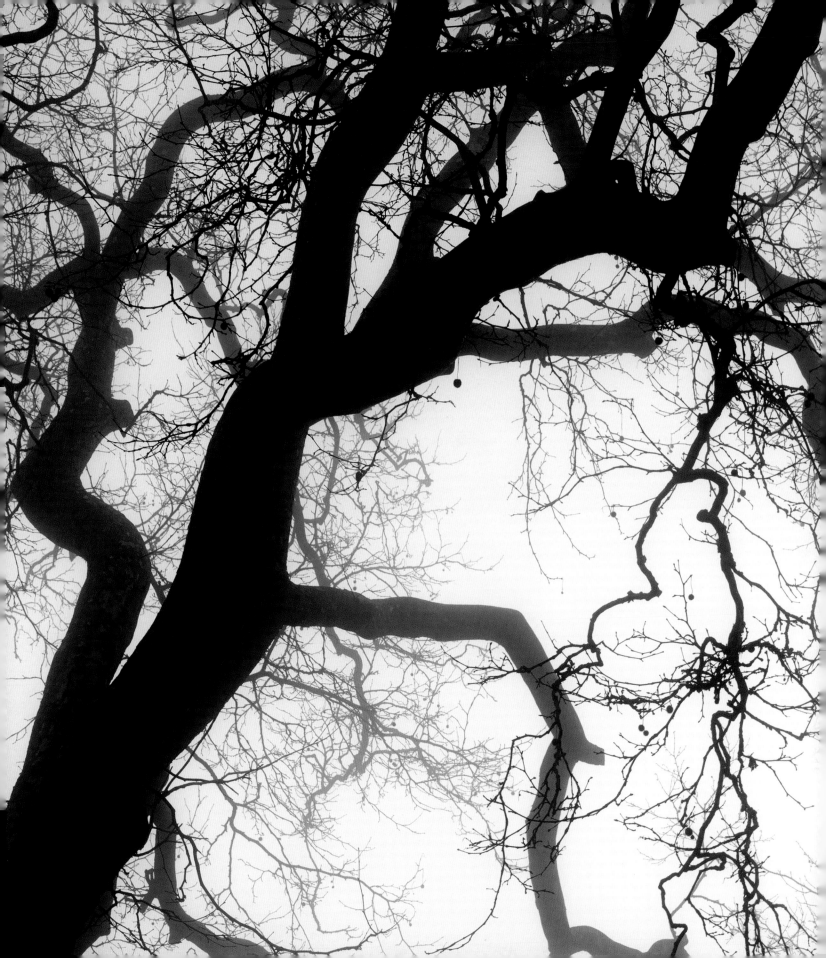

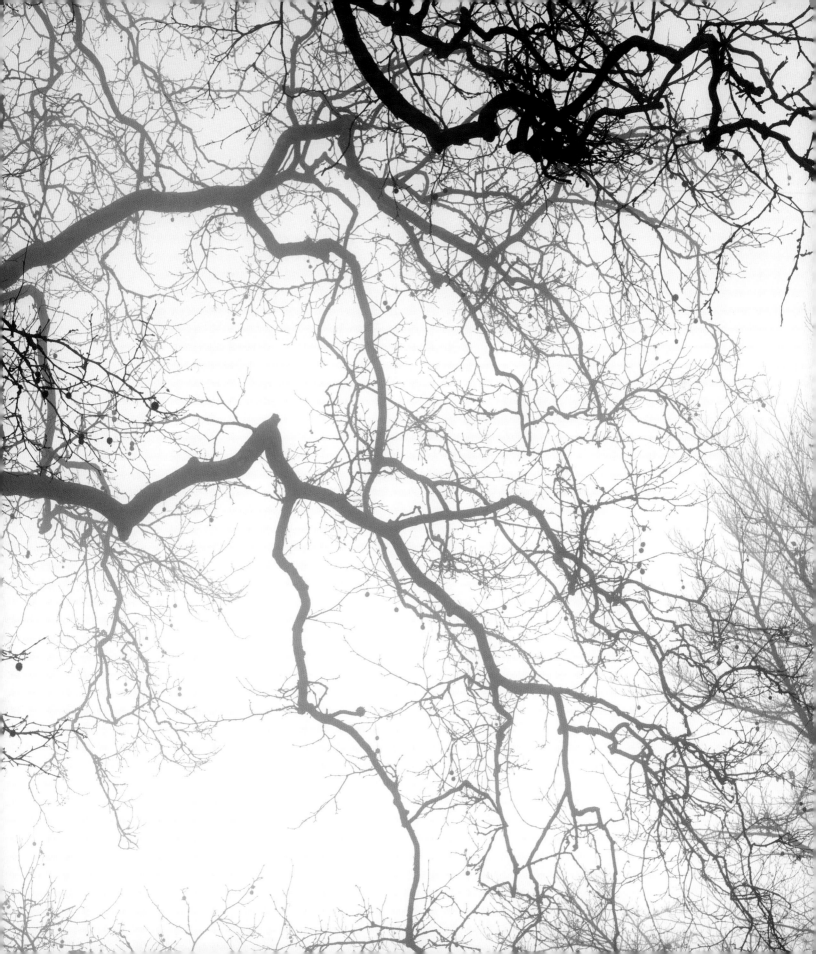

Sycamore tree against a foggy sky

the leaves drift down to the ground. Only when that process is complete can trees retire to rest.

Finally, we return to the conifers. Holding on to needles certainly brings advantages in the spring, because the trees can get going immediately without having to wait for new growth. However, many new shoots dry out when the crowns warm up in the spring sun and begin to photosynthesize while the ground is still frozen. By the time the trees are aware of the danger, it's too late. They cannot shut down transpiration and their needles go limp, especially those from last year, which don't yet have a thick coat of wax.

Apart from that, spruce, pines, firs, and Douglas firs change out their needles because they too must rid themselves of waste materials. They shed the oldest needles, which are damaged and don't work very well anymore. As long as the trees are healthy, firs always keep ten, spruce six, and pines three years' worth of needles, as you can tell by taking a look at the annual growth intervals on their branches. Pines especially, which shed about a quarter of their green needles, can look somewhat sparse in winter. In spring, a new year's worth of needles is added along with fresh growth, and the crowns look the picture of health once again.

TELLING TIME

IN MANY LATITUDES, forests drop leaves in the fall and leaf out in the spring, and we take this cycle for granted. But if we take a closer look, the whole thing is a big mystery, because it means that trees need something very important: a sense of time. How do they know that winter is coming or that rising temperatures aren't just a brief interlude but an announcement that spring has arrived? We've begun to solve the puzzle with fruit trees, at least. It seems the trees can count! They wait until a certain number of warm days have passed, and only then do they trust that all is well and classify the warm phase as spring. But warm days alone do not mean spring has arrived.

Shedding leaves and growing new ones depends not only on temperature but also on how long the days are. Beeches, for example, don't start growing until it is light for at least thirteen hours a day. That in itself is astounding, because to do this, trees must have some kind of ability to see. It makes sense to look for this ability in the leaves. After all, they come with a kind of solar cell, which makes them well equipped to receive light waves. And this is just what they do in the

summer months, but in April the leaves are not yet out. We don't understand the process completely, but it is probably the buds that are equipped with this ability. The folded leaves are resting peacefully in the buds, which are covered with brown scales to prevent them from drying out. Take a closer look at these scales when the leaves start to grow, and hold them up to the light. Then you'll see it. They're transparent!

And how do trees register that the warmer days are because of spring and not late summer? The appropriate reaction is triggered by a combination of day length and temperature. Rising temperatures mean it's spring. Falling temperatures mean it's fall. Trees are aware of that as well. And that's why species such as oaks or beeches, which are native to the Northern Hemisphere, adapt to reversed cycles in the Southern Hemisphere if they are exported to New Zealand and planted there. And what this proves as well, by the way, is that trees must have a memory. How else could they inwardly compare day lengths or count warm days?

Trees need a sense of time for more than just their foliage. This sense is equally important for procreation. If their seeds fall to the ground in fall, they mustn't sprout right away. If they do, two problems present themselves. First, the delicate shoots won't have time to get woody, which means they will freeze. Second, when the weather is cold, there is very little for deer to eat, and they would be only too happy to pounce on the fresh, green growth. So it's better to sprout in the spring along with all the other plants. Therefore, seeds register cold, and only when extended warm periods follow hard frost do the baby trees dare to come out of their protective coverings. Many seeds don't possess a sophisticated counting mechanism like the one used to trigger leaf growth, and that's why it works so well when squirrels and jays bury beechnuts and acorns an inch or so deep in the soil. Down there it doesn't warm up until true spring arrives. Light seeds, such as the seeds of birches, have to pay more attention. With their little wings, they always land on the surface of the soil and just lie there. Depending on where they come to rest, they might end up in bright sunlight, and therefore, these little ones must be able to wait and register the appropriate day length just as their parents do.

On the country road between my home village of Hümmel and the next small town in the Ahr valley stand three oaks. They are a commanding

PREVIOUS SPREAD
Spruce seedling and red chokecherry leaves

presence out in the open fields, and the area is
named in their honor. They are growing unusually
close together: mere inches separate the one-
hundred-year-old trunks. That makes them ideal
subjects for me to study, because the environmen-
tal conditions for all three are identical. Soil, water,
local microclimate—there can't be three different
sets of each within a few yards. This means that
if the oaks behave differently, it must be because
of their own innate characteristics. And they do,
indeed, behave differently!

In winter, when the trees are bare, or in sum-
mer, when they are in full leaf, the driver of a car
speeding by wouldn't even notice three separate
trees. Their interconnecting crowns form a sin-
gle large dome. The closely spaced trunks could
all be growing from the same root, as happens
sometimes if downed trees start to regrow. How-
ever, the triad of fall color points to a very different
story. Whereas the oak on the right is already
turning color, the middle one and the one on
the left are still completely green. It takes a cou-
ple of weeks for the two laggards to follow their
colleague into hibernation. But if their growing
conditions are identical, what accounts for the dif-
ferences in their behavior?

The timing of leaf drop, it seems, really is a question of character.

A deciduous tree has to shed its leaves. But
when is the optimal moment? Trees cannot antici-
pate the coming winter. They don't know whether
it is going to be harsh or mild. All they register
are shortening days and falling temperatures. If
temperatures are falling, that is. There are often
unseasonably warm days in the fall, and now the
three oaks find themselves in a dilemma. Should
they use these mild days to photosynthesize a
while longer and quickly stash away a few extra
calories of sugar? Or should they play it safe and
drop their leaves in case a sudden frost forces them
into hibernation? Clearly, each of the three trees
decides differently.

The tree on the right is a bit more anxious than
the others, or to put it more positively, more sen-
sible. What good are extra provisions if you can't

FOLLOWING SPREAD
There's speculation that the "knees" of bald cypress protruding above the water transport oxygen to the roots, like breathing tubes connecting divers to the surface.

shed your leaves and have to spend the whole winter in mortal danger? So, get rid of the lot in a timely manner and move on to dreamland! The two other oaks are somewhat bolder. Who knows what next spring will bring, or how much energy a sudden insect attack might consume and what reserves will be left over afterward? Therefore, they simply stay green longer and fill the storage tanks under their bark and in their roots to the brim. Until now, this behavior has always paid off for them, but who knows how long it will continue to do so? Thanks to climate change, fall temperatures are remaining high for longer and longer, and the gamble of holding on to leaves is being drawn out until November. All the while, fall storms are beginning as punctually as ever in October, and so the risk of getting blown over while still in full leaf rises. In my estimation, more cautious trees will have a better chance of surviving in the future.

ADAPTING TO CHANGE

SO WHY DO trees live so long? After all, they could grow just like wild flowers: grow like gangbusters for the summer, bloom, set seed, and then be recycled into humus. That would have one definite advantage. Every new generation brings with it the opportunity for genetic modifications. These mutations are most likely to occur during mating and fertilization, and in a world that is constantly changing, adaptation is necessary for survival. For example, mice produce a new generation every few weeks; flies are a lot quicker. Every time hereditary traits are passed down, genes can be damaged, and with a stroke of luck, this damage will introduce a particularly beneficial new characteristic. In short, this is what we call evolution. It helps organisms adapt to changing environmental conditions and, therefore, promotes the survival of each species. The shorter the interval before the next generation, the more quickly animals and plants can adapt.

Trees seem completely uninterested in this scientifically established imperative. They simply live to be ancient—on average many hundreds, but sometimes even thousands, of years old. Of course, they propagate at least every five years, but this doesn't usually produce a completely new generation of trees. Even if the young trees exhibit brilliant new traits, they must often wait centuries before they can bloom and pass these genes along. You might expect this to put the trees in an almost impossible situation.

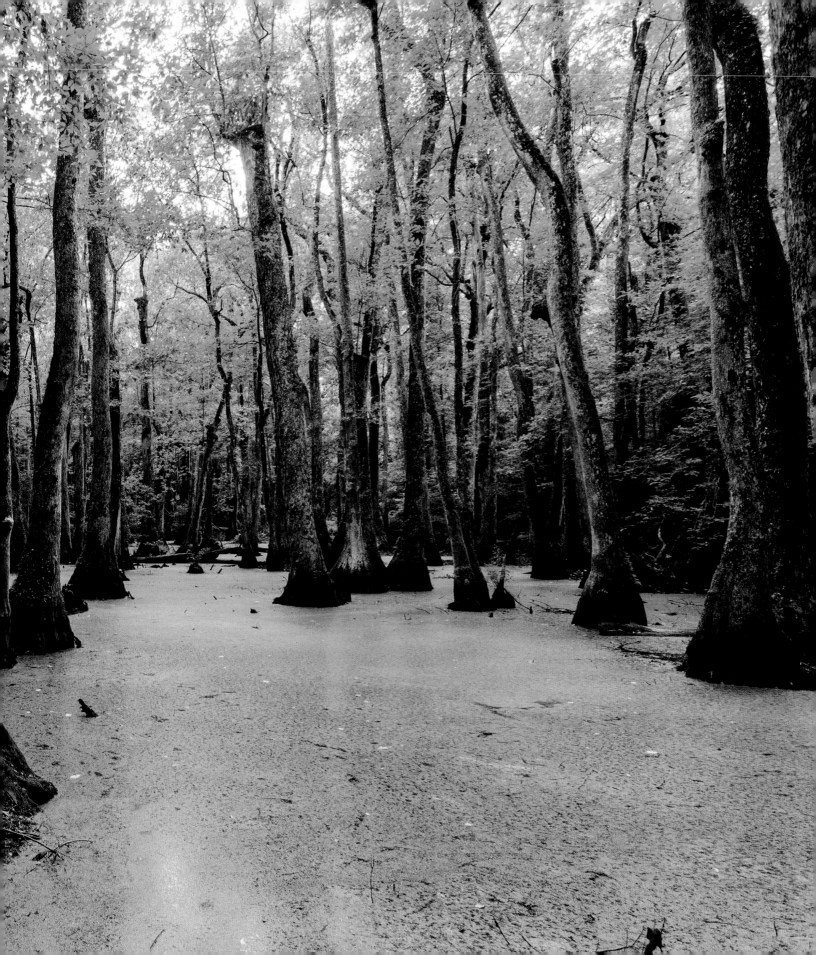

Lodgepole pines are adapted to a wide range of habitats.

Trees exhibit great tolerance for variations in climate. But this is not enough to satisfy everything they need to do. When temperatures and rainfall fluctuate, many animals and fungi move from south to north and vice versa. That means that trees must also be able to adapt to unfamiliar pests. The climate can also change so severely that it falls outside the range the trees can tolerate. And because they have no legs to carry them away and nowhere to turn for help, they have to adapt so that they can deal with the situation themselves. The first opportunity to do this comes at the very earliest stage of life. Shortly after fertilization, when the seeds are ripening in the flower, they react to environmental conditions. If it is particularly warm and dry, appropriate genes are activated. Scientists have proved that under these conditions, spruce seedlings are better able to tolerate warm weather—though they lose the same measure in frost resistance.

Mature trees can adapt as well. If spruce survive a dry period with little water, in the future they are markedly more economical with moisture and they don't suck it all up out of the ground right at the beginning of summer. The leaves and needles are the organs where most water is lost through

Not all blue spruce are the same shade of blue, but trees that grow together tend to look alike, which suggests that their needle color may be determined by their genes.

transpiration. If the tree notices that water is in short supply and thirst is becoming a long-term problem, it puts on a thicker coat. The tree toughens up the protective waxy layer on the upper surface of its leaves. The walls of the cells within the leaves keep them watertight, and the tree increases the thickness of the cell walls by adding extra layers.

Once a tree has exhausted its behavioral repertoire, genetics come into play. Speedy adaptation is not an option, but other responses are available. In a forest that has been left to its own devices, the genetic makeup of each individual tree belonging to the same species is very different. This is in contrast to people, who are genetically very similar. In evolutionary terms, you could say we are all related. In contrast, the individual beeches growing in a stand near where I live are as far apart genetically as different species of animals. This means each tree has different characteristics. Some deal better with drought than cold. Others have powerful defenses against insects. And yet others are perhaps particularly impervious to wet feet. If climatic conditions change, the first individuals to die will be those that have the hardest time dealing with the new status quo. A few old trees will die, but most of the rest of the forest will remain standing. If conditions become more extreme, one tree species could even be decimated without this being the end of the forest. Usually, a sufficiently large number of trees remain to produce enough fruit and shade for the next generation.

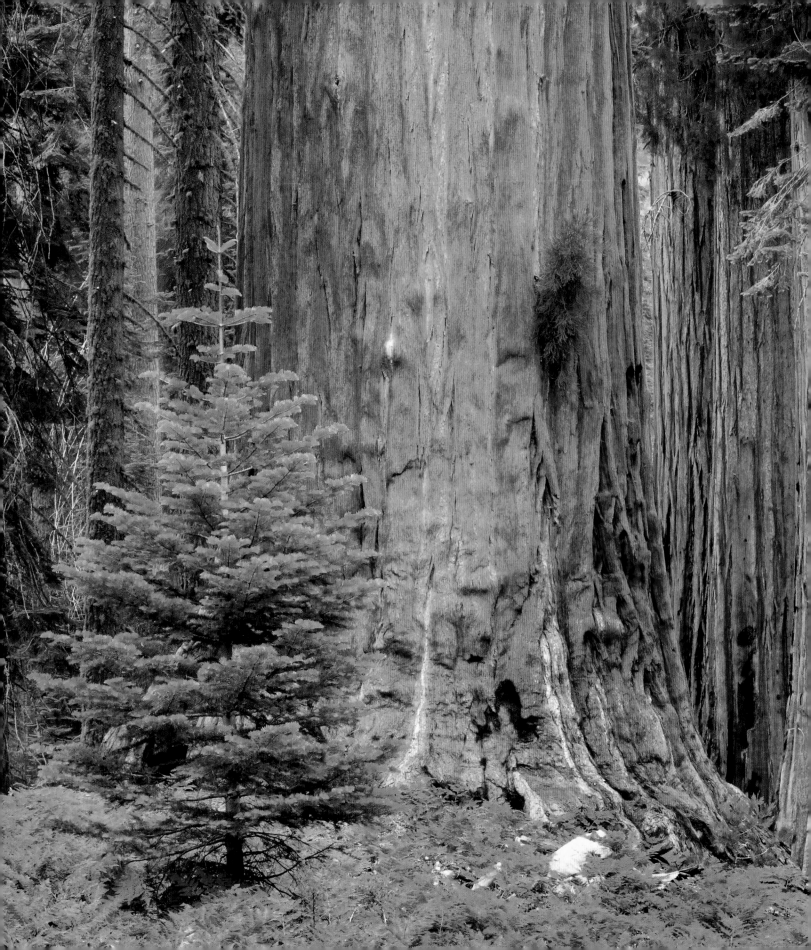

Out on a Limb

EXOTIC TROPHIES

HAVE YOU EVER wondered why giant redwoods in Europe never grow particularly tall? Even though quite a lot of them are more than 150 years old, very few have yet topped 160 feet. In their homeland—forests on the western slopes of the Sierra Nevada in California—they easily grow more than twice that size. Why don't they do that in Europe? If we think back to tree kindergarten, to their extremely long and drawn-out youth, we might be tempted to say: They're still children. What do you expect? But that doesn't jibe with the enormous diameters of the older giant redwoods in Europe, which often exceed 8 feet (measured at chest height). Clearly, they know how to grow. They just seem to be putting their energy into growing in the wrong direction.

Their location gives a clue as to why this might be the case. They were often planted in city parks by princes and politicians as exotic trophies. What is missing here, above all, is the forest, or—more

specifically—relatives. At 150 years old, they are, when you consider a potential life-span of many thousands of years, indeed only children, growing up here in Europe far from their home and without their parents. No uncles, no aunts, no cheerful nursery school—no, they have lived all their lives out on a lonely limb. And what about the many other trees in the park? Don't they form something like a forest, and couldn't they act like surrogate parents? They usually would have been planted at the same time and so could offer the little redwoods no assistance or protection. In addition, they are very, very different kinds of trees. To let lindens, oaks, or beeches bring up a redwood would be like leaving human children in the care of mice, kangaroos, or humpback whales. It just doesn't work, and the little Americans have had to fend for themselves. No mother to nurse them or keep a strict eye out to make sure the little ones didn't grow too quickly. No cozy, calm, moist forest around them. Nothing but solitude.

And if that weren't enough, in most cases, the soil is a complete disaster. Whereas the old-growth forest offers soft, crumbly, humus-rich, constantly moist soil for their delicate roots, European parks offer hard surfaces that have been depleted of nutrients and compacted after years of urbanization. What's more, members of the public like to walk up to the trees, touch their bark, and relax in the shadow of their crowns. Over the decades, constant trampling around the base of the trees leads to further soil compaction, which means that rain drains away far too quickly, and in winter, the trees cannot build up a supply of water to last the summer.

The mechanics of planting haunt the trees for the rest of their lives.

The trees are kept alive and handled in nurseries for years before being moved to their final location. Every fall, their roots are trimmed to keep them compact in the nursery beds so that they can later be moved more easily. The root ball is cut back, and to make sure the crown doesn't

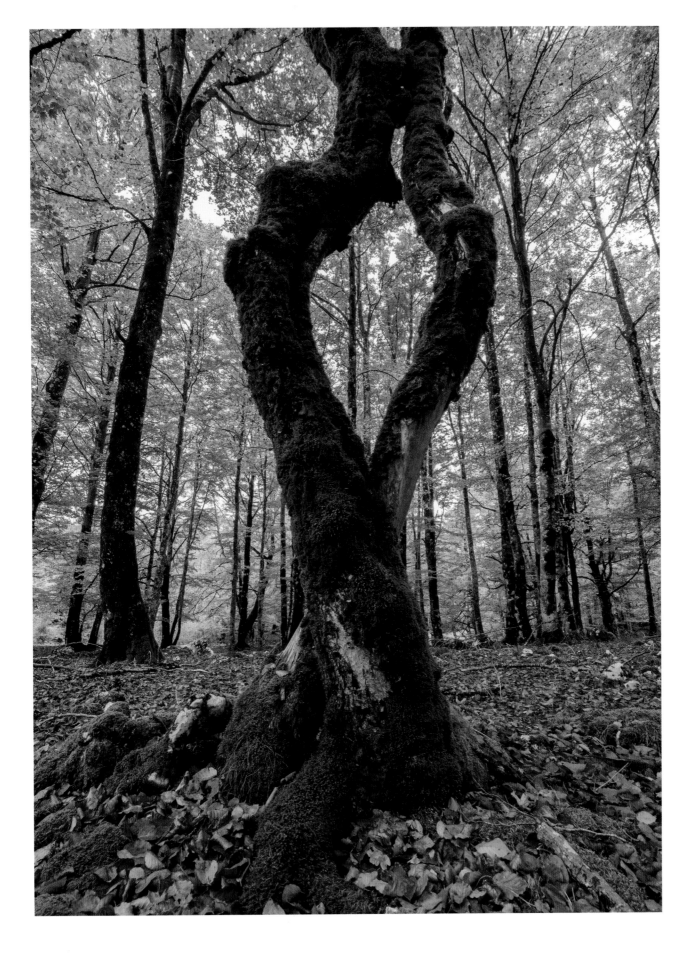

PREVIOUS SPREAD
Maple trees and tulip trees

FACING
Street trees regimented in rows tough it out
in the city.

wilt from thirst thanks to the root reduction, it too is heavily reduced. All this is done not to improve the health of the tree but simply to make it easier to handle. Unfortunately, when the roots are pruned, the brain-like structures are cut off along with the sensitive tips. Ouch! After that, it is as if this interference makes the trees lose their sense of direction underground. They stop growing roots down into the soil and form a flat plate of roots near the surface instead, severely restricting the trees' ability to find water and food.

The young trees don't seem to mind. They stuff themselves with sugary treats because they can photosynthesize as much as they like in full sun. It's so easy to get over the loss of a mother's tender care. And in the early years, the water problems in a rock-hard soil are barely noticeable. After all, the saplings are being lovingly cared for and watered by gardeners when they get dry. But above all, there is no strict discipline. No "Take it easy," no "Just wait a couple of hundred years." Every young tree can do just as it likes. So, every year, they go at it as though they were in a race, and every year, they put on a growth spurt. After a certain height, the childhood bonus seems to run out. Irrigating 65-foot-tall trees takes an enormous amount of water and time. To thoroughly moisten the roots, the gardeners must spray many gallons of water out of their hoses—per tree! And so, one day, the care simply stops.

At first, the giant redwoods don't really notice. They've lived high on the hog for decades and done whatever they wanted. Their thick trunks are like paunches attesting to an orgy of solar indulgence. In the early years, it doesn't really matter much that the cells inside their trunks are very large, contain a lot of air, and are therefore susceptible to fungal infections. Their side branches also show signs of their loutish behavior. The trees in the park know nothing about the etiquette manual that guides the old-growth forest, calling for thin branches in the lower regions of the trunk, or even for no branches at all. Thanks to the generous amounts of light that reach right to the ground, the redwoods grow thick side branches that later increase their girth so much that the image the trees bring to mind is that of doped-up body builders. True, all the branches on the lower 6 to 10 feet of the trees are usually sawn off by the gardeners to give visitors an unobstructed view of the park, but when compared with old-growth forests, where thicker branches are not allowed below 65

Angel Oak, South Carolina. Left to their own
devices and given appropriate support,
some lucky park trees can dream of reaching
a venerable old age.

and sometimes not even below 165 feet, the trees'
growth is brazenly decadent.

What the trees end up with are short, thick
trunks topped with crowns. Extreme examples
of park trees seem to be nothing but crown. Their
roots don't penetrate more than 20 inches down
into the heavily trampled soil, and therefore, they
offer little in the way of support. That's very risky,
and trees of a normal height would be much too
wobbly. The growth habit of redwoods in the far-
off old-growth forests ensures a low center of
gravity, so they are pretty stable. It takes a huge
storm to upset their equilibrium. Once European
redwoods have passed the hundred-year mark (the
trees are now the age of schoolchildren), that's the
end of easy living. The topmost branches wither
away, and no matter how hard the trees try to
grow up again, they have reached the end of the
road.

STREET KIDS

URBAN TREES ARE the street kids of the forest,
and some are growing in locations that make the
name an even better fit—right on the street. The
first few decades of their lives are similar to those
of their colleagues in the park. They are pampered
and primped. Sometimes they even have their own
personal irrigation lines and customized watering
schedules. When their roots want to go out and
get established in their new territory, they're in for
a big surprise. The soil under the street or pedes-
trian walkway is harder even than the soil in parks,
because it has been compacted by machines using
large vibrating metal plates. That's a huge disap-
pointment for the tree. The roots of forest trees
don't actually grow very deep. Few species grow
deeper than 5 feet, and most call a halt to down-
ward growth much sooner. That's not a problem
in the forest, where there is almost no limit to
how wide the roots can grow. Unfortunately, this
isn't the case on the side of the street. The roadway
restricts growth in one direction, there are pipes
under the pedestrian zones, and soil has been
compacted during construction.

When trees are planted in these restricted
spaces, conflicts are inevitable. In such places,
plane trees, maples, and lindens like to feel out
underground wastewater pipes. We notice the
damage when the next storm comes and the
streets fill with water. Then specialists armed
with root probes investigate to see which tree has

caused the blockage. The culprit is sentenced to death for its excursion under the sidewalk and into what it thought was paradise. The offending tree is cut down, and its successor is planted in a built-in root cage to discourage such behavior in the future.

Why do trees grow into pipes in the first place? For a long time, city engineers thought the roots were somehow attracted by moisture seeping from loose connections between the pipes or by nutrients in the wastewater. However, the results of an extensive applied study by the Ruhr University Bochum point in a completely different direction. The study found the roots in the pipes were growing above the water table and did not seem interested in extra nutrients. What was attracting them was loose soil that had not been fully compacted after construction. Here, the roots found room to breathe and grow. It was only incidentally that they penetrated the seals between individual sections of pipe and eventually ran riot inside them. What this means is that when trees in urban areas run up against ground as hard as concrete wherever they turn, they get desperate, and it is only as an absolutely last resort that they finally find a way out into sloppily backfilled trenches. Once they get there, they are a problem.

There is no remedial support for the trees, only for the pipes, which are now reburied in especially well tamped down soil so that the tree roots can no longer find a footing there. Their puny underground anchoring systems—which in Nature could cover more than 700 square yards and are now restricted to an area shrunk to a tiny percentage of that—are not capable of supporting trunks that weigh many tons.

It is no surprise that summer storms topple a particularly large number of street trees.

But there is even more these tough plants have to bear. The urban microclimate is heavily influenced by heat-inducing asphalt and concrete. Whereas forests cool themselves on hot summer nights, streets and buildings radiate the heat they soaked up during the day, keeping

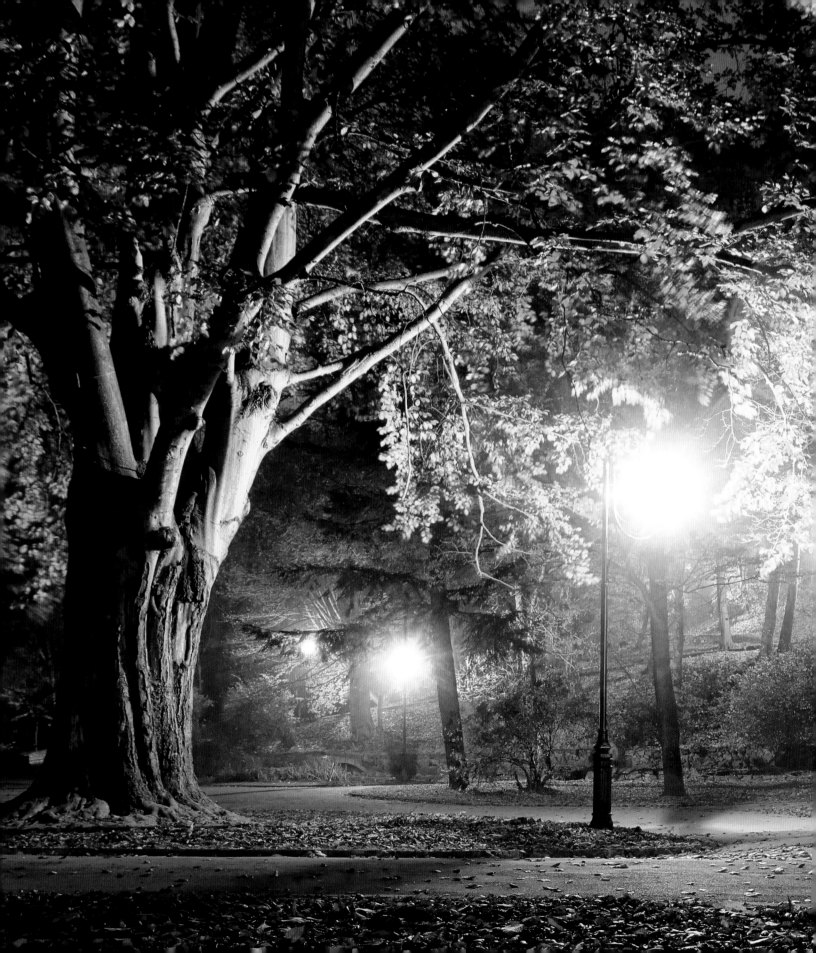

FACING

It seems trees need their rest just as much as we do, and sleep deprivation is as detrimental to trees as it is to us. In 1981, the German journal *Gartenamt* reported that 4 percent of oak deaths in one American city happened because the trees were subjected to light every night.

temperatures elevated. Radiated heat makes the air extremely dry. Not only that, but it's full of exhaust fumes. Many of the companions that look after the well-being of trees in the forest (such as the microorganisms that make humus) are missing. Mycorrhizal fungi that help collect water and food are present only in low numbers. Urban trees, therefore, have to go it alone under the harshest conditions.

As if that were not enough, they also have to deal with unsolicited extra fertilizers. Above all, from dogs, which lift their legs at every available trunk. Their urine can burn bark and kill roots. Winter salt leads to similar damage. Depending on the severity of the cold, salt is sometimes applied around trees. In addition, the needles on conifers, which are still attached to the branches in winter, have to deal with the salt spray thrown up by car tires. At least 10 percent of the salt ends up in the air and falls back down on trees—among other resting places—where it burns the foliage. These painful injuries show up as small yellow and brown spots on the needles. The burns reduce the trees' ability to photosynthesize the next summer and, therefore, weaken the trees. Weakness equals

pests. It's easier for scales and aphids to strike them, because street trees have limited resources they can put toward defending themselves. High urban temperatures are a contributing factor, and hot summers and warm winters in cities favor the insects, which survive in larger numbers.

At the end of the day, the stresses the trees must bear are so great that most of them die prematurely. Even though they can do whatever they want when they're young, this freedom is not enough to compensate for the disadvantages they face later in life. One consolation is that because streets and pathways are often planted with rows of the same species of trees, at least they are able to communicate with other members of their species. Plane trees—recognizable by their attractive bark, which peels off in colorful flakes—are a popular choice for these regimented plantings. Whatever it is these street kids talk to each other about through their scent-mail—and whether the tone of these messages is as rough as their lives—the street gangs are keeping this information strictly to themselves.

6

Forest Benefits

CREATING CLIMATES LARGE AND SMALL

A FOREST IS a gigantic carbon dioxide vacuum that constantly filters out and stores this component of the air. Some of this carbon dioxide returns to the atmosphere after a tree's death, but most of it remains locked in the ecosystem forever. The crumbling trunk is gradually gnawed and munched into smaller and smaller pieces and worked, by fractions of inches, more deeply into the soil. The rain takes care of whatever is left, as it flushes organic remnants down into the soil. The farther underground, the cooler it is. And as the temperature falls, life slows down, until it comes almost to a standstill. And so it is that carbon dioxide finds its final resting place in the form of humus, which continues to become more concentrated as it ages. In the far distant future, it might even become bituminous or anthracite coal.

Today's deposits of these fossil fuels come from trees that died about 300 million years ago. They

looked a bit different—more like 100-foot-tall ferns or horsetail—but with trunk diameters of about 6 feet, they rivaled today's species in size. Most grew in swamps, and when they died of old age, their trunks splashed down into stagnant water, where they hardly rotted at all. Over the course of thousands of years, they turned into thick layers of peat that were then overlaid with rocky debris, and pressure gradually turned the peat to coal. Thus, large conventional power plants of the modern era are burning fossil forests.

What if we allowed trees to follow in the footsteps of their ancestors and store carbon dioxide in the ground once again?

Today, hardly any coal is being formed because forests are constantly being cleared. As a result, warming rays of sunlight reach the ground and help the species living there kick into high gear. This means they consume humus layers even deep down into the soil, releasing the carbon they contain into the atmosphere as gas. Despite this, you can observe at least the initial stages of coal formation every time you walk in the forest. Dig down into the soil a little until you come across a lighter layer. Up to this point, the upper, darker soil is highly enriched with carbon. If the forest were left in peace from now on, this layer would be the precursor of coal, gas, or oil.

What sense does it make for trees to constantly remove their favorite food from the system? And all plants do this, not just trees. Even algae out in the oceans extract carbon dioxide from the atmosphere. When the plants die, the carbon dioxide sinks into the muck, where it is stored in the form of carbon compounds. Thanks to these remains—and the remains of animals, such as the calcium carbonate excreted by coral, which is one of the largest repositories of carbon dioxide on earth—after hundreds of millions of years, an enormously large amount of carbon has been removed from

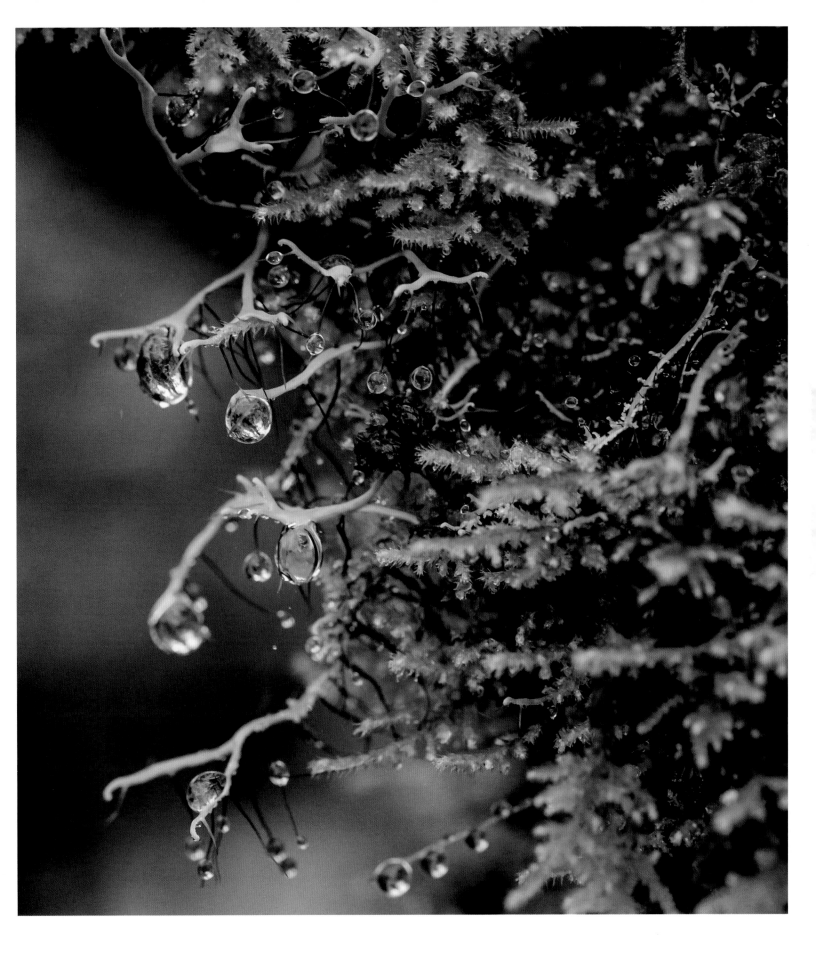

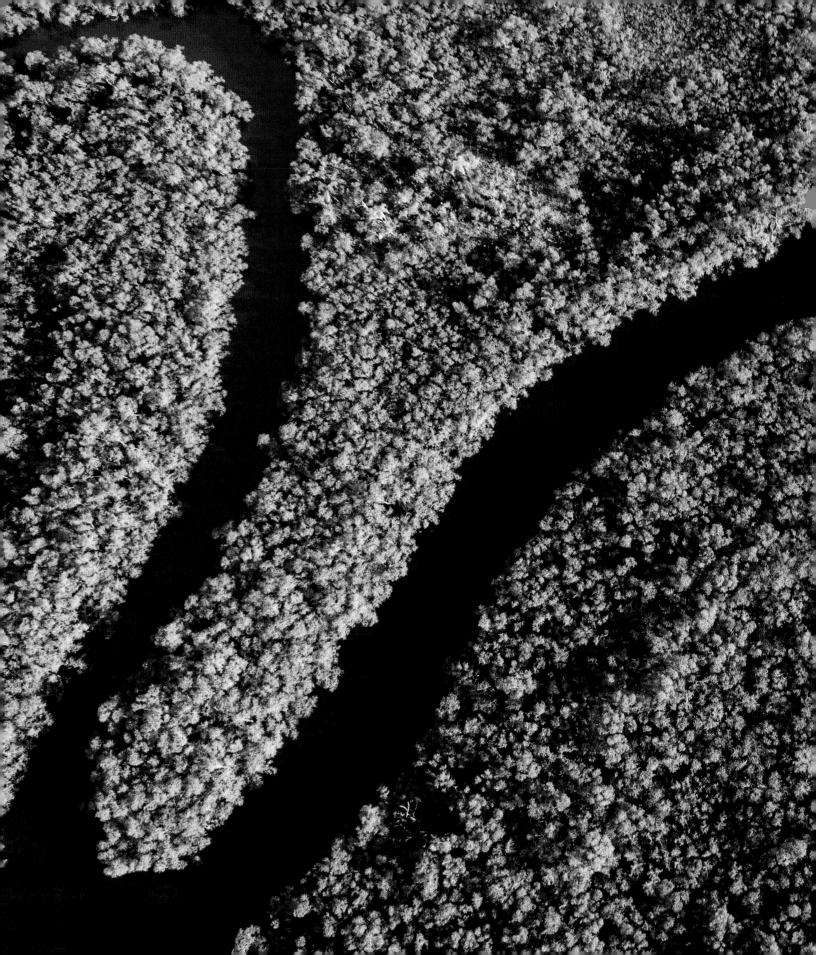

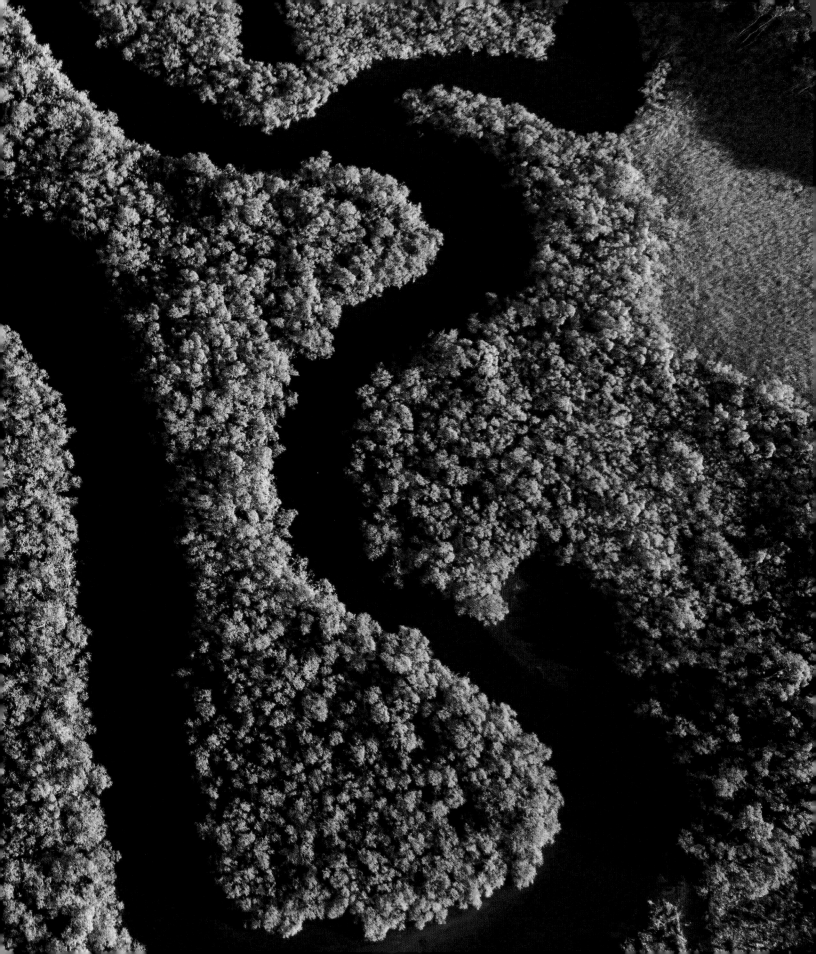

the atmosphere. When the largest coal deposits were formed, in the Carboniferous period, carbon dioxide concentrations were much higher—nine times today's levels—before prehistoric forests, among other factors, reduced carbon dioxide to a level that was still triple the concentration we have today.

Where is the end of the road for our forests? Will they go on storing carbon until someday there isn't any left in the air? In the modern era this is no longer a question in search of an answer, thanks to our consumer society, for we have already reversed the trend as we happily empty out the earth's carbon reservoirs. There has been a measurable fertilizing effect as the levels of carbon dioxide in the atmosphere have risen, and the latest forest inventories document that trees are growing more quickly than they used to. So, from the trees' point of view, could it perhaps be a blessing that we are liberating greenhouse gases from their underground prisons and setting them free once again? Ah, not so fast. If you are a tree, slow growth is the key to growing old. And so the tried-and-tested rule holds true: less (carbon dioxide) is more (life-span).

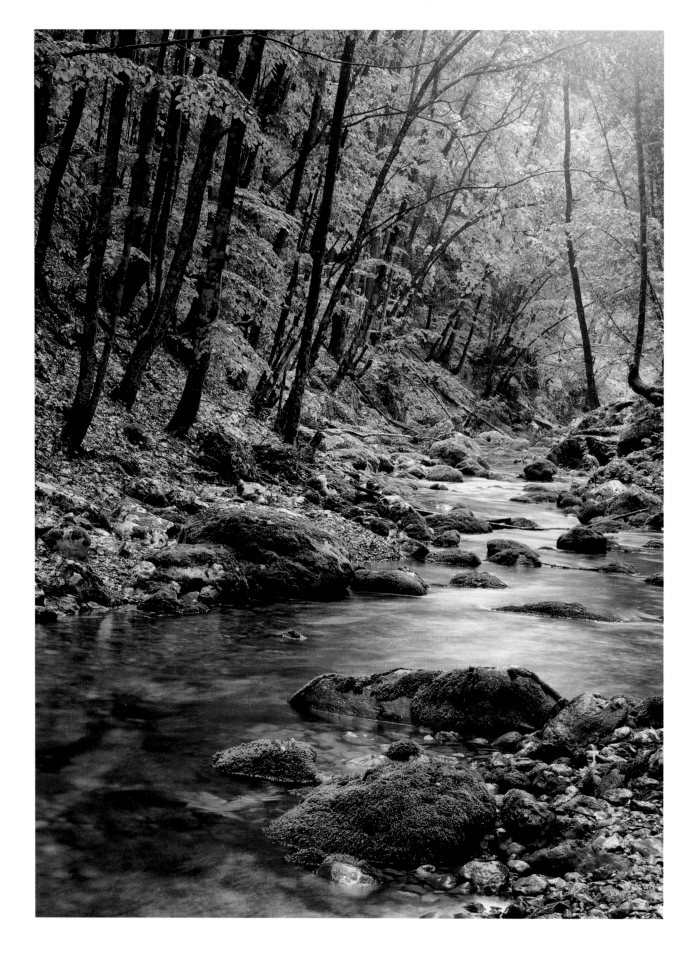

The older the tree, the more quickly it grows. If we want to use forests to combat climate change, we must allow them to grow old.

Trees influence global climate, but have you ever wondered how they exert their influence on their immediate environment? My eureka moment on this subject came in a little forest growing on dry, sandy, nutrient-deficient soil near Bamberg, Germany. Forest specialists once claimed that only pines could flourish here. To avoid creating a bleak monoculture, beeches were also planted so that their leaves could neutralize the acid in the pine needles to make them more palatable to the creatures in the soil. There was no thought of using the deciduous trees for lumber; they were considered to be so-called service trees. But the beeches had

no intention of playing a subservient role. After a few decades, they showed what they were made of.

With their annual leaf drop, the beeches created an alkaline humus that could store a lot of water. In addition, the air in this little forest gradually became moister, because the leaves of the growing beeches calmed the air by reducing the speed of the wind blowing through the trunks of the pines. Calmer air meant less water evaporated. More water allowed the beeches to prosper, and one day they grew up and over the tops of the pines. In the meantime, the forest floor and the microclimate had both changed so much that the conditions became more suited to deciduous trees than to the more frugal conifers. As foresters like to say, the forest creates its own ideal habitat.

The way mature forests manage water and cool themselves down is fascinating. On an extremely hot August day that chased the thermometer up to 98 degrees Fahrenheit, students from RWTH Aachen discovered that the floor of the deciduous forest I manage, which is being allowed to age naturally, was up to 50 degrees cooler than that of a regularly thinned coniferous plantation only a couple of miles away. This cooling effect, which meant less water lost, was very clearly because of

the biomass, which also contributed shade. The more living and dead wood there is in the forest, the thicker the layer of humus on the ground and the more water is stored in the total forest mass. Evaporation leads to cooling, which, in turn, leads to less evaporation. To put it another way, in summer an intact forest sweats for the same reason people do and with the same result.

Whoever sweats a lot must also drink a lot. And during a downpour, you have the opportunity to observe a tree taking a long swig. Because downpours usually happen at the same time as storms, I can't recommend taking a walk out into the forest. However, if you, like me (often because of work), are outside anyway, then you can observe a fascinating spectacle. Mostly, it is beeches that indulge in such all-out drinking binges. Like many deciduous trees, they angle their branches up. Or, you could say, down. For the crown opens its leaves not only to catch sunlight but also to catch water. Rain falls on hundreds of thousands of leaves, and the moisture drips from them down onto the twigs. From there, it runs along the branches, where the tiny streams of water unite into a river that rushes down the trunk. By the time it reaches the lower part of the trunk, the water is shooting down so fast that when it hits the ground, it foams up. During a severe storm, a mature tree can down an additional couple of hundred gallons of water that, thanks to its construction, it funnels to its roots. There, the water is stored in the surrounding soil, where it can help the tree over the next few dry spells.

Spruce and firs can't do this. Their crowns act like umbrellas, which is really convenient for hikers. If you're caught in a shower and stick close to the trunks, you'll hardly get wet at all, and neither will the trees' roots. Spruce branches intercept one third of the rain that falls and return it to the atmosphere. Deciduous forests intercept only 15 percent of the rain that falls, which means they are profiting from 15 percent more water than their needle-bedecked colleagues. Spruce do this because they are comfortable in cold regions where, thanks to the low temperatures, the groundwater hardly ever evaporates. When they are planted in places where it is warmer and drier, they are almost always suffering from thirst.

How does water get to the forest, anyway, or—to take a step further back—how does water reach land at all? It seems like a simple question, but the answer turns out to be rather complicated. For one

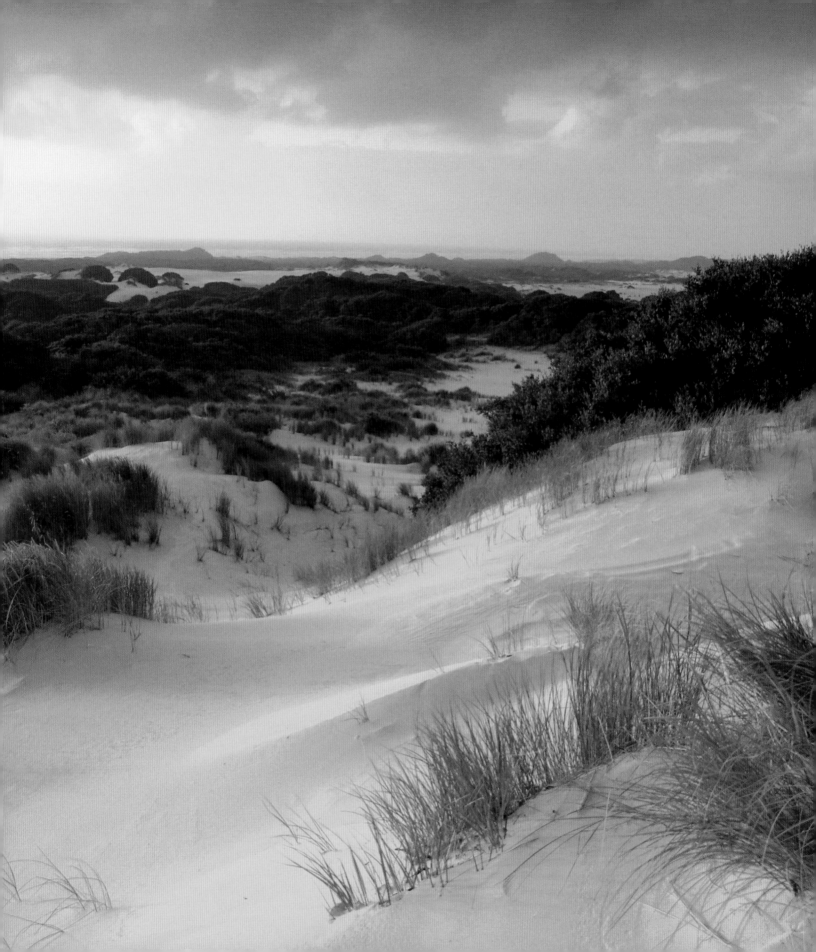

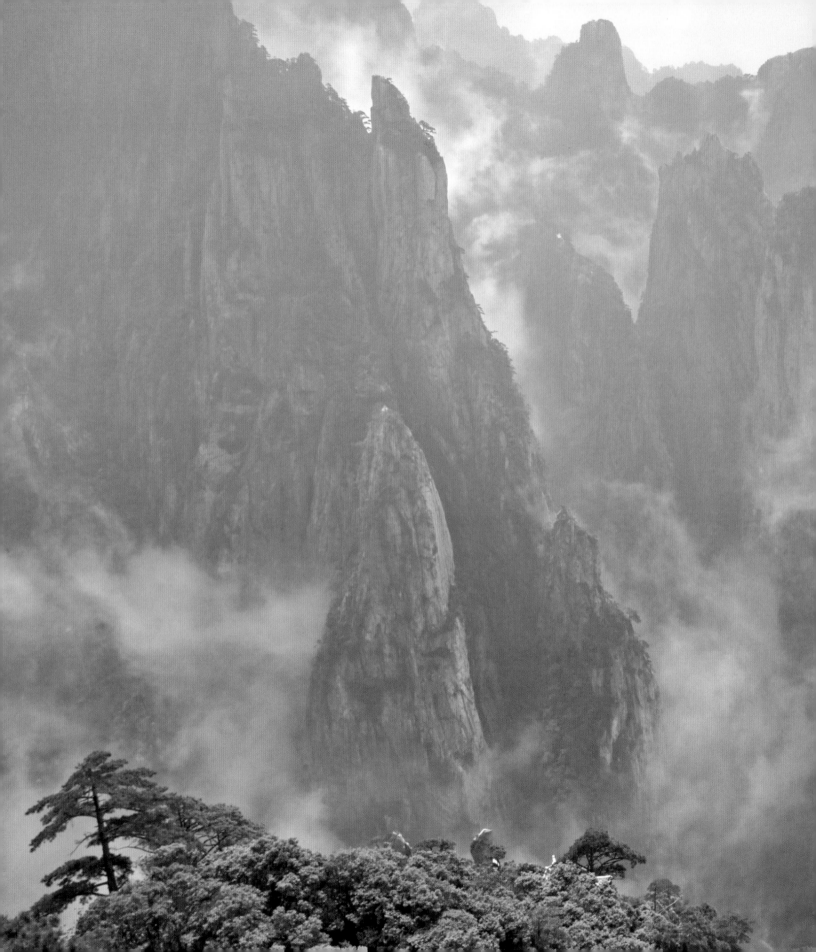

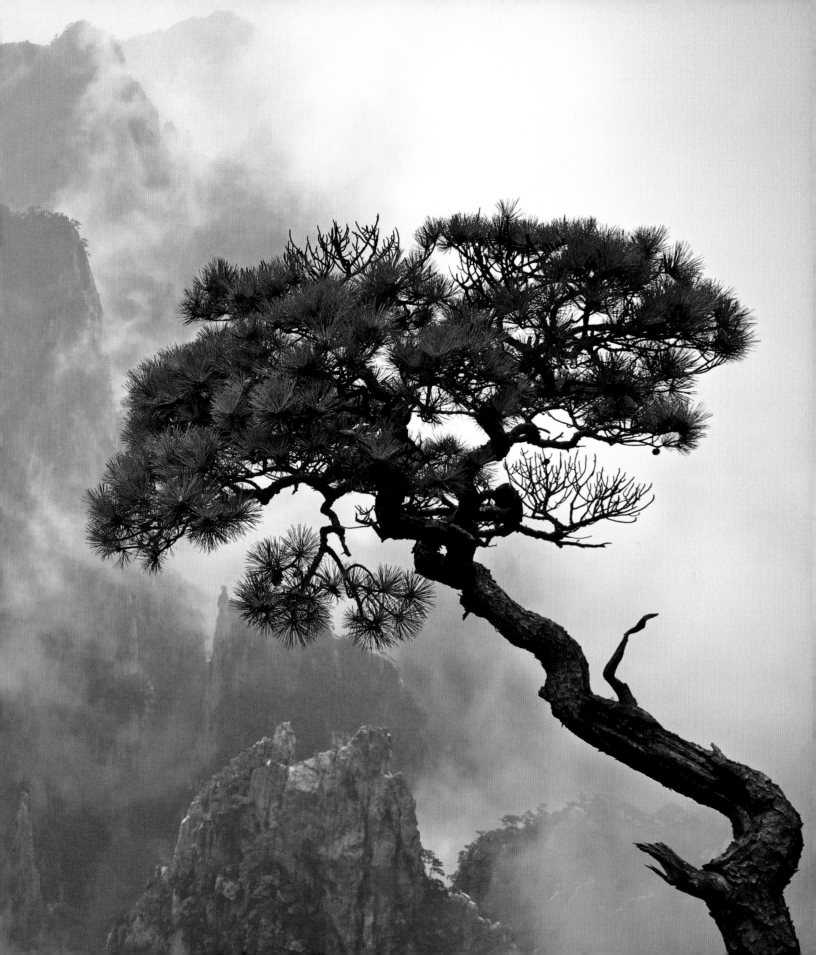

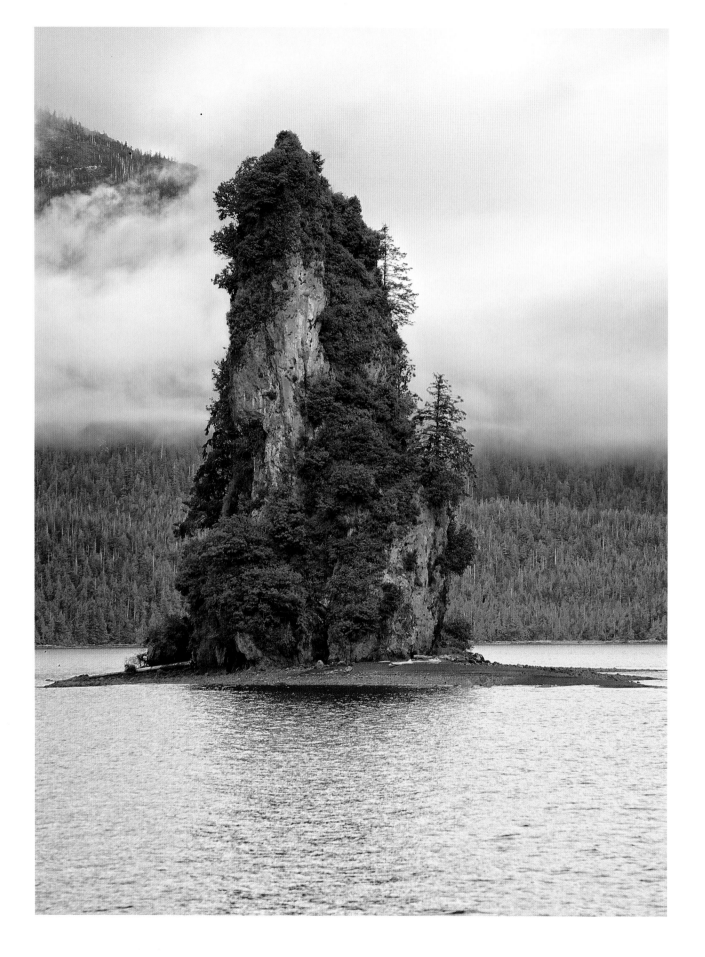

of the essential characteristics of land is that it is higher than water. Gravity causes water to flow down to the lowest point, which should cause the continents to dry out. The only reason this doesn't happen is thanks to supplies of water constantly dropped off by clouds, which form over the oceans and are blown over land by the wind. However, this mechanism only functions within a few hundred miles of the coast. The farther inland you go, the drier it is, because the clouds get rained out and disappear. When you get about 400 miles from the coast, it is so dry that the first deserts appear. If we depended on just this mechanism for water, life would be possible only in a narrow band around the edges of continents; the interior of land masses would be arid and bleak. So, thank goodness for trees.

Forests matter at a more fundamental level than most of us realize.

Of all the plants, trees have the largest surface area covered in leaves. Part of every rainfall is intercepted in the canopy and immediately evaporates again. In addition, each summer, trees drink up water from the land, which they release into the air through transpiration. This water vapor creates new clouds that travel farther inland to release their rain. As the cycle continues, water reaches even the most remote areas. This water pump works so well that the downpours in some large areas of the world, such as the Amazon Basin, are almost as heavy thousands of miles inland as they are on the coast.

There are a few requirements for the pump to work: From the ocean to the farthest corner, there must be forest. And, most importantly, the coastal forests are the foundations for this system. If they do not exist, the system falls apart. It doesn't matter if it's a rain forest or the Siberian taiga, the trees transfer life-giving moisture into landlocked interiors. The whole process breaks down if coastal forests are cleared. It's a bit like if you were using an electrical pump to distribute water and you pulled the intake pipe out of the pond. The fallout is already apparent in Brazil, where the Amazonian rain forest is steadily drying out.

Coniferous forests in the Northern Hemisphere influence climate and manage water in other ways, too. Conifers give off terpenes, substances originally intended as a defense against illness and pests. When these molecules get into the air, moisture condenses on them, creating clouds that are twice as thick as the clouds over non-forested areas. The possibility of rain increases, and in addition, about 5 percent of the sunlight is reflected away from the ground. Temperatures in the area fall. Cool and moist—just how conifers like it. Given this reciprocal relationship between trees and weather, forest ecosystems probably play an important role in slowing down climate change.

The forest floor also acts as a huge sponge that diligently collects rainfall. The trees make sure that the raindrops don't land heavily on the ground but drip gently from their branches. The loosely packed soil absorbs all the water, so instead of the raindrops joining together to form small streams that rush away in the blink of an eye, they remain trapped in the soil. Once the soil is saturated, excess moisture is released slowly and over the course of many years, deeper and deeper into the layers below the surface. It can take decades before the moisture once again sees the light of day. Fluctuations between periods of drought and heavy rain become a thing of the past, and what remains is a constantly bubbling spring. Although it has to be said, it doesn't always bubble. Often it looks more like a swampy-squishy area, a dark patch on the forest floor seeping toward the nearest stream.

MORE THAN MEETS THE EYE

FOR US HUMANS, soil is more obscure than water, both literally and metaphorically. Whereas it is generally accepted that we know less about the ocean floor than we know about the surface of the moon, we know even less about life in the soil. Trees stabilize soil with their roots and protect it against rains and storms. Soil erosion is one of the forest's most dangerous natural enemies. Disturbed forests can lose considerably more soil per year than they can replace through the weathering of stones underground. Sooner or later, only the stones remain. In contrast, in intact forests, the soil becomes deeper and richer over time, so growing conditions for trees constantly improve. Up to half the biomass of a forest is hidden in this lower story. There are more life-forms in a handful

FOLLOWING SPREAD
Forest canopy and cup fungi

of forest soil than there are people on the planet, and a mere teaspoonful contains many miles of fungal filaments.

Minute soil organisms, the first link in the forest food chain, are like terrestrial plankton.

Because of their small size, most of the species living in forest soils cannot be detected with the naked eye, but they all work the soil, transform it, and so make it valuable for the trees. Let's take a look at beetle mites, of which there are about a thousand known species in European latitudes. They are less than 0.04 inches long and look like spiders with inadvisably short legs. Their bodies are two-tone brown, which blends in well with their natural environment: the soil. Mites? That brings up associations with household dust mites, which feed on the flakes of skin we shed and other waste products, and may trigger allergies in some people. At least some of the beetle mites act in a similar way around trees. The leaves and fragments of bark trees shed would pile up several yards deep if it weren't for a hungry army of microscopic creatures ready to pounce on the detritus. To do this, they live in the cast-off leaf litter, which they devour voraciously. Other species specialize in fungi. These creatures crouch in small underground tunnels and suck the juices that ooze out of the fungi's fine white threads. Finally, beetle mites feed on the sugar trees share with their fungal partners. Whether it's rotting wood or dead snails, there is nothing that doesn't have its corresponding beetle mite. They appear everywhere at the intersection between birth and decay, and so they must be considered essential components of the ecosystem.

Then there are the weevils. They look a bit like tiny elephants that have lost their enormous ears, and they belong to the most species-rich family of insects in the world. In Europe alone there are about 1,400 species. With the help of their long snouts, the little creatures eat small holes in leaves and stems, where they lay their eggs. Protected from predators, the larvae gnaw little passages

inside the plants and grow in peace. Some species of weevil can no longer fly, because they have become accustomed to the slow rhythms of the forest and its practically eternal existence. The farthest they can travel is 30 feet a year. If you find these weevils, you can be sure the forest has a long, uninterrupted history, for if their forests are disturbed, their chances of survival are slim.

While all this activity is going on below in undisturbed forests, there are unseen contributors to forest health perched way up high in the branches of ancient trees. Dr. Zoë Lindo of McGill University in Montreal researched Sitka spruce on the West Coast of Canada that were at least five hundred years old. First of all, she discovered large quantities of moss on the branches and in the branch forks of trees of this advanced age. Blue-green algae had colonized the trees' mossy cushions. These algae capture nitrogen from the air and process it into a form the trees can use. Rain then washes this natural fertilizer down the trunks and into the soil, making it available to the roots. Thus, old trees fertilize the forest and help their offspring get a better start in life.

Is there any hope at all that one day we will again be able to marvel at authentic old-growth forests with a full complement of microorganisms? It is entirely possible. Research carried out by students in the forest I manage has shown that microscopic organisms—at least those associated with coniferous forests—can cover astonishing distances. Old spruce plantations show this particularly clearly. There, the young researchers found species of springtails that specialize in spruce forests. But my predecessors here in Hümmel planted such forests only a hundred years ago. Prior to that, we had predominantly old beech trees, just like everywhere else in Central Europe. So how did these conifer-dependent springtails get to Hümmel? My guess is that it must have been birds that brought these terrestrial creatures as stowaways in their plumage. Birds love to take dust baths in dead leaves to clean their feathers. When they do this, tiny creatures that live in the soil must surely get trapped, and they are then unloaded during a dust bath in the next forest. If in the future more mature forests are allowed, once again, to develop undisturbed, then birds can see to it that the appropriate subletters show up again as well.

And what do forests in all their surprising complexity have to offer us? People who want to take a deep breath of fresh air or engage in physical

activity in a particularly agreeable atmosphere step out into the forest. There's every reason to do so. The air truly is considerably cleaner under the trees, because the trees act as huge air filters. Their leaves and needles hang in a steady breeze, catching large and small particles as they float by. Per year and square mile this can amount to 20,000 tons of material. Trees trap so much because their canopy presents such a large surface area. The filtered particles include pollen and dust blown up from the ground, and harmful particles from human activity, such as acids, toxic hydrocarbons, and nitrogen compounds, also accumulate in the trees like fat in the filter of an exhaust fan above a kitchen stove.

Trees not only filter materials out of the air but also pump substances into it. Phytoncides are substances with antibiotic properties that are released by trees to fight off pests, and there has been some impressive research done on them. A biologist from Leningrad, Boris Tokin, described them like this back in 1956: if you add a pinch of crushed spruce or pine needles to a drop of water that contains protozoa, in less than a second the protozoa are dead. In the same paper, Tokin writes that the air in young pine forests is almost germfree,

thanks to the phytoncides released by the needles. In essence, then, trees disinfect their surroundings. The phytoncides in conifers are particularly pungent, and they are the origin of that heady forest scent that is especially intense on hot summer days.

Step out into the forest. Breathe deeply. How do you feel? Forests differ a great deal from one another depending on the species of trees they contain.

Coniferous forests noticeably reduce the number of germs in the air, which feels particularly good to people who suffer from allergies. However, reforestation programs introduce spruce and pines to areas where they are not native, and

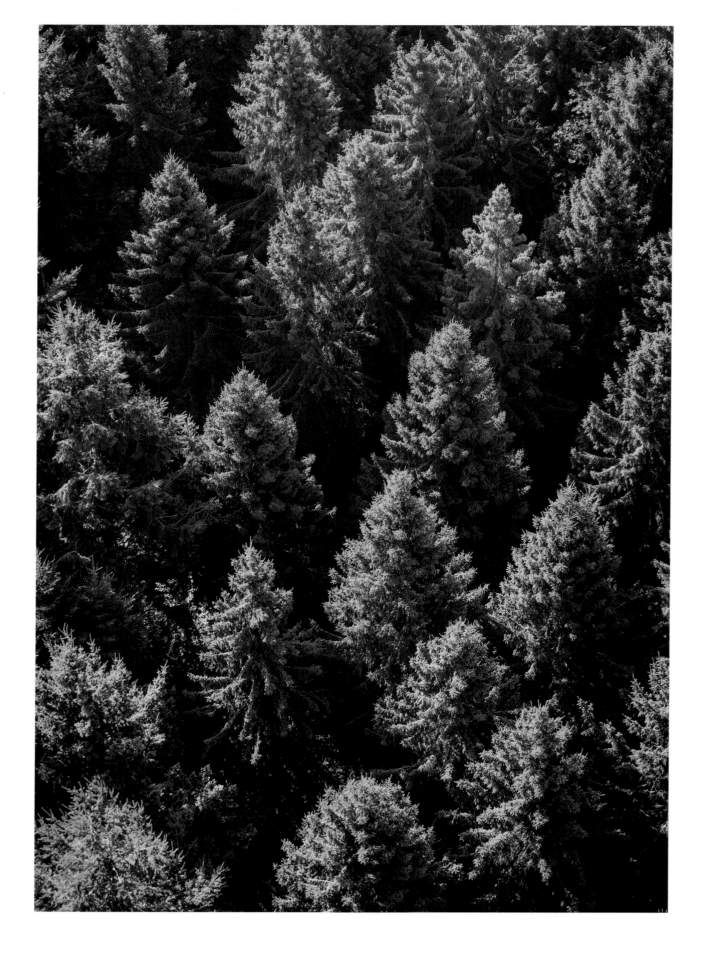

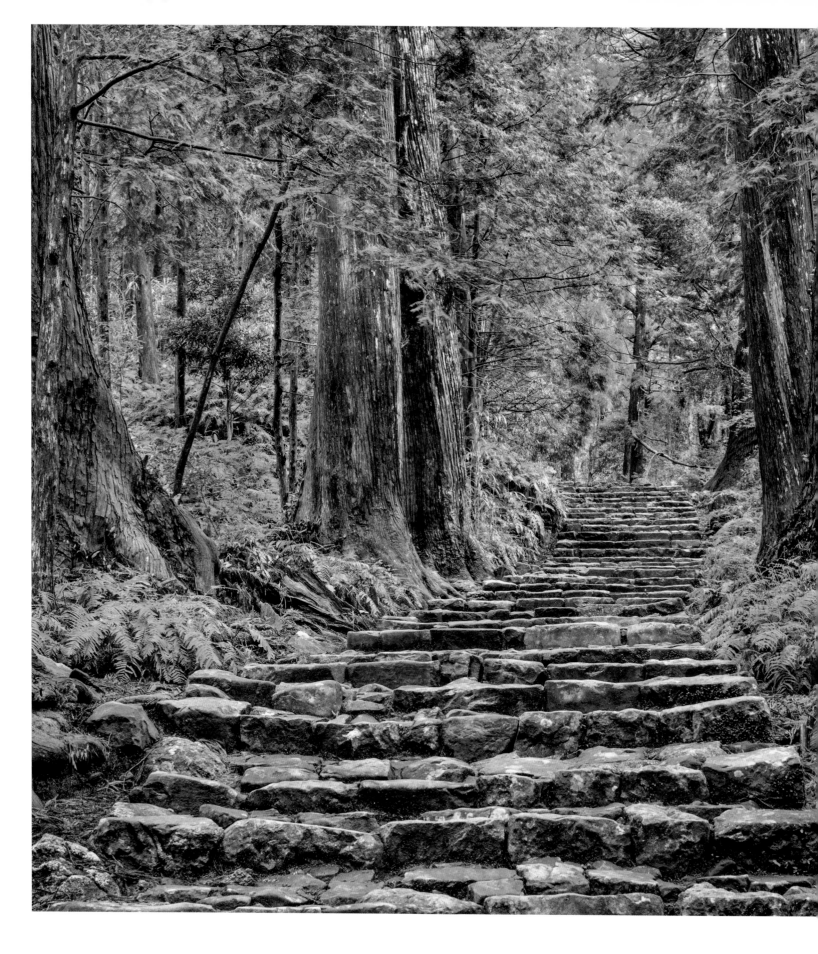

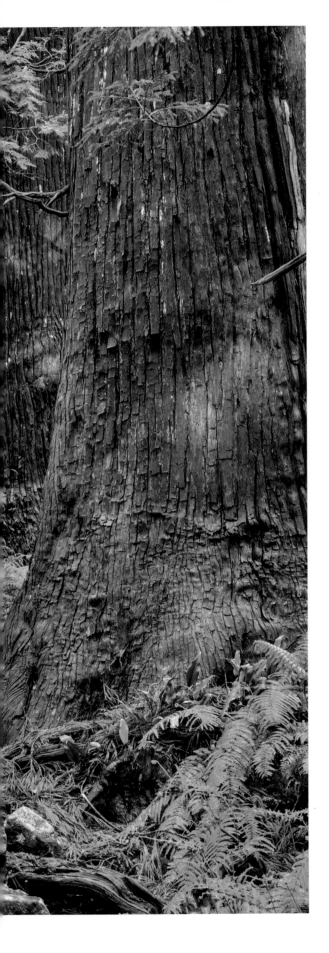

the newcomers experience substantial problems in their new habitats. Usually, they are brought to low elevations that are too warm and dry for conifers to thrive. As a result, the air is dustier, as you can clearly see when the dust motes are backlit by sun streaming down on a summer's day. And because the spruce and pines are constantly in danger of dying of thirst, they are easy prey for bark beetles, which come along to make a meal of them. At this point, frantic scent-mails begin to swirl around in the canopy. The trees are "screaming" for help and activating their arsenal of chemical defenses. You absorb all of this with every breath of forest air you take into your lungs. Is it possible that you could unconsciously register the trees' state of alarm?

Consider this. Threatened forests are inherently unstable, and therefore, they are not appropriate places for human beings to live. And because our Stone Age ancestors were always on the lookout for ideal places to set up camp, it would make sense if we could intuitively pick up on the state of our surroundings. Whether we can somehow listen in on tree talk is a subject that has been addressed in the specialized literature. Korean scientists

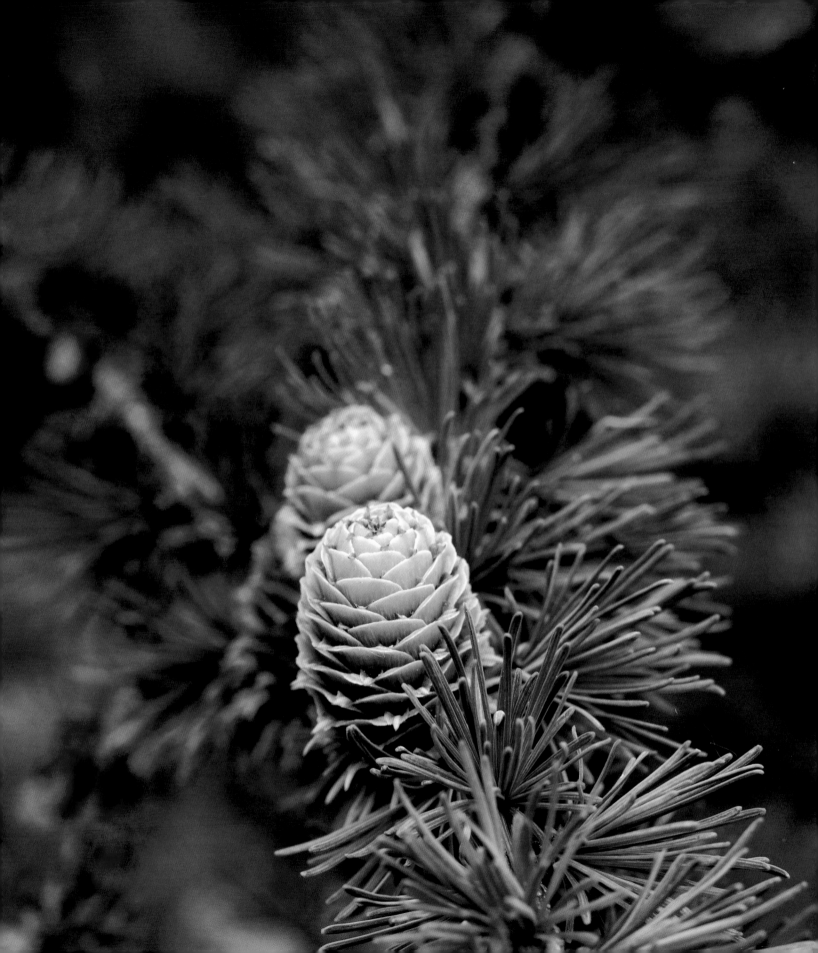

tracked older women walking through forests and urban areas. The result? When the women walked in the forest, their blood pressure, their lung capacity, and the elasticity of their arteries improved, whereas an excursion into town elicited none of these changes. It's possible that germ-killing phytoncides have a beneficial effect on our immune systems as well as on the trees' health. Personally, however, I think the swirling cocktail of tree talk is the reason we enjoy being out in the forest so much.

Walkers who visit one of the ancient deciduous forest preserves in the forest I manage always report that their heart feels lighter and they feel right at home. If they walk instead through coniferous forests, which in Central Europe are mostly planted and are, therefore, more fragile, artificial places, they don't experience such feelings. Possibly it's because in the ancient forest preserves, fewer "alarm calls" go out, and therefore, most messages exchanged between trees are contented ones, and these messages reach our brains as well, via our noses. I am convinced that we intuitively register the forest's health. Why don't you give it a try?

LOOKING TO THE FUTURE

IN THESE TIMES of dramatic environmental upheaval, our yearning for undisturbed nature is increasing. Countries around the world are enacting legislation to protect what remains of their original forests. In the United Kingdom, the designation "ancient woodlands" affords some protection to woodlands that have existed continuously since at least the 1600s. Often formerly the property of large estates, over their history they have been intensively managed for wood and wildlife, and so, although the woodland itself may be ancient, the trees that grow there may not. In Australia, the term "old-growth forest" helps protect some ancient forests from logging, but as economic interests push back, arguments are inevitably raised about the precise meaning of the term.

In the United States, forest preserves, such as the Adirondack and Catskill parks in New York State, keep economic interests out of the forests. According to the state constitution, the preserve "shall be forever kept as wild forest lands," and the timber shall not be "sold, removed or destroyed." What started as a measure to ensure that excessive

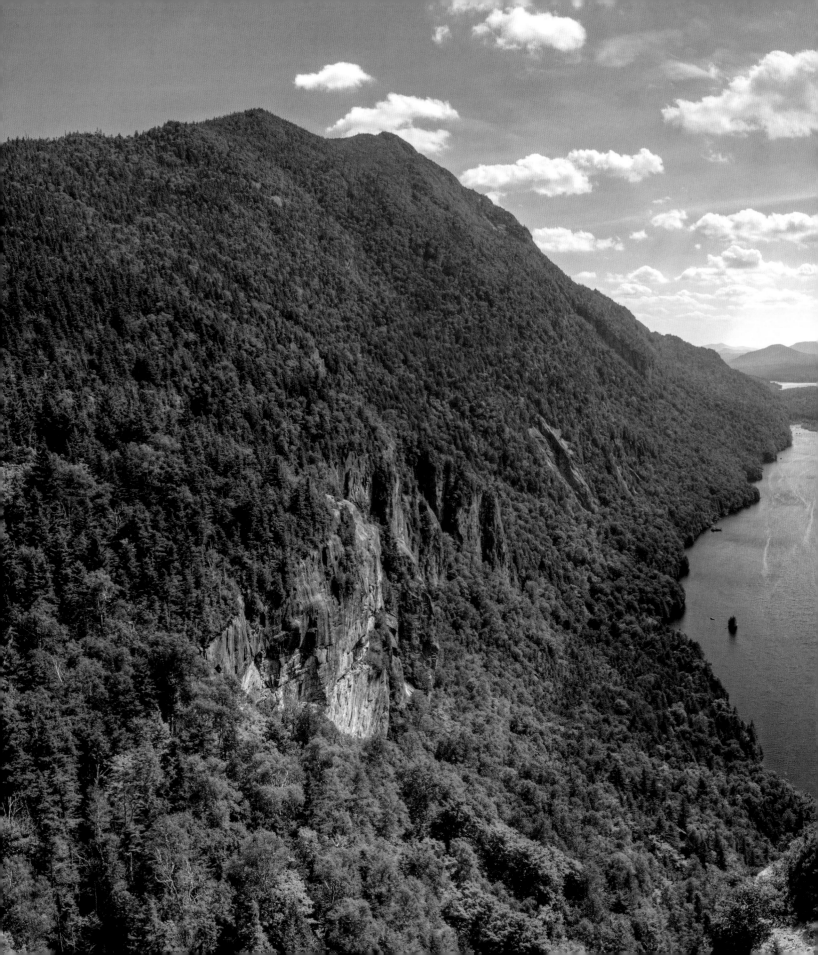

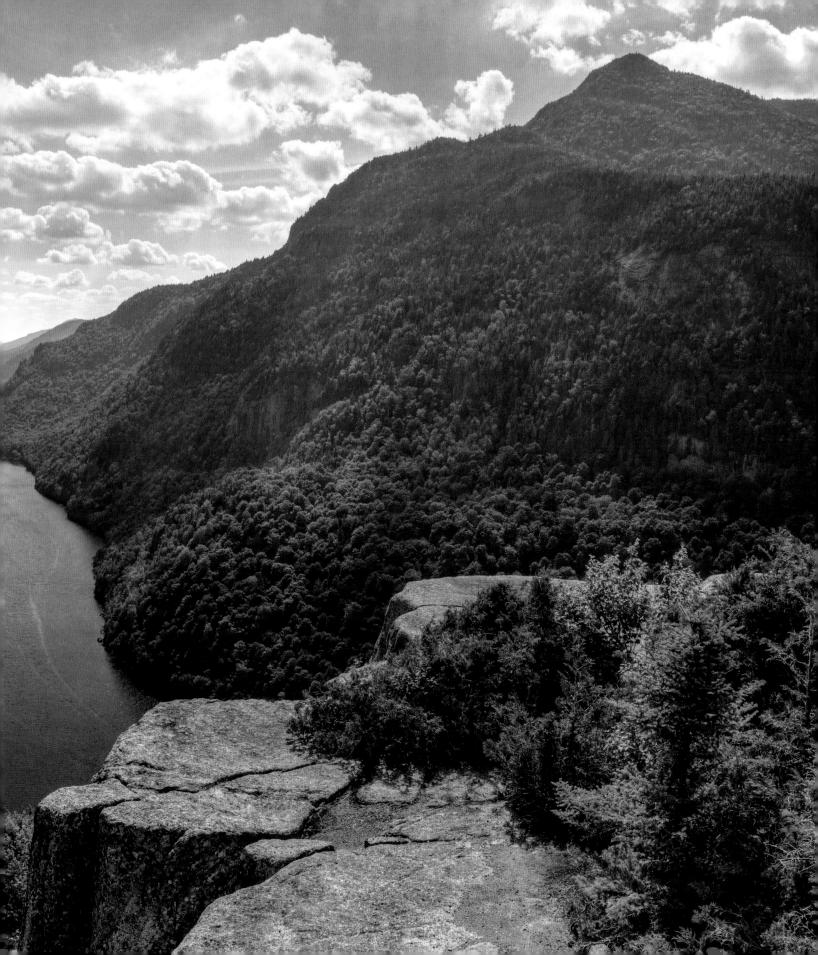

logging in the nineteenth century didn't lead to soil erosion and silting up of the economically important Erie Canal has turned into a resource dedicated to the forest itself and visitors who "leave no trace" as they pass through.

Even more remote is the Great Bear Rainforest in northern British Columbia, which covers almost 25,000 square miles along the rugged coast. Half of this area is forested, including about 8,900 square miles of old-growth trees. This primeval forest is home to the rare spirit bear, which, although it is white, is not a polar bear but a black bear with white fur. First Nations in the area have been fighting since the 1990s to protect their homelands. On February 1, 2016, an agreement was announced to keep 85 percent of the forest unlogged, though it does allow for 15 percent of the trees, mostly old growth at low elevations, to be removed. After a long hard struggle, some progress, at least, has been made in protecting this very special place. Chief Marilyn Slett, president of Coastal First Nations, is well aware of the forest's importance: "Our leaders understand our well being is connected to the well being of our lands and waters... If we use our knowledge and our wisdom to look after [them], they will look after

us into the future." The Kichwa of Sarayaku, Ecuador, see their forest as "the most exalted expression of life itself."

Old-growth forests have a calming effect and offer better experiences for people seeking rest and relaxation.

We are part of Nature, and we are made in such a way that we can survive only with the help of organic substances from other species. We share this necessity with all other animals. The real question is whether we help ourselves only to what we need from the forest ecosystem, and—analogous to our treatment of animals—whether we spare the trees unnecessary suffering when we do this.

What organic farms are to agriculture, continuous cover forests with careful selective cutting

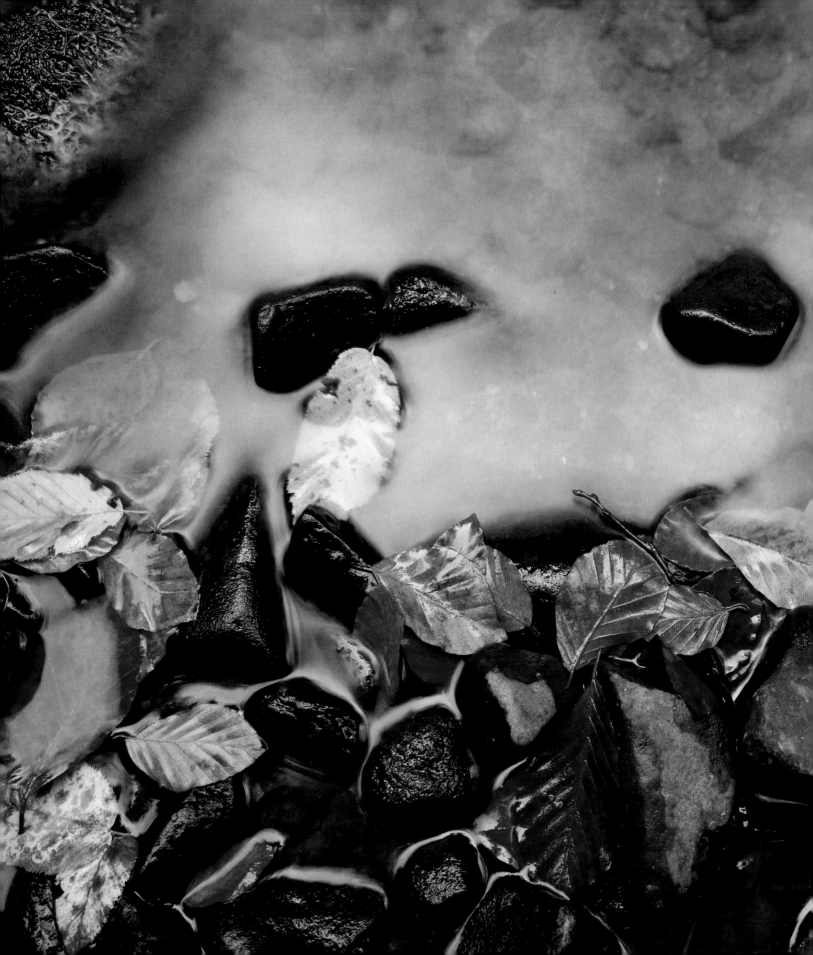

are to silviculture. In these forests, trees of different ages and sizes are mixed together so that tree children can grow up under their mothers. Occasionally, a tree is harvested with care and removed using horses. And so that old trees can fulfill their destinies, 5 to 10 percent of the area is completely protected. Lumber from forests with such species-appropriate tree management can be used with no qualms of conscience.

In the case of Switzerland, a whole country is concerned with the species-appropriate treatment of all things green. The constitution reads, in part, that "account [is] to be taken of the dignity of creation when handling animals, plants and other organisms." Although this point of view has elicited a lot of headshaking in the international community, I, for one, welcome breaking down the moral barriers between animals and plants. When the capabilities of vegetative beings become known, and their emotional lives and needs are recognized, then the way we treat plants will gradually change, as well. Forests are not primarily lumber factories and warehouses for raw material, and only secondarily complex habitats for thousands of species, which is the way modern forestry currently treats them. Completely the opposite, in fact.

Wherever forests can develop in a species-appropriate manner, they offer particularly beneficial functions that are legally placed above lumber production in many forest laws. I am talking about respite and recovery. Current discussions between environmental groups and forest users give hope that in the future forests will continue to live out their hidden lives, and our descendants will still have the opportunity to walk through the trees in wonder.

Ancient forests achieve the fullness of life with tens of thousands of interwoven and interdependent species.

Fish and mesquite tree

And just how important this interconnected global network of forests is to other areas of Nature is made clear by this little story from Japan. Katsuhiko Matsunaga, a marine chemist at Hokkaido University, discovered that leaves falling into streams and rivers leach acids into the ocean that stimulate the growth of plankton, the first and most important building block in the food chain. More fish because of the forest? The researcher encouraged the planting of more trees in coastal areas, which did, in fact, lead to higher yields for fisheries and oyster growers.

But we shouldn't be concerned about trees purely for material reasons; we should also care about them because of the little puzzles and wonders they present us with. Under the canopy of the trees, daily dramas and moving love stories are played out. Here is the last remaining piece of Nature, right on our doorstep, where adventures are to be experienced and secrets discovered. And who knows, perhaps one day the language of trees will eventually be deciphered, giving us the raw material for further amazing stories. Until then, when you take your next walk in the forest, give free rein to your imagination—in many cases, what you imagine is not so far removed from reality, after all!

Afterword

THIS BOOK IS an illustrated, abridged edition of
a book I wrote to describe my experiences in the
forest I manage in the Eifel mountains in Germany.
I wanted to give readers a lens to help them take
a closer look at trees. It was clear from the book's
success that the story I had to tell struck a chord
with many, many people. If the photographs and
text in this book have inspired you to find out
more about trees, I invite you to read the full text
of *The Hidden Life of Trees*, which will give you
more details about the fascinating science and
as-yet-unresolved mysteries of forests, and the
role they play in sustaining our world and making
it the kind of place where we want to live.

FACING
Maple leaves

FOLLOWING SPREAD
Pine forest

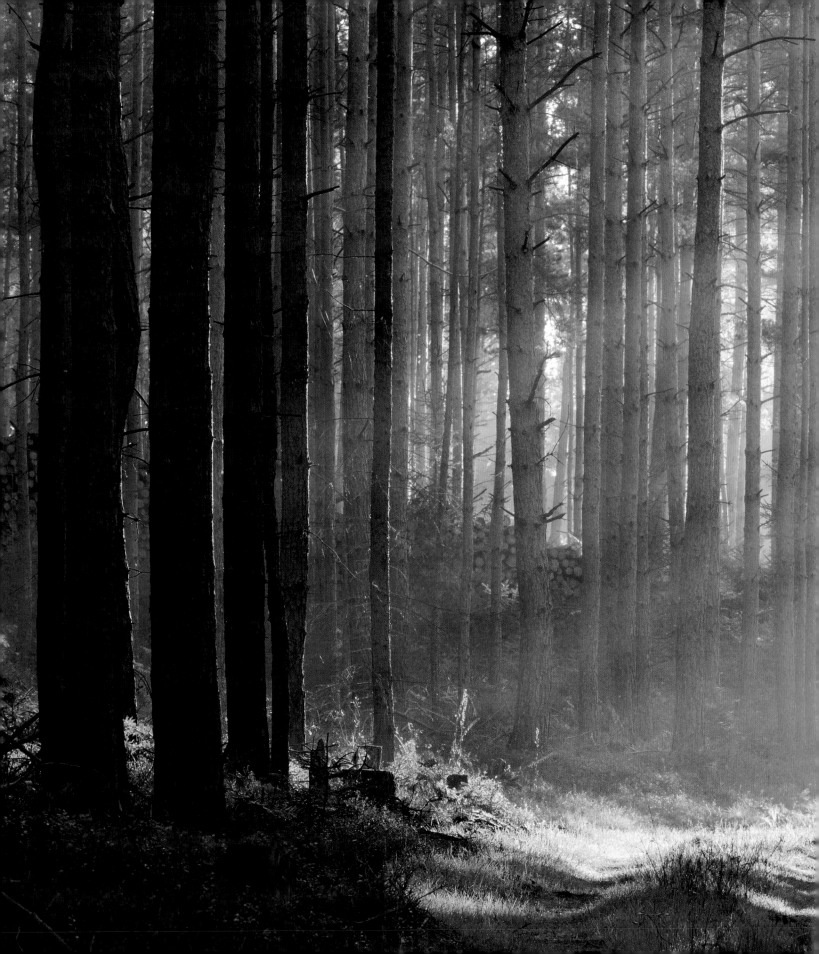

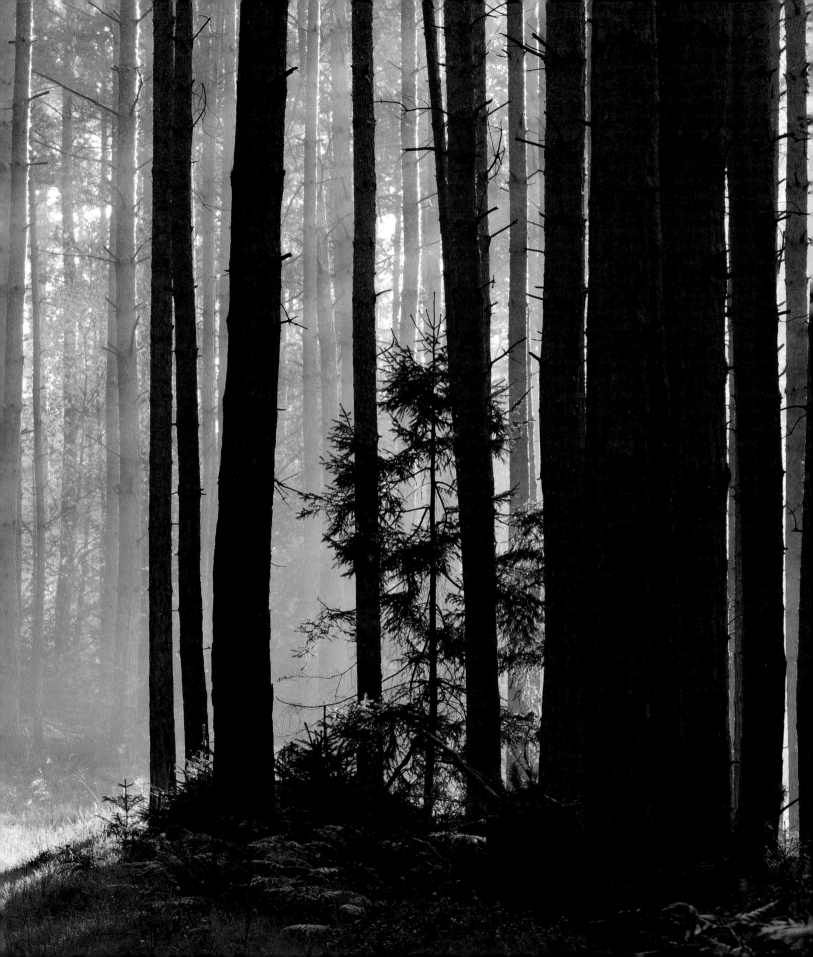

Illustrations

74–75 Stag beetle, © Beautymart/Bigstock.com

77 Pine marten, Ontario, © iStock.com/SeventhDayPhotography

79 Nurse log, Olympic National Park, Washington, © Jon Mowe/Shutterstock.com

80 Bracket fungus, © iStock.com/DebraLeeWiseberg

82–83 Beech trees, the Netherlands, © Bob van den Berg Photography/Getty Images

85 Golden larch, China, © Jorge Salcedo/Shutterstock.com

86–87 Beech woodland, Tandle Hill Country Park, Greater Manchester, England, © Loop Images Ltd/Alamy Stock Photo

88 Alpine larch, Lake Viviane in The Enchantments, Alpine Lakes Wilderness, Washington, © Greg Vaughn/Alamy Stock Photo

90–91 Conifers, Two Top Mountain, Montana, © KenCanning/Getty Images

92 Bare winter trees, Scotland, © iStock.com/Vladimirovic

93 Alder tree covered in snow, © iStock.com/Eerik

95 Basswood seeds, © iStock.com/Max-Photos

96–97 Sycamore tree, Oxfordshire, England, © Tim Gainey/Alamy Stock Photo

100 Spruce seedling, © iStock.com/deborahkr

101 Red chokecherry leaves, Jackson Hole, Wyoming, © TheGreenMan/Shutterstock.com

104–5 Cypress swamp, Louisiana, © iStock.com/zodebala

106–7 Pine needles, Sierra Nevada, California, © iStock.com/GomezDavid

109 Blue spruce needles, © iStock.com/gimages777

110–11 Giant sequoia, Sequoia and Kings Canyon National Parks, California, © Inge Johnsson/Alamy Stock Photo

113 Deciduous trees, Urbasa-Andía Natural Park, Navarra, Spain, © Javier Fernández Sánchez

114 Maple trees, Vancouver, British Columbia, © iStock.com/jamesvancouver

115 Tulip trees, Paseo de la Reforma, Mexico City, © iStock.com/Alija

116 Sidewalk trees, © SergeBertasiusPhotography/Shutterstock.com

118–19 Angel Oak, Charleston, South Carolina, © iStock.com/Pgiam

122 Park trees illuminated at night, © Poznukhov Yuriy/Shutterstock.com

124–25 Petrified wood, © iStock.com/TatianaMironenko

127 Dewdrops on moss, © timmy1608/Shutterstock.com

128—29 Brazil, © Filipe Frazao

130–31 Dominica, © iStock.com/Meinzahn

132 Forest stream, © djgis/Shutterstock.com

135 Henty Dunes, Tasmania, © totajla/Shutterstock.com

136–37 Huangshan pine, Mount Hua, Shaanxi province, China, © iStock.com/phototropic

138 New Eddystone Rock, Misty Fjords National Monument, Alaska, © iStock.com/bjray1

142 Forest canopy, © iStock.com/fotoVoyager

143 Cup fungi (*Cookeina tricholoma*), © iStock.com/Yok46233042

144 Red velvet mite (*Trombidium* sp.), © Ezume Images/Shutterstock.com

147 Coniferous forest, © iStock.com/fotoVoyager

148–49 Kumano Kodō Sacred Trail, Japan, © iStock.com/SeanPavonePhoto

150 Immature cones, © iStock.com/zhekos

152–53 Ausable Lake, Adirondack Mountains, New York, © iStock.com/lightphoto

155 Bernese Oberland, Switzerland, © iStock.com/OGphoto

156 Beech leaves in stream, © iStock.com/rdonar

158–59 Fish and mesquite tree, Rio Grande Valley, Texas, © Rolf Nussbaumer Photography/Alamy Stock Photo

160–61 Maple leaves, Phu Kradueng National Park, Thailand, © ThavornC/Shutterstock.com

162–63 Pine forest, © iStock.com/ AVTG

**DAVID
SUZUKI
INSTITUTE**

THE DAVID SUZUKI INSTITUTE is a non-profit organization founded in 2010 to stimulate debate and action on environmental issues. The Institute and the David Suzuki Foundation both work to advance awareness of environmental issues important to all Canadians.

We invite you to support the activities of the Institute. For more information please contact us at:

David Suzuki Institute
219 – 2211 West 4th Avenue
Vancouver, BC, Canada V6K 4S2
info@davidsuzukiinstitute.org
604-742-2899
www.davidsuzukiinstitute.org

Cheques can be made payable to The David Suzuki Institute.